THE
SARPEDON
KRATER

THE LANDMARK LIBRARY

Chapters in the History of Civilization

The Landmark Library is a record of the achievements of humankind
from the late Stone Age to the present day. Each volume in the series
is devoted to a crucial theme in the history of civilization, and offers
a concise and authoritative text accompanied by a generous
complement of images. Contributing authors to The Landmark
Library are chosen for their ability to combine
scholarship with a flair for communicating their
specialist knowledge to a wider,
non-specialist readership.

ALREADY PUBLISHED

Guernica, James Attlee
Hadrian's Wall, Adrian Goldsworthy
The British Museum, James Hamilton
Eroica: The First Great Romantic Symphony, James Hamilton-Paterson
Magna Carta, Dan Jones
Messiah, Jonathan Keates
Stonehenge, Francis Pryor
City of Light: The Reinvention of Paris, Rupert Christiansen
Skyscraper, Dan Cruickshank

FORTHCOMING VOLUMES
Dante's Divine Comedy, Ian Thomson
The Royal Society, Adrian Tinniswood
The Rite of Spring, Gillian Moore
Shakespeare: The Theatre of Our World, Peter Conrad
Versailles, Colin Jones
The Ancient Olympics, Robin Waterfield
Gilgamesh, Michael Schmidt

THE SARPEDON KRATER

THE LIFE AND AFTERLIFE OF A GREEK VASE

NIGEL SPIVEY

HEAD
of ZEUS

An Apollo Book

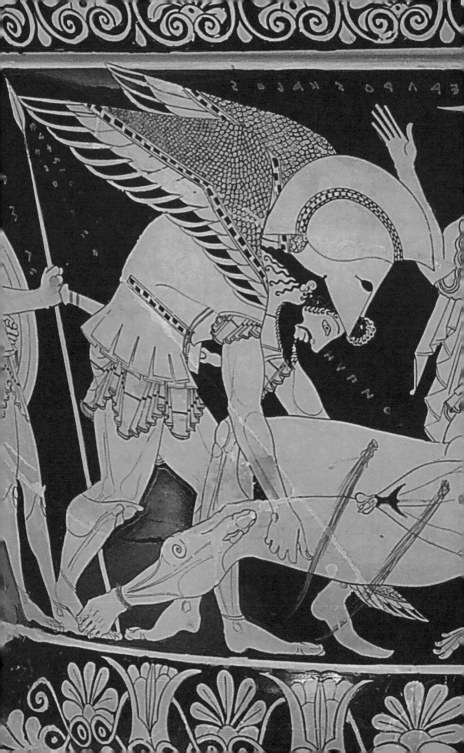

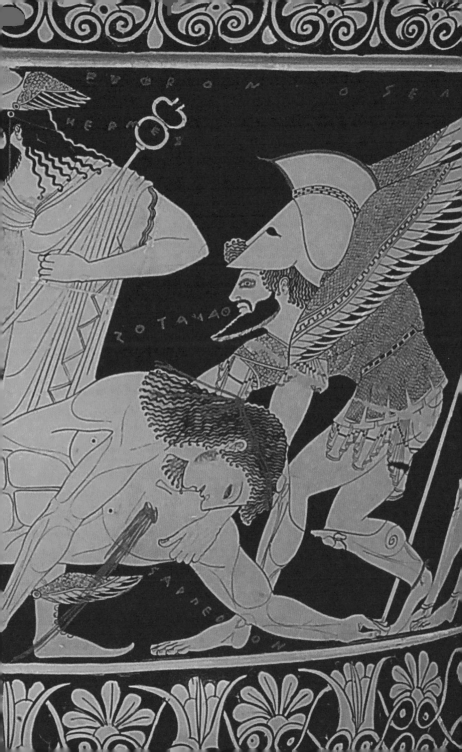

This is an Apollo book, first published
in the UK in 2018 by Head of Zeus Ltd

1 3 5 7 9 10 8 6 4 2

A CIP catalogue record for this book is available
from the British Library.

ISBN (HB) 9781786691613
 (E) 9781786691606

Designed by Isambard Thomas
Printed in Spain by Graficas Estella

Head of Zeus Ltd
First Floor East
5–8 Hardwick Street
London EC1R 4RG

WWW.HEADOFZEUS.COM

IMAGE CREDITS: Plates 1–3: SAEM
(Soprintendenza archeologica per l'Etruria
meridionale). Fig.1: Ingrid Geske.
3: Staatliche Antikensammlungen und
Glyptothek München/Renate Kühling.
7: Dario Pignatelli/Reuters. 8: after *FR* pl.
22. 9: after *FR* pl. 61.10: after Graef &
Langlotz, *Die antiken Vasen von der
Akropolis zu Athen* (Berlin 1925), pl. 8. 11:
Image from the Beazley Archive, courtesy
of the Classical Art Research Centre,
University of Oxford. 12: Courtesy of the
Getty's Open Content Program. 13: after
FR pl. 92. 17: Image from the Beazley
Archive, courtesy of the Classical Art
Research Centre, University of Oxford. 18:
after *FR* pl. 157. 19: after *Mon.Piot* 9 (1902),
pl. 2. 23: after *FR* pl. 63. 24, 28, 32, 37, 38:
SAEM. 40: After *Mon. dell'Inst.* 6 (1858), pl.
21. 43: after *CVA Athens* 2, pl. 20(4). 42, 45,
46: Metropolitan Museum. 47: National
Museums, Liverpool. 51: Cleveland
Museum of Art. 39, 44, 64, 67: By Courtesy
of the Trustees of the British Museum. 54:
after O. Jahn, *Griechische Bilderchroniken*,
pl. 1. 55: Naples, Museo Archeologico. 57:
after G.P. Bellori, *Antiche lucerne sepolcrali
figurate raccolte dalle cave sotterranee e
grotte di Roma* (Rome 1691), pl.10. 60: after
Koch 1975, pl. 75. 61: The Warburg
Institute. 63: after Koch 1975, pl. 84. 65:
Reproduced by permission of the Provost
and Fellows of Eton College. 71: Francesco
Rinaldi. 74: Larry Burrows/The LIFE
Picture Collection/Getty Images. Other
images: the author, or archives of the
Museum of Classical Archaeology,
Cambridge.

Preface

As vases go, the Sarpedon krater is relatively large. As landmarks go, it is almost ridiculously small – standing just over 45 centimetres (18 in) high (Plates 1–3). How can an object of such size be categorized along with those monuments we usually regard as 'landmarks' – Stonehenge, the Pyramids, the Great Wall of China?

It is a claim of the present series that the term 'landmark' may be extended to works of art that are not architectonic structures – so including certain pieces of music, pictures and literary texts. Even in that extended sense a terracotta vessel would seem an unlikely candidate to be considered a 'landmark'. Anyone who sees the Sarpedon krater on display may sense its monumental quality; the principal subject of its decoration is undeniably grand, properly 'epic' and truly 'awesome'. Yet the case for regarding it as an eminent and influential achievement within world culture needs to be made – and that is the project of this book.

It was the first Greek vase to fetch $1,000,000 on the art market. Such was the value in 1972: it could now be multiplied several times. So the object has acquired an impressive capital worth. Its modern history involves illicit tomb raiding, intrigue, duplicity, litigation, international outrage and possibly homicide. Chapter 2 attempts to clarify the sequence of events, although some details of the heist (including the possible instance of homicide) seem destined for obscurity.

The vase is signed by Euxitheos, the potter who shaped it, and by Euphronios, who painted it. As an example of ceramic construction, it is ambitious and well executed. Perhaps only those viewers who have themselves attempted to 'throw' wet clay into a symmetrical, well-defined shape will really appreciate the level of skill displayed by the potter; in any case, it is the name of the painter that creates the modern price-tag. Before the krater was found, Euphronios was already celebrated in academic and connoisseur circles as one of a group of artists in ancient

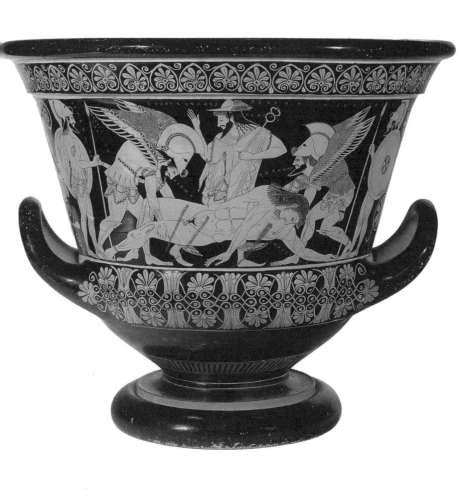

Plates 1–3 Views of the Sarpedon krater, signed by Euphronios as painter and by
Euxitheos as potter, *c*.515–510 BC. H 45.7 cm (18 in); diameter of mouth 55.15 cm
(21.7 in). Cerveteri, Museo Archeologico.

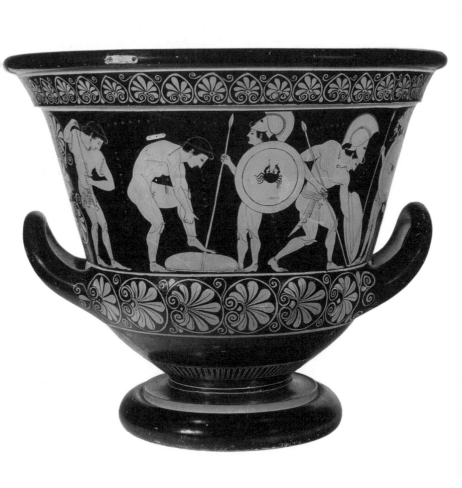

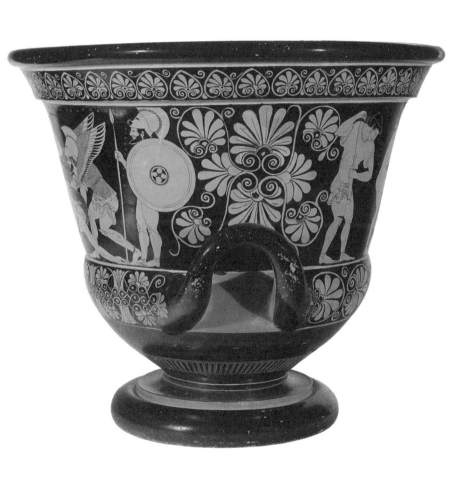

Athens dubbed 'the Pioneers'. How far these artists were aware of being avant-garde at the time is debatable. But there was some camaraderie around Euphronios, which helps to define his own style – and that is the focus of Chapter 3.

'Small is beautiful': beyond that adage, the very mobility of this object through space and time is part of its 'landmark' status – and key to its metaphorical power. Created in Athens towards the end of the sixth century BC, the krater may have been used for a drinking-party (symposium) in that city: it was probably produced for that purpose – the word *kratêr* literally translates as 'mixer', i.e. a vessel primarily intended for the blending of wine with water at a formal occasion. This formal occasion, the symposium, is the focus of Chapter 4.

Participants at a symposium were bound by a certain shared culture, tantamount to peer pressure. Wherever the vase was used for its intended function, it challenged viewers to recognize a narrative source for at least part of its decoration. We presume this to have been the epic poetry of Homer – though it may not have been Homer's *Iliad* exactly as that text has come down to us. The question of why an epic scene was appropriate for a drinking-party is addressed in Chapter 5 – and in particular, why the scene features the bloodied body of Sarpedon, a 'foreign fighter' at Troy. (It is in this chapter that readers will find a detailed analysis of the krater.)

At some point the krater made its first long journey, across the Mediterranean from Athens to Etruria (Italy). There are so many vases painted by Euphronios that come from Etruria – and in particular, the Etruscan site of Cerveteri (ancient Caere), half an hour's drive up the coast from Rome – that a direct export is not inconceivable. In any case, some Etruscan owner of the vase used it, perhaps as it was intended to be used – as a mixing-bowl. The krater got broken, and was neatly repaired with metal rivets: presumably treasured nonetheless, it was eventually deposited in

a tomb in one of the cemeteries of Cerveteri. It is unclear when this happened, but certainly it was before the mid-fourth century BC by which time the status of 'heirloom' may have been acquired.

How a vase intended for a symposium then became suitable as an item of Etruscan mortuary ritual is the topic of Chapter 6. The same chapter also takes note of how the motif of personified Sleep and Death lifting up a body – apparently 'invented' by Euphronios, since we have no earlier instance of it – went into service for funerals at Athens, too: becoming a decorative theme on the ceramic oil-flasks (*lekythoi*) that Athenians offered to their dead.

Chapter 7 traces the wider diffusion of that motif. 'Classical', 'Hellenistic', 'Roman' – the standard divisions of style in the Greek and Roman world imply chronological sequence, but also geographical extension. It is in this way that the motif takes wings. The krater itself is underground. But we find testimonies to its remote ingenuity in various media, and in places wherever Greek or Greek-trained artists and craftsmen travelled.

That process – for which terms such as 'diffusion', 'allusion', 'recycling' and 'reworking' may often overlap – is here characterized as the krater's 'afterlife'. This in turn borrows the terminology and method associated with Aby Warburg (1866–1929), for whom the study of 'antiquity's afterlife' (*das Nachleben der Antike*) began as a personal project and developed into an academic institution. Warburg's method is that embraced by Chapter 8, where we find the Sarpedon motif borrowed and 'reborn' in Christian imagery of the Renaissance. The chapter concludes with a brief attempt to comprehend the enduring aesthetic appeal of the motif – beyond the rather drastic psychological explanation that a bit of us rejoices at the sight of a dead fellow human.

Our journey ends, with Chapter 9, at Xanthos in Lycia: historically the final resting-place of Sarpedon, the hero who inspired this heroic work of art.

'The Million-Dollar Vase'

The Finding of the Krater –
and the Battle for its Custody

'The finest Greek vase there is.' The pride with which a new acquisition was announced in the *Metropolitan Museum of Art Bulletin* for autumn 1972 was, in retrospect, asking for trouble. Its sentiment might not be controversial: this book essentially supports the superlative claim. But proclaiming the splendour of the result deepened the shadows cast by the means of its achievement. The tale of how our vase was acquired by the New York museum, and why it was then 'repatriated' to Italy, is notorious. Some details remain irredeemably obscure. Nonetheless it seems worth making a synthesis – as follows.

The story could begin with a minor episode. A twelve-year-old boy is taken for his first visit to the grand archaeological museums in Berlin. It is 1930: Wall Street has hardly recovered from the 'Great Crash' of its stock market, while in Germany, National Socialism is becoming a significant political movement. But this young visitor from Thuringia is transfixed by the sight of a single Greek vase in one of the cabinets of the Antikensammlung. It is a large krater, decorated with scenes from an Athenian gymnasium: athletes caught in various poses, along with their trainer and junior attendants (Fig. 1). The vase is not signed, yet the museum label refers to an artist by name: 'Euphronios'. The boy resolves there and then that he will become an archaeologist, and devote his life to studying such fascinating objects as this.

This is how Dietrich von Bothmer, long-serving curator of antiquities at the New York Metropolitan Museum, recounted the moment that shaped his career as an expert in Greek painted pottery. *Se non é vero é ben trovato*, as Italians would say – 'if not true, then it ought to be'; or else, suppose the child to be the father of the man, and so the boy first enchanted upon seeing a splendid vase by Euphronios becomes the careful scholar who forsook professional caution in order to acquire a similar vase by the same painter – similar in shape, that is, yet even more outstanding in decoration. Either way, it is a sort of love affair

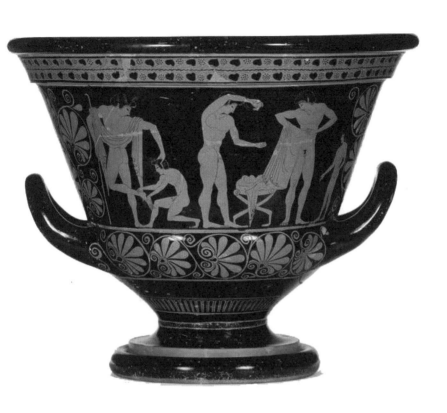

Fig. 1 Calyx-krater attributed to Euphronios, reportedly found near Capua in the 1870s. An early work, *c.*520 BC. See also Fig. 18. H 34.8 cm (13.7 in). Berlin, Antikensammlung F 2180.

– and goes some way to explaining the modern drama of the Sarpedon krater. Of the various protagonists in this drama, none was more passionately motivated than Dietrich von Bothmer.

His youthful ambition, along with his opposition to Nazism, took him first to Britain, then the United States. Awarded a Rhodes Scholarship in 1938 (when Germans were still eligible for that award), Bothmer became a student of J. D. Beazley, then Lincoln Professor of Classical Archaeology at Oxford. So he apprenticed himself to the world's acknowledged supreme expert on ancient Greek vase-painting – and developed, by his own admission, into a devoted disciple. Not only did he learn Beazley's methods for attributing even anonymous paintings to specific 'hands', and gain a mastery of these methods that would enable him, before long, to become the expert's most trusted collaborator, but he also showed a particular flair for reuniting 'orphans' with their 'family' – that is, seeing how fragments of a single vase, even when scattered across different continents, could be pieced together. The interruption of war brought emigration to America, where Bothmer continued his studies first at Berkeley (under H. R. W. Smith, also a former Beazley student), and subsequently at Chicago, before volunteering for military service in the Pacific. Demobbed (with distinction), he resumed the vocation of scholar and connoisseur. Though an ocean lay between them, he maintained a steady correspondence with Beazley in Oxford, exchanging notes, sketches and photographs, and it became their custom to arrange an annual meeting.

Among Beazley's early works is a monograph entitled *Attic Red-Figured Vases in American Museums* (1918). This carried a dedication to Edward Warren and John Marshall, saluting 'their unwearied labour in building up the magnificent collection of vases in America'. Warren, the son of a paper-mill magnate, began using his inheritance to buy classical antiquities while still a student, visiting Rome. Marshall, his companion, would be hired

Fig. 2 Detail of a psykter attributed to Euphronios. The deranged King Pentheus, already bleeding profusely, is gripped on each side by two maenads (one named, perhaps ironically, Galene, 'Calm'); other maenads are rushing around the vase. H 12.8 cm (5 in). Boston, Museum of Fine Arts 10.221a–f.

by the New York Metropolitan Museum as its 'European agent' for the acquisition of classical antiquities. Marshall undertook that office in 1906, at a time when the Metropolitan Museum possessed very few Greek vases. By the time of his death, in 1928, Marshall had achieved remarkable results. Curator Gisela Richter – who appointed Bothmer as assistant curator at the Met in 1946 – could declare that, over two decades, 'a collection was formed which is not only representative of the chief periods of Athenian red-figure but which ranks as one of the finest in the world'.

If only it could include Euphronios. The fact remained that American museums possessed very little of the painter's work. Frank Tarbell, director of the American School of Classical Studies at Athens 1888–9, had acquired some sherds, which eventually passed to the University of Chicago. In 1910, the Museum of Fine Arts at Boston had purchased a number of antiquities from Edward Warren, including several pieces of a *psykter* (wine-cooler: see p. 87) that Beazley attributed to Euphronios. Said to have come from the Etruscan site of Orvieto, this vase, even in its fragmentary state, showed an artistic ambition to orchestrate emotive scenes within the limited space of a curved vessel (Fig. 2).

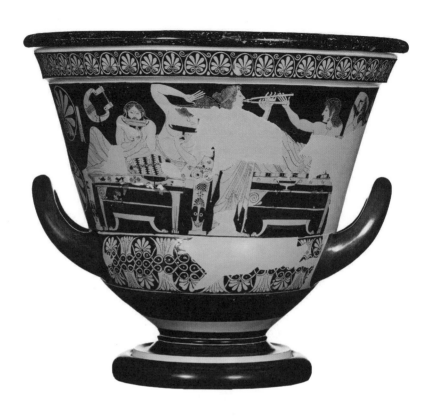

Fig. 3 Fragmentary calyx-krater attributed to Euphronios, with scenes of a symposium. The piping figure is labelled Syko ('Fig'); the reclining drinker with frontal face, Thoudemos; the handsome youth gesticulating from his couch, 'Smikros' ('Tiny'). (The hair and facial features of this figure closely match those of Sarpedon – see Fig. 78). H 44.5 cm (17.5 in). Munich, Antikensammlungen 8935.

Opportunities to acquire works of such archaic interest and quality seemed unlikely to multiply. Then, in the early 1960s, a partial calyx-krater attributed to Euphronios, showing scenes of a drinking-party or *symposion*, was brought to academic attention by the Boston-based classical archaeologist Emily Vermeule (Fig. 3). Noting gratefully that the fragmentary vessel had been loaned first for an exhibition at Providence, Rhode Island, and subsequently to the Boston Museum of Fine Arts, Vermeule remained discreet concerning the owner's identity. As for the likely provenance of the vase, she made no direct comment, merely observing – from signs of wear on the rim, and an ancient repair to its surviving handle – that 'the krater probably enjoyed constant use as a show piece at Etruscan banquets before being consigned to the tomb'. The vase eventually passed into the holdings of Munich's Staatliche Antikensammlungen in 1969 – by which time it had been 'certificated', as it were, within the oeuvre of Euphronios. Sir John Beazley (knighted in 1949, and subsequently made a Companion of Honour in 1959, for his services to scholarship) had already included it as an addendum to the second edition of his *Attic Red-Figure Vase-Painters* (1963). In the laconic style he used for these compendious catalogues, Beazley simply gave the provenance of the krater as 'Philadelphia market', and added: 'Attributed by Hecht'.

In his preface to the same book, Beazley acknowledged the assistance he had received from two individuals – for their 'kind acts', 'and for bringing to my notice vases that would otherwise have escaped me'. One was Herbert Cahn, proprietor of a family firm in Basel dealing in ancient coins and artefacts. The other was Robert ('Bob') Hecht. Like Cahn, Hecht had studied classical archaeology seriously before taking up trade in antiquities during the 1950s. A former Fellow of the American Academy at Rome, he became domiciled in that city, and used it as a base for business with museums and collectors around the world. Though

remembered as a 'suave' and 'worldly' operator, Hecht could also be indiscreet: in 1962, for example, his excitement about some coins he had acquired in Turkey led him to examine them on an internal flight: witnessed doing so, and challenged by police at Istanbul airport with attempting illegal export, he was thereafter banned from returning to the country. In Italy, the previous year, he had been charged (along with Herbert Cahn, and others) on suspicion of dealing in stolen goods. Acquitted on that occasion, he prospered, supplying such respectable institutions as the British Museum and the Louvre; and making occasional visits to Oxford, where he shared photographs of freshly discovered Greek vases with Beazley.

Where were these Greek vases coming from? Not, normally, from Greece as such: as we shall see (p. 46), as a result of various historical and archaeological factors, such vases tend to be recovered from the tombs of the Etruscans – the ancient inhabitants of that part of Italy once defined as 'Etruria'. The Etruscan heartlands – a territory located, broadly speaking, between Rome and Florence – are estimated to contain around half a million tombs. Many of those tombs lie beneath the surface of land in agricultural use; many of them were long ago emptied of their contents, comprising the 'grave goods' that the Etruscans were accustomed to deposit with their dead. Tomb raiders in ancient and medieval times would have been searching for jewellery, or any metallic items. Since the late eighteenth century, however, pottery was also regarded as worth finding. Accordingly, modern-day inhabitants of Etruscan areas became ingenious at probing for burials. No sophisticated sensing devices were required: a long steel rod, the *spillone* – pointed at one end, with a handle at the other for drilling it into the ground – was usually sufficient to locate a potential hoard. Practitioners of the pursuit – known as *tombaroli*, or *clandestini* – worked usually under the cover of darkness. Typically, they were local farmhands or labourers, apprenticed in

boyhood as rogue archaeologists, and sheltered by endemic Italian distrust of state authority, whether represented by the military police (*carabinieri*) or archaeological superintendencies – the latter swift to annexe land deemed archaeologically important, and not so swift to compensate farmers for land annexed. Fields, pastures and volcanic escarpments around the prime centres of South Etruria – Tarquinia, Vulci, Veii and Cerveteri – were generic findspots. Some *tombaroli* claim to have emptied, over years of activity, thousands of tombs.

There was a time when spoils from the tombs (or carefully encrusted replicas of such spoils) were put on sale in Rome, at the Porta Portese flea-market, or in the shop-windows of dealers, such as Fallani's on the Via del Babuino. (Not so nowadays, for reasons that will become obvious.) This was certainly the case when Hecht began his career. How he laid hands upon the Euphronios vase that he sold to Munich in the 1960s is not clear – but it is significant that he was later able to supply the same museum with further pieces of that vase, up until 1988.

With demand eager, it made sense (for Hecht) to pursue the possibility that further works by Euphronios lay waiting to be recovered from Etruscan tombs. Any problems of direct liaison with the localized gangs of *tombaroli* were eased when, in the mid-1960s, Hecht became acquainted with Giacomo Medici. Medici was the son of a minor antiquities vendor who kept a stall in Rome's Campo Marzio. Father and son had already been charged with trading in looted objects, a protracted trial ending in short suspended prison sentences. Medici junior thereby learned to keep his activities more covert and selective. Rather than stand outdoors in Piazza Borghese, selling assorted detritus from antiquity to passing tourists, it was safer, and more lucrative, to specialize in procuring 'top-end' objects from the clandestine hauls in Etruria and elsewhere. Medici knew where and how the *tombaroli* worked; his clients, to begin with, were private

collectors in Italy. Hecht brought a much wider dimension to the business, connecting not only with international museums and collectors, but also with academic experts. Beyond Beazley (whom Hecht would refer to as 'Jackie D.'), these experts included Oxford-based scientists who had developed the technology of measuring residual thermoluminescence in pottery (and other materials), thereby providing assurance of authenticity.

The Hecht–Medici alliance began with an Athenian red-figure drinking cup. This was sold to a collector in Switzerland, for considerably more than Hecht had paid to Medici – so Hecht was happy; in turn, Hecht had paid Medici considerably more than Medici had paid the *tombaroli* – so Medici was happy; and Medici would have paid the *tombaroli* considerably more than they usually earned in a month, or even a year, in their 'day jobs' – so they were happy too. Such was the economic chain set up for the transfer of an ancient object out of Italy. For Hecht and Medici, this marked the beginning of a collaboration that endured for several decades, and encompassed a large quantity and variety of artefacts, including numerous pieces of Etruscan terracotta temple decoration, portions of wall-paintings cut away from Etruscan tombs, precious metalwork and more. Switzerland was a favoured place for making sales, and some notable buyers and dealers, such as Herbert Cahn and Elie Borowski, were based there; but final destinations were worldwide, and Etruria not the only source. In 1970, for example, Hecht paid Medici $67,000 for assorted relics from a tomb ransacked on a hill near Montelibretti, overlooking the Tiber valley: these were the grave goods of a 'Sabine prince', including gold-relief panels and horse-trappings from the royal ceremonial gig – and were sold on by Hecht to the Ny Carlsberg Glyptotek in Copenhagen for $240,000.

Greek vases, however, were favoured stock-in-trade. A good idea of what Medici was able to supply, with or without Hecht as intermediary, may be gained from the catalogue of a sale

at Christie's, New York, in June 2000 – the collection of Elie Borowski, comprising 157 pieces, of which 146 lots were sold – for a total of $7,053,906. Even fragments could be valuable: so long as enough of the original decoration survived for an attribution to be made. The Beazley method of attribution (outlined in more detail on p. 53) only required a few diagnostic elements to secure a painter's identity – some typical flourish of drapery, or telling anatomical hieroglyph, such as an ankle-bone – so long as one had the required experience and expertise. Not many archaeologists could claim as much; but one of the few was, as previously noted, Dietrich von Bothmer. Put in charge of the Department of Greek and Roman Art at the Met in 1959, he was already acquainted with Hecht, and practised his attribution skills by making minor purchases. Most of these were fragments – always useful for teaching purposes, if not 'orphans' in need of adoption – and most were for his private collection. To buy a major piece on behalf of the Metropolitan Museum was not something he could do alone.

For any museum official, the risks of purchasing antiquities without demonstrable provenance were well known at the time. Both John Marshall and Gisela Richter had been famously duped by several fake Etruscan terracotta statues, purchased by the Met between 1915 and 1921 (one at a cost of $40,000). It was under Bothmer's watch, in 1961, that the Met eventually acknowledged these figures as forgeries. (Even from pictures, the modernity seems blatant – though perhaps that is just benefit of hindsight.) But were certain acquisitions worth the risk? A palpable spirit of rivalry prevailed, especially among institutions in the New World (and in particular during the 1970s, as the private antiquities collection of oil magnate J. Paul Getty began to be transformed into a public museum). In 1967 the Met had gained an aggressive new director, Thomas Hoving, a self-confessed self-publicist who liked to project events at the museum as front-page news, even if it meant 'making the [Egyptian] mummies dance'. His approach

to museum holdings was shamelessly commercial: an object was worth acquiring so long as it compelled the public to come, in droves, to see it.

Exactly what happened with the excavation of the Sarpedon krater, and its sale to the Metropolitan Museum in 1972, has probably gone to the grave with its protagonists. Dietrich von Bothmer and Thomas Hoving both died in late 2009, and Bob Hecht passed away in 2012, just a few weeks after his trial for dealing in looted antiquities came to an inconclusive end (by statute of limitations). A seven-strong team of *tombaroli* (plus two lookouts) is reckoned to have been involved in finding the vase: most of them, too, are now deceased, and in any case, none of them was ever likely to break the traditional Italian code of loyal silence (*omertà*) among thieves.

So far as events can be reconstructed, it seems that the krater was found one night in December 1971, as raiders were probing an overgrown cliffside below the site of the Etruscan city of Caere, or Cerveteri, about half an hour's drive north from Rome. The area is known as the Greppe Sant'Angelo: not far from the sprawl of the modern town, and somewhat overgrown, it retains a clear view over the Vaccina valley and a route leading inland. (Fig. 4). Following the mythical precedent of some other modern archaeological discoveries, such as the cave-paintings of Lascaux, the *tombaroli* liked to say that they came across a tomb while hunting wild boar. More likely, they knew that the area formed part of a cordon of cemeteries around the Etruscan city, and as such was good hunting-ground for ancient treasures (see p. 46).

It took repeated sessions of digging to break into the grave complex (a series of connected chambers) where the vase was contained, and then to clear it. Whether the structure of the tomb was already collapsed, or collapse was caused by the intrusion, is obscure. For the intruders, a clearance was all that was intended. None of those involved was interested in delicate stratigraphy, or

Fig. 4 Structures in the Greppe Sant'Angelo necropolis, Cerveteri, where the Sarpedon krater was allegedly found. The site lies in the southeastern lee of the plateau on which ancient Caere stood. The visible facades of the necropolis belong mostly to mock-palatial tombs created in the late fourth and third centuries BC.

taking notes, or collecting any of the information that proper archaeologists would wish to have. This, essentially, is the scientific disaster caused by the illicit antiquities trade. However, we have reports regarding another object recovered from the same tomb – to the effect that along with the Sarpedon krater, there was also a drinking cup, or *kylix*, by Euphronios: and this kylix also showed the transport of the body of Sarpedon (see Figs. 37 and 38). Dubious as it is, the information potentially carries fascinating implications about ancient Etruscan ownership (see p. 53).

As for the krater, it remains uncertain whether it was shattered by the manner in which the *tombaroli* forced their way into its place of deposition; and it is unfortunate that there is no reliable account of where it was located in the tomb-structure. Had it been left with other grave goods on the floor of the chamber, or resting upon a carved couch – or was it (as Hecht heard) recovered from the tomb's corridor-entrance (*dromos*)? It is not inconceivable that the vase was actually found intact, then deliberately broken up to facilitate the smuggling process – although no one has ever admitted as much. In any case, its fifty or more pieces were bagged up and duly shown to Giacomo Medici, who did not hesitate to make a cash payment of some 50 million lire (about $88,000). He took some Polaroid shots of the fragments before transferring

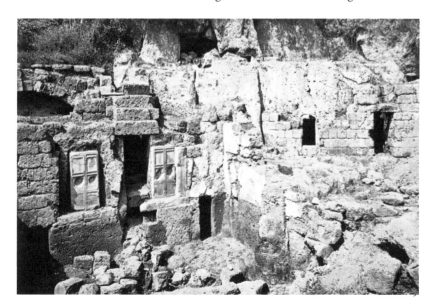

them to a safe-deposit box in Lugano, just across the Italian–Swiss border. Then he alerted Robert Hecht. The snapshots were sufficient to prompt an immediate response. Hecht made the journey to Lugano, liked what he saw, and made a deal with Medici for 1.5 million Swiss francs, or $350,000. He paid an advance, with the rest to come by instalments, and immediately took the fragments to Zürich for reassemblage by Fritz Bürki, a former university technician whose skill and discretion could be trusted. Then he went off for a family Christmas skiing holiday.

'And a happy vacation it was.'* On his return, Hecht cast around for potential buyers, while Bürki worked on restoring the vase. As it happened, his first sale of a vase had been made to the Metropolitan Museum, back in 1950, when Dietrich von Bothmer was junior to Christine Alexander. That vase was a handsome Apulian krater decorated with a rare image of a statue being painted, for which the Met paid $10,000. According to Hecht, Bothmer on that occasion declared that his (Hecht's) vocation was 'to ferret out the good objects worthy of collecting'. The Cerveteri find surely counted as one such. Hecht's initial sales pitch, conveyed in a teasing and elliptical letter, was calculated to fascinate the New York expert. What if a vase of similar dimensions to one listed by Beazley – the 'Herakles and Antaios krater' in the Louvre (see Fig. 13) – and 'in PERFECT condition' were available? A subsequent letter maintained the enigmatic style, except in one respect: the asking price. This was not just any old Greek 'pot'. It should be classified as if it were a masterpiece

* Quoting from a handwritten and apparently autobiographical memoir seized by French and Italian officers in late 2000 (or early 2001: various dates are given), when they raided the residence in Paris to which Hecht had relocated in 1974. With a preface added by Arthur Houghton, former Getty curator, the memoir has been partially and privately printed at the behest of Hecht's widow; it is not however a straightforward personal confession, and does not offer a consistent story about Hecht's involvement with the Sarpedon krater.

by Monet – and valued accordingly. (One of Hoving's first controversies at the Met was his purchase of Monet's *Garden at Sainte-Adresse* for $1.4 million.)

Bothmer was duly intrigued – but knew that Hoving would have to be equally intrigued for a purchase to result. Hecht travelled to New York, and showed them some photographs. Then Bothmer and Hoving, along with the Met's deputy director Theodore Rousseau, took a flight to Zürich to see for themselves. It was now June of 1972, and with a few final touches from Bürki the vase would be completely restored.

In his account of the visit, published two decades later, Hoving admits his spontaneous 'total adoration' for the vase, as encountered in a Swiss suburban garden. It showed, he said, everything that he admired in a work of art: '[it is] flawless in technique, is a grand work of architecture, has several levels of heroic subject matter, and keeps on revealing something new at every glance'. Hoving describes Bothmer as 'dumbstruck' by the vase; as for himself, he recalled, 'at the split second I first looked at it, I had vowed to myself to get it'.

Hoving suspected from the outset that the vase had been 'illegally dug up in Italy', Bothmer must have shared that suspicion. But neither of them pressed Hecht about the provenance: clearly, they did not want to know too much. Interviewed in 1997, Bothmer said that if the vase had been marked with an Etruscan inscription, he would not have bought it, because 'then it would have been obvious that it came from Etruria'.† Hecht's first remark about provenance was made as a joke (he said the vase had belonged to his Finnish grandmother). Yet his non-joking cover story must have seemed thin and unconvincing to anyone seasoned in classical archaeology. According to Hecht, the vase

† Nørskov 2002, 331.

had appeared in a shoebox (or a hatbox: consistency of such details was lacking), from the collection of an elderly Armenian antiquities merchant called Dikran Sarrafian (or Sarafian), based in Beirut. Sarrafian had provided Hecht with written testimony that the pieces had belonged to his family since the First World War. Subsequently, the same Sarrafian recalled that his father had acquired a box full of fragments in London, in 1920 [*sic*], 'in exchange for a collection of gold coins from the Near East'.

Hecht claimed to be acting on behalf of Sarrafian, and implied that his client wanted a good price – from which he (Hecht) would take a 10 per cent commission. What was a good price? Nothing less than a million dollars. How should the Met find such money? Thomas Hoving, who had recently 'de-accessioned' paintings by van Gogh and Henri Rousseau from the collection, wondered if there were some Greek sculptures he could trade. By Hecht's account, Bothmer revealed that there was already an intention of selling off the Met's holdings of thousands of Greek and Roman coins. Hecht advised using Sotheby's; Hoving and Bothmer acted accordingly, and secured a cash advance ($1.6 million, says Hecht) from the auction house. The Roman gold coins were sold in November 1972, and the Greek silver in April 1973, netting several millions. (Though some protests ensued, the strategy was not hugely controversial: since 1909, ancient coins had been the preserve of the American Numismatic Society, not the Met.)

Flying out with Hecht from Switzerland in a first-class seat of its own, the fully restored vase cleared US Customs in New York at the end of August. Hecht declared its value at a million dollars, and was duly remitted that sum. Bothmer was absolutely confident of the krater's authenticity, and regarded a thermoluminescence test as unnecessary. Hoving could not restrain his glee when announcing his latest 'capture' (in his memoirs he confesses 'a near-sexual pleasure'). 'The histories of art will have to be rewritten', he claimed, as for the very first

Fig. 5 Dietrich von Bothmer at the New York Metropolitan Museum, with the Sarpedon krater close to hand, autumn 1972. The Beazley method of attribution was based on close examination – yet, in Bothmer's phrase, 'one only truly sees with the heart'.

time a work of art featured on the front cover of the *New York Times Magazine* (issue of 12 November 1972). The Sarpedon krater was displayed in a transparent cabinet of its own, designed by an expert from Tiffany's; it stood in the centre of a gallery, so that visitors could appreciate its quality from all angles. A press photograph showed Dietrich von Bothmer at his desk; spread before him were pictures of the vase he would publish in the museum's quarterly magazine, a special issue about Greek vases. The curator was not given to hyperbole by nature, but he too was patently delighted, and irrepressibly sure of the krater's academic importance (Fig. 5). Hence the opening line of his initial publication: 'In the field of painted Greek pottery, it may without exaggeration be considered the finest Greek vase there is.'

Bothmer, in his advisory report to the Acquisitions Committee of the Met, had forecast that the krater 'would bring us the recognition that is our constant aim to achieve'. But – as he and Hoving might have anticipated – there was a toll to be paid for all the publicity. Journalists and commentators wanted to know how the museum had come by such an extraordinary object; and, naturally, how much it had cost. When the answers to those questions were not forthcoming, informal investigations began. The cost was easy enough to discover, by checking the records of US Customs. The provenance was intriguingly mysterious: as

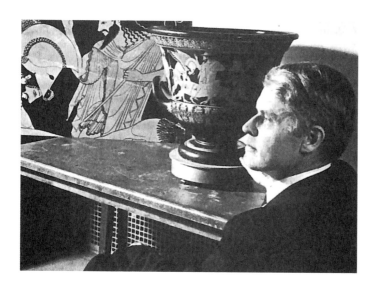

one reporter noted, the vase had apparently been conjured 'out of thin air'. Hoving at first insisted upon secrecy for the sake of future possible dealings; but since rumours were already circulating about an illicit Italian origin, it became necessary to divulge the name of Dikran Sarrafian – and accordingly to produce some substantiation of the Lebanese story concocted by Hecht.

Hoving's regular sobriquet for the krater – 'the hot pot' – may have been coined as a quip, but its criminal implications did not diminish over time. Matters were not clarified when in 1974 he received (so his memoirs report) a letter from a woman in Chicago who attested that she and her husband had visited Dikran Sarrafian in Beirut a decade earlier and were shown a box containing fragments of a Greek vase. Confusingly, Hoving gives the name of this woman as 'Muriel Silberstein': she was, rather, Muriel Steinberg Newman, well known as a collector of Abstract Expressionist art (and who in 1980 donated much of her collection to the Met). Even more confusingly, Hoving then became sure that Sarrafian *had* possessed pieces of a krater by Euphronios – but, being incomplete, this had to be another krater. In his published memoirs, Hoving revealed what he thought had happened. Bob Hecht had acquired some fragments of a krater by Euphronios, long held by Dikran Sarrafian, back in 1971. Then came the find at Cerveteri, a year or so later, of the Sarpedon piece. To assist his sale of the latter, Hecht introduced paperwork from his previous transaction with Sarrafian: simple as that. Since a second (and fragmentary) krater by Euphronios had indeed recently come onto the market, Hoving considered the mystery solved.

Putting aside the peculiar letter from 'Muriel Silberstein' (probably now unverifiable, since Muriel Newman died in 2008), the muddle of Hoving's account is compounded by mention of a *third* Euphronios vase: not a krater, but a drinking cup or kylix, also on offer from Hecht, and also representing Sleep and Death with the corpse of Sarpedon. Bothmer was keen to acquire it –

but by now Hoving wanted nothing more to do with Euphronios, or perhaps any Greek vases at all: 'the hot pot' was only getting hotter. We shall return to the kylix in a later chapter (see p. 146); as for the second krater, which Hoving supposed to be ex-Sarrafian, we may note that it entered the antiquities collection of the Hunt brothers, Texan commodities-billionaires (as did the kylix, c.1980). Certainly it comprises fragments that might once have fitted into a modest-sized box. But evidence would eventually surface to prove that this vase, too, had been looted from Cerveteri.[*]

Hecht, in his 'autobiographical' memoir, claims that he felt happy to have secured a price for the vase that would provide for Dikran Sarrafian in old age. But how much recompense – if any – went to Sarrafian is not known. In 1977, both Sarrafian and his wife were killed in what Hoving refers to as 'a mysterious car crash', in Beirut. Meanwhile, Italian authorities were intensifying their search for evidence to demonstrate the truth of rumours that the Sarpedon krater had come from a tomb at Cerveteri. As it happened, a parcel of land by the Greppe Sant'Angelo site had come up for sale in autumn of 1972 – and it had been bought by one Giacomo Medici, with a colleague who ran an antiquities outlet in Switzerland. Ostensibly the pair intended to set up a pork farm. There was a surreal period during which an official archaeological team, headed by Giuseppe Proietti, was joined in exploring the site not only by officers of the carabinieri, but Medici too. This was in the summer of 1974.

[*] The vase, now in the Villa Giulia, features a particular moment in the mythology of Herakles. The hero has dealt a mortal blow to the brigand Kyknos, who sinks to the ground; but central to the scene is Athena, her aegis outstretched, intervening to obstruct her fellow Olympian deity Ares – father of Kyknos, intent on avenging his son's death (in one version of the episode, Kyknos transforms into a swan). There may have been a special interest in Herakles at Cerveteri, provenance of the Paris krater showing Herakles and Antaios: see p. 147.

The previous year, Medici's elder brother Roberto had 'disappeared', along with an accomplice, while in Naples on antiquities-related business: his burnt-out car was all that police ever found of him. The value of Greek vases now attracted some serious criminals. And the record price set by the Sarpedon krater had another effect. The local *tombaroli* had each received something like $8,500 for the vase. To learn that it had subsequently fetched $1,000,000 was galling. It seems that in vengeful spirit, one of their number decided to assist criminal investigations by supplying the carabinieri with an anonymous letter denouncing himself. When officers interviewed this Armando Cenere – who had already talked to journalists – he told them that he had not been directly involved in digging the tomb at the Greppe Sant'Angelo, only acting as lookout. (So perhaps he did not break the rules of *omertà*.) As lookout, however, Cenere caught a glimpse of the painted pottery brought up from the tomb – and when shown a photograph of the krater, he claimed to recognize the image of 'a man bleeding' as seen one night in December 1971. Cenere also pointed investigators in the direction of Hecht. His testimony was enough to encourage Italian authorities to commence the process of legal proceedings. But the country's criminal justice system is not known for its swift efficiency. By the time the case came to court at Civitavecchia, in autumn 1978, Dikran Sarrafian was dead, Hoving had stepped down as director at the Met – and Armando Cenere could no longer swear to his memory of events. The judge declared insufficient proof for prosecution.

Meanwhile, Robert Hecht had quitted Rome for Paris. Giacomo Medici also moved, to base himself in Geneva. Neither of them, however, abandoned the antiquities trade. The Met continued to purchase, as did the Museum of Fine Arts at Boston; while on the West Coast of the USA there was an institution with an annual spending budget of *c.*$80 million, and a curator keen

to buy classical material of all sorts. This was Jiri Frel, who prior to joining the J. Paul Getty Museum at Malibu in 1973 had spent a year at the Met – long enough for Thomas Hoving to judge him as 'a shifty, troublesome guy' who 'sullied... the entire museum profession' (the adage *it takes one to know one* comes to mind). Frel may be chiefly remembered for the purchase of a large-scale forgery ('the Getty *kouros*'), and as architect of a tax-evasion scheme whereby wealthy individuals purchased antiquities, had them valued at hyperbolic prices, then gave them to the Getty – offsetting the donation against their dues to the Internal Revenue Service. During his time at Malibu, however, Frel enthusiastically (and with some personal expertise) built up the Getty's holdings of Greek vases. By 1983 he had the confidence to launch a publication entitled *Greek Vases in the J. Paul Getty Museum*. International scholars were invited to publish the new acquisitions. This was a service to the academic community, undoubtedly; yet it also, as a cynic might observe, provided a sort of intellectual 'laundering' of stolen goods. Frel's declared sources for those goods ranged from the studiously vague (e.g. 'European art market') to the spuriously particular (e.g. 'the Count Esterhazy').

Frel was eventually arraigned and demoted for his misdemeanours; he left the Getty in 1986. But his strategies of acquisition lingered at the museum. With hindsight, it is clear that one particular assemblage of fragments heightened suspicion about illicit provenance. This was the enormous kylix discussed in an article by Dyfri Williams (then of the British Museum) in 1991. Congratulating the Getty upon possessing 'one of Onesimos's grandest cups', Williams began by establishing that although the foot of the vase once carried the inscription EUPHRONIOS EPOIESEN, 'Euphronios made [this]', here the Euphronios who painted the Sarpedon krater was signing as potter, not painter. The style of the painting belonged to his (presumed) pupil, Onesimos – a prolific vase-painter who in pious prosperity appears to have

offered seven marble basins to Athena on the Acropolis during the early fifth century BC. Euphronios, as potter, is credited with developing and perfecting a distinct type of 'jumbo cup' that was wide in diameter and shallow in depth: not at all practical for the purpose of drinking, surely, but offering extra space for painted decoration (see p. 53). As Williams showed, Onesimos exploited the extra space ingeniously, showing on the cup's exterior surface two episodes from Homer's *Iliad* – the handmaiden Briseis led away to Agamemnon, a cause for 'the wrath of Achilles'; also, apparently (the scene is incomplete), the duel between Ajax and Hector – and, within the cup, a complex evocation of the *Ilioupersis* or 'Fall of Troy'. Beyond its size, however, and the grand narrative scope of its decoration, the vase was distinguished by an unusual feature. Scratched within the recess of its base there runs an Etruscan inscription (Fig. 6). The Etruscan language may have its obscure aspects, and only half of the original base survives, but the gist of this graffiti is not difficult to understand: *'This vase was dedicated by [? – the name is missing] to Hercle.'*

'Hercle' is the Etruscan for Herakles (the Roman Hercules), who as hero and deity was venerated across the Mediterranean. Latin sources speak of a *fons Herculis*, a spring sacred to Herakles, at Cerveteri. The precise variant of Etruscan script used in the dedication was identified as characteristic of Cerveteri. Dyfri Williams did not comment on these associations; the reception of the vase was not within the scope of his discussion, and the implications of the inscription had already been noted by Jacques Heurgon and other Etruscan experts. But while the manuscript of his article was in press, Williams was shown photographs indicating that further fragments of the cup had appeared 'on the market', and he mentioned these by way of both an 'Addendum' and then a 'Postscript'. The significance was clear enough. The kylix, which had been broken and then repaired in antiquity, came from Cerveteri – and 'came' in the imperfect tense.

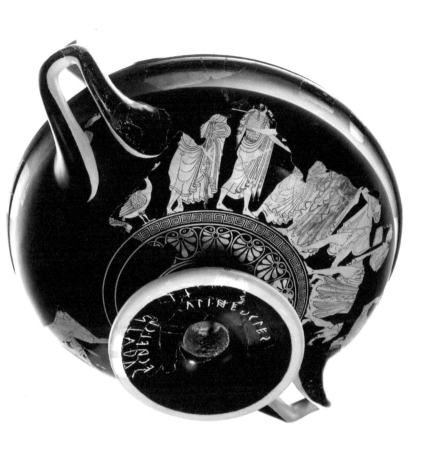

Fig. 6 'Type C' kylix, attributed to Onesimos as painter, and signed by Euphronios as potter. The interior of the cup shows, centrally, Neoptolemos (the son of Achilles) attacking King Priam and his family by an altar to Zeus; and in a separate register, further scenes of the sack of Troy. Date c.500–490 BC. H 20.5 cm (8 in); d. 46.5 cm (18 in). Cerveteri, Museo Archeologico.

A campaign of digging in the Sant'Antonio area of Cerveteri, just above the Greppe Sant'Angelo, began in 1993. The present author was part of those excavations, and can remember the regular disheartening experience of leaving the site at the end of the day, and returning the next morning to find that it had been visited by *clandestini* during the night. It is hard to say how much was pilfered. A favourite trick of the visitors was to bury a cigarette packet for us to find. But at least the architectural structures of two adjacent temples were brought to light; and one votive indication of a cult to Herakles (a small bronze club) was sufficient to compound local rumours that the large cup in the Getty had once been dedicated in this vicinity. One of the team, Maria Antonietta Rizzo, who was then archaeological superintendent for the Cerveteri area, aired allegations about the origins of the kylix at an international conference held in Viterbo during 1997, a meeting where Marion True, curator of antiquities at the Getty since 1986, happened to be present. The emotive pressure to restore Italy's lost *patrimonio culturale* was overtly reinforced with the academic ideal of understanding ancient objects in their archaeological context. It is to Marion True's credit that she responded immediately with an offer to return the kylix, if the Italian authorities would submit their information about its origins. A dossier of evidence was prepared – and the vase returned to the custody of the Italian state in February 1999.

Back in 1972, the Sarpedon krater had been tagged 'the million-dollar vase'. Its fame, by price, had since been eclipsed by more than one ancient Greek pot. At a Sotheby's sale in 1990, the fragmentary krater by Euphronios showing Herakles and Kyknos, owned by the Hunt brothers, was sold (to New York-based collectors Shelby White and Leon Levy) for $1,760,000. The Hunts' Sarpedon kylix by Euphronios was also sold at the same auction, for $742,000. Its purchaser was Giacomo Medici, who with a broad smile saw off a rival bidder (Robin Symes –

acting for the Met) and became reunited with a vase that he had once supplied to Robert Hecht for a considerably smaller sum. Either he wanted it back, for love of Euphronios – or (more likely) he calculated that its capital value could only increase.

Perhaps even Medici sensed that an epoch of illicit digging was coming to a close. His own part in it was soon to end. '*Nucleo TPC*', a special unit of the carabinieri, dedicated to catching and prosecuting all those involved in the illicit traffic of art and antiquities, had by now developed into an effective force.[*] Collectors and museum staff beyond Italy were also in their sights. In the summer of 1995, Medici's premises at Freeport Geneva were raided, yielding fresh evidence about the various past transactions (in the course of the operation a Swiss policeman – in a scene worthy of Clouseau – managed to drop the Sarpedon kylix). Combined with material seized during the swoop upon Hecht's Paris apartment, sufficient evidence was accumulated for criminal proceedings to be launched. Medici stood trial in 2003; True and Hecht were both indicted in 2005. Though they could be tried separately, all three were charged with conspiracy.

Thomas Hoving's successor at the Metropolitan Museum was Philippe de Montebello. While legal processes in Rome took their course, with various appeals and procrastinations – Hecht and Medici were respectively past and approaching the age-limit for imprisonment in Italy, and charges against Marion True, who resigned from her Getty post in autumn 2005, were eventually dropped – evidence that the Sarpedon krater had been looted from a tomb in the Greppe Sant'Angelo necropolis of Cerveteri was undeniable. There were also a number of other objects among the New York museum's recent acquisitions for which Italian authorities had gathered similarly incontrovertible

[*] *TPC* = 'Tutela del Patrimonio Culturale', 'safeguarding Italy's cultural inheritance'; formed in 1969, and given more extensive powers in 1992.

proof of criminal origin, such as an ensemble of Hellenistic silver from Morgantina in Sicily. Montebello seized the initiative. Late in 2005, he made a proposal to the Italian government. It remained a moot issue, in terms of international law, as to whether the Metropolitan Museum could ever be obliged to give up the offending objects. Montebello suggested an 'out of court settlement' that might suit both parties. Acknowledging 'past improprieties in the acquisition process' – yet maintaining that purchases had been made 'in good faith' – the Met would give up its title to the krater by Euphronios, along with the silverware from Morgantina, and five further pieces of ancient Greek painted pottery, purchased variously between 1972 and 1999. For its part, the Italian Ministry of Culture – whose representatives included Giuseppe Proietti, a former director of the Villa Giulia, who had also been superintendent at Cerveteri in the 1980s – agreed to provide the Metropolitan with long-term future loans 'of works of art of equivalent beauty and importance to those being returned'. Hailing 'the appropriate solution to a complex problem', Montebello was thereby able to reassure the Met's visitors (and trustees) that there was, in effect, no resultant depletion of museum holdings – rather, the welcome prospect of hosting in New York a series of masterpieces otherwise confined to Italy.

By a sub-clause to this agreement, the Sarpedon krater was permitted to extend its sojourn at the Met for the inauguration of new Greek and Roman galleries. Then, in January 2008, the return journey was made, with due measure of triumphal pomp, to Rome (Fig. 7). A special exhibition of the vase in company with other archaeological 'homecomings', given the Greek title *Nostoi*, was immediately staged at the presidential Palazzo del Quirinale; thereafter, the krater went to the National Etruscan Museum at Rome, in the Villa Giulia, for permanent display.

Or so it was assumed. In December 2014 the vase was loaned, along with the grand kylix recovered from the Getty, to Cerveteri's Archaeological Museum – a modest collection of local antiquities created in 1967 from the *caserma pubblica*, and in structure recalling a medieval dungeon. If the authorities at the Villa Giulia were expecting it back, they were thwarted. In November 2015, Italian Minister of Culture Dario Franceschini announced that, in accordance with a government strategy of allocating art-works to their places of origin, and diffusing tourism in Italy beyond principal cities, the Sarpedon krater, and the kylix signed by Euphronios as potter, would remain in Cerveteri. So 'the million-dollar vase', after all its modern adventures, now occupies a glass cabinet approximately half a mile away from the Etruscan cemetery where it was once intended – by its last ancient owner – to rest for eternity.

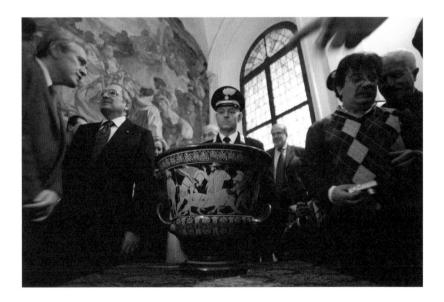

Fig. 7 The 'homecoming' of the Sarpedon krater to Rome, January 2008.

Euphronios and 'the Pioneers'

The Production of a 'Masterpiece':
A Portrait of the Artist
and his Ambience

The first discoveries of vases signed by Euphronios, and of one vase apparently referring to him, were made during or shortly after 1828, at the Etruscan site of Vulci. Located in what is now the region of Lazio, about 50 miles (80 km) north of Rome, Vulci was once among the prime centres of Etruria. In its heyday, around 500 BC (before Rome's expansion brought an end, one by one, to the Etruscan cities), Vulci enjoyed prosperous contact with the wider Mediterranean, to judge by the contents of its extensive cemeteries. Taken over by the Romans, the site became malarial in antiquity, and largely depopulated. It was semi-desolate agricultural land belonging to the Papal States when, in the early nineteenth century, it was made part of a settlement with Lucien Bonaparte, brother of Napoleon. The first notice of the ancient tombs came when Lucien's ploughmen found the soil collapsing beneath them. Lucien, with some previous experience as an 'archaeologist' – his further Italian properties included the remains of Cicero's villa at Tusculum – instigated excavations. 'Clearance' might be a better term for what took place at Vulci. The quantity of objects within the tombs was phenomenal; and in particular, the proportion of Greek painted vases among these objects was unprecedented.

As hundreds, eventually thousands, of such vases emerged from the site, antiquarians sought to comprehend various aspects of the historical process whereby images of recognizably Greek iconographic pedigree – showing episodes of Homeric epic, for example, or figures from the Olympian pantheon – along with inscriptions clearly written in ancient Greek – came to be deposited in Etruscan graves. Prince Lucien stoutly asserted that the workmanship was local. Learned observers were more cautious. Among them was Eduard Gerhard, who as founder of an archaeological society at Rome endeavoured to catalogue

the Vulci finds before they were dispersed.* Gerhard thought there must have been some sort of colonial outpost of Greeks, specifically Athenians, at Vulci. So it is that our first mention of Euphronios in modern scholarship is as a '*vasellaio volcente*', a 'Vulcian potter'. Two vases signed by Euphronios from Vulci had been noted by Gerhard, and he was soon afterwards able to add a third (now lost), retrieved from Bomarzo, in the Viterbo area.

Given the notoriety attached to our 'million-dollar vase' by Euphronios, it is interesting to note that when Lucien Bonaparte began offering his collection for auction – at Paris, in the mid-1830s, when he needed ready cash – a kylix by Euphronios, showing Herakles taking the cattle of Geryon, was offered at a minimum price of 8,000 francs, remarkably high at the time. It did not make that figure then, but was subsequently acquired for King Ludwig I of Bavaria, and now belongs to the Munich Antikensammlungen (Fig. 8).

No one today believes that Euphronios was Etruscan, nor even an immigrant who came to Etruria and settled there (as certain Greek craftsmen demonstrably did, from perhaps as early as the mid-seventh century BC). The academic clarification of Euphronios as an artist, however, took several decades to establish. Further pieces bearing the name of Euphronios were reported from Vulci, also from Cerveteri and Tarquinia: a total of nine vases with the signature formed the basis of a dissertation submitted to the University of Vienna by Wilhelm Klein, published first in 1879 and revised in 1886. Klein's work was saluted (by Oxford's Percy Gardner) as the first 'scientific study of vases', attempting stylistic analysis of particular exponents of the red-figure technique. It failed, however, to define Euphronios convincingly as a 'master'. A rival scholar, Adolf Furtwängler,

* This was the Instituto di Corrispondenza Archeologica established in 1829 – later the Deutsches Archäologisches Institut.

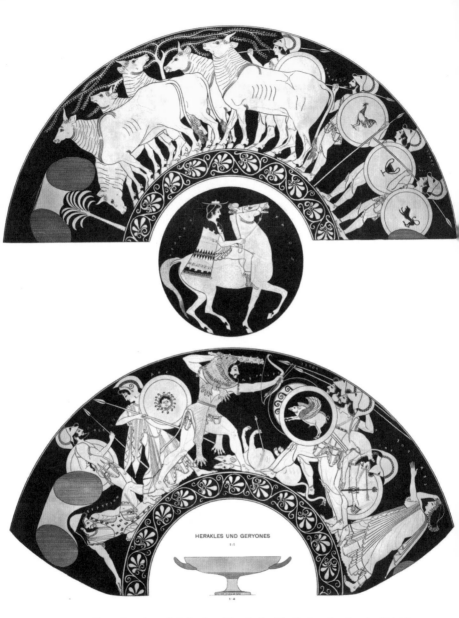

Fig. 8 Drawings of a kylix signed (on the foot) by Euphronios; found at Vulci, in about 1830. The rider on the cup's interior is inscribed HO PA[I]S LEAGROS ('the boy Leagros') (see p. 95). 'Type B' shape, H 15.9 cm (6.3 in). Munich, Staatliche Antikensammlungen 8704.

whose eye for distinctions among painters had been trained by producing a descriptive catalogue of the collection of Greek vases at Berlin, censured Klein for indulging '*Euphronios-Phantasien*'. For his part, Furtwängler was able to argue convincingly that a large krater in Arezzo (Fig. 9), which had been known since at least the early eighteenth century, could be counted as a work by Euphronios – even though there was no signature.

The Athenian credentials of Euphronios (and other late-archaic vase-painters) were confirmed in 1882, when archaeological investigations upon the Acropolis of Athens, close by to the Parthenon, yielded plentiful fragments of vessels that must have been used for festivals and dedications in the years before the Persian occupation of Athens in 480 BC – including the remains of the magnificent 'parade cup' by Euphronios (Fig. 10). The debris of material either broken during that occupation and buried soon after, or else buried before the Persians encroached, includes numerous statues and pieces of temple sculpture – and so makes a definable visual 'city of images' in which to locate our artist.

Furtwängler's attribution of the Arezzo krater (hedged with some telling caveats regarding the painter's identity) heralded a new method of studying Greek vases. Klein and others had shown interest in artists' signatures; broadly speaking, however, the principal interest had so far been focused upon the pictorial subject of a vase. In the latter part of the nineteenth century, a discipline emerged that was more concerned with defining the creators of the images. An Italian savant, Giovanni Morelli, developed a technique of 'scientific connoisseurship' to decide

overleaf Fig. 9 Drawings of a volute-krater attributed to Euphronios, showing Herakles and Telamon in combat with the Amazons. The vase appears in Thomas Dempster's *De Etruria regali* of 1723 (Vol. 1, Fig. 19). H 59.5 cm (23.4 in). Arezzo, Museo Archeologico 1465.

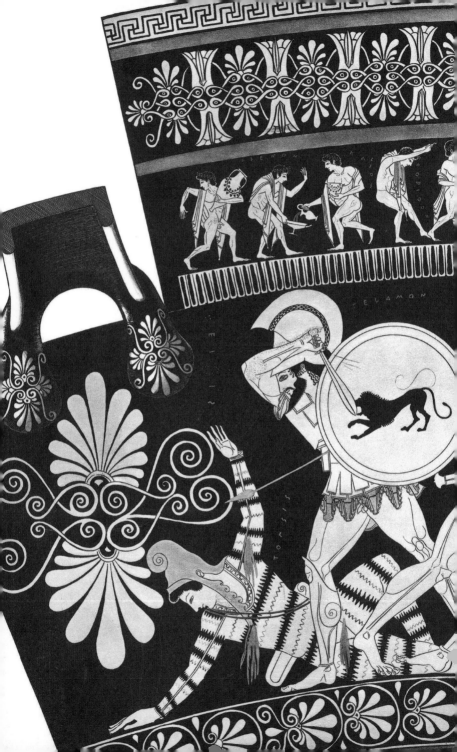

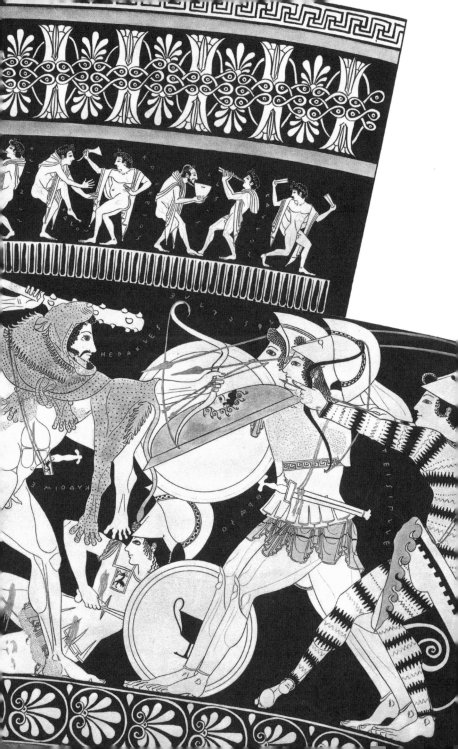

questions of attribution in the field of Italian Renaissance painting. Essentially this technique entailed identifying the 'hand' responsible for a figurative picture not so much from its overall effect, but rather from clues contained in its subsidiary details. The rendering of minor bodily parts, such as earlobes and fingernails, was of especial interest to Morelli (who had trained as an anatomist). His claim was that an artist naturally tended to represent these unobtrusive components of a figure cursively, even thoughtlessly – or at least with less conscious effort relative to the 'main lines' of aspect and character. The methodological similarity between Morelli's approach and Freudian psycho-analysis was noted by Sigmund Freud himself; historians like also to make a connection with the sort of microscopic scrutiny made famous by fictional detectives (notably Sherlock Holmes). Furtwängler had noticed that Euphronios was an artist whose forte lay in finesse of detail. Another German scholar, Paul Hartwig, had shown how attributions of anonymous Greek vases could be made by close observation of such detail. The credit for

Fig. 10 Fragment of a kylix from the Athenian Acropolis, attributed to Euphronios (and with part of his signature?), as originally published. Peleus takes the hand of his bride, Thetis, in a wedding procession with Olympian deities. Traces of gilded clay used for jewellery and divine trappings. The cup is now reconstructed, with a diameter of 44.5 cm (17.5 in). Athens, National Archaeological Museum 15214.

extending 'Morellian' analysis into the world of ancient vase-painting, however, lies with J. D. Beazley – who, although he did not live to see the Sarpedon krater, is inseparable from its modern story (see p. 23). Beazley began to scrutinize Greek vases while he was still an undergraduate at Oxford, and published his first list of attributions in 1910. He knew about Morelli's technique, and eventually met Morelli's celebrated disciple in the field of Italian 'Old Master' paintings, Bernard Berenson. *'However obscure he may be, the artist cannot escape detection if only sufficiently delicate tests be applied.'* Beazley developed his own ways of deploying this 'Morellian' principle (Fig. 11). He did not scorn photographs, but he prized direct inspection of a vase, not only handling it, but also 'reliving' its lines of draughtsmanship – either by pencil drawings in a notebook, or else copying details by means of flimsy tracing-paper laid upon the vase (see Fig. 17).

Style was paramount when it came to determining whose 'hand' was responsible for the images; signatures, though increasingly frequent on Athenian vases made after *c.*570 BC, could be misleading. The situation with Euphronios was complicated by the presence of two different verbs attached to his name. One signature declares *Euphronios egraphsen*, 'Euphronios painted [this]'; the other, *Euphronios epoiêsen*, 'Euphronios made [this]'. The verbs imply respectively that a vessel shaped and fired by another potter was decorated by Euphronios; or that Euphronios did the shaping ('throwing') and firing of a vessel which was then painted by someone else. We see in the Sarpedon krater the former scenario: Euxitheos the potter, Euphronios the painter. (Euphronios is also known to have painted vases created by Kachrylion as potter: judged to be early works, including the Sarpedon cup.) As for the second scenario, it is demonstrated by the grand kylix currently exhibited near the Sarpedon krater in

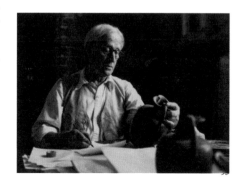

Fig. 11 J.D. Beazley (1885–1970) at work in Italy, *c.*1960.

the Cerveteri museum (see Fig. 6): a piece turned on the wheel by Euphronios, then decorated by Onesimos – if that is the division of labour implied by *epoiêsen* and *egraphsen*.

It is likely that craftsmen at Athens were versatile in both skills. A workable hypothesis is that after several decades of activity as a painter, Euphronios turned to potting; and perhaps did so by necessity, because his eyesight was no longer sharp enough for fine brushwork. An inscribed marble base from the Acropolis records a dedication (probably of a bronze statue) by a potter (*kerameus*) named Euphronios: since this seems to be a vow to Athena in her divine aspect of providing health (*hygeia*), it may support such a theory, though the date assigned to the epigraphy (*c.*475 BC) does not quite fit a supposed turning-point in the artist's career of *c.*500 BC.[*] Nonetheless, the activity of Euphronios as potter has been calculated as extending until *c.*470 BC. The painters with whom he collaborated were Onesimos – also considered his pupil – the Antiphon Painter, and the Pistoxenos Painter.

Inherent in Beazley's genealogy of painters is the assumption that there are 'masters' and 'pupils'. From what we know of the organization of craft in ancient Greece, it seems likely that Euphronios would have started in a ceramic workshop as a young boy, perhaps assisting his father. If he was born *c.*535 BC (Beazley's estimate), he could have been producing his own work by 520 BC. Stylistic affinities suggest an apprenticeship with one of the first generation of painters exploring the red-figure technique – plausibly the Andokides Painter, or Psiax. But this would not have been a system of personal tuition. There may have been something like a dozen employees in a single establishment, closely sharing space – and sharing the work. The fact that finished products were often signed by individuals as painters naturally encourages our notion that an Athenian pottery workshop was

[*] IG I3 824; Athens, Epigraphical Museum EM 6278.

like a modern art school, giving creative spirits opportunities to express themselves. Beazley, raised in a period of fashionable respect for 'the arts and crafts', searched for traces of personality, even genius, among repeated marks of individualized style. Thus it happens that we have a 'group' exhibiting a collective stylistic identity, yet comprising a number of distinct protagonists. Beazley called them the 'Pioneer Group', because they were apparently united by a commitment to a technically adventurous mode of drawing, especially of the human figure (see p. 70). He distinguished a dozen or so different 'hands' within the group; prominent among those who signed their names were Euphronios, Euthymides and Phintias. Conceivably they were all employed in one small 'factory' (*ergastêrion*) located among other such in the northwestern district of ancient Athens known as Kerameis or Keramês – which gives rise to a 'Potters' Quarter', the 'Kerameikos' (and thus our English word 'ceramic').

It was one of Beazley's successors at Oxford, Martin Robertson, who wondered if Euphronios and Euthymides might have been brothers. Their names, respectively translating as 'good sense' and 'good/cheerful spirit', seem similar enough – and, as we shall see, there are possible signs of fraternal rivalry between them. It was Robertson, too, who liked to imagine a workshop with a certain seating-plan to the benches – 'Hypsis by the side of Euthymides', 'Phintias in the middle', 'Smikros by the side of Euphronios'. These are affectionate speculations (from a man who was, as a teacher, the soul of gentility). But they cannot conceal a disquieting degree of incertitude about artistic identities here. (Tellingly, both in print and *viva voce* Robertson frequently used the phrase 'I *feel*' when allocating a vase to one painter or another.)

Beazley deployed various terms to signal a measure of doubt when it came to assigning a vase to a name – e.g. 'close to', 'manner of', 'imitation of' – along with various signals of proximity or influence, such as 'group', 'kinship', 'school', 'circle'. He claimed

these terms were not interchangeable, yet never thoroughly defined the nuances of difference, saying that it would be too tedious to do so – and he admitted that a certain amount of intuition was involved. Consequently, there are detractors, who regard this entire method as something of a dark art, or 'society game'. Some archaeologists would say that it only serves the art market. One problem it generates is sometimes referred to as the '*amico di Sandro*' syndrome – alluding back to the world of Italian Renaissance painters, and the notorious problem of separating the work of (Sandro) Botticelli from one of his (supposed) assistants or 'friends'. We know that the Athenian pottery workshops were places of collective effort. What if several individuals collaborated on one vase, not only dividing 'potting' and 'painting', but subdividing the painting?

Anyone who consults Beazley's catalogue of vases belonging to the Pioneer Group soon notices, beyond the initial impression of crisp Oxonian order, a quantity of loose ends and fuzzy edges – or (to be fair to Beazley) a certain amount of unfinished business. The studies of Klein and Furtwängler had already shown that Euphronios was not always easy to distinguish from his 'fellows', and these 'fellows' not always within the designated group: so, for example, experts admit that 'early work' signed by Euphronios shows stylistic traits that would have caused it to be attributed to a 'non-Pioneer' painter called Oltos – had it not been signed by Euphronios. A significant tally of vases gathered by Beazley under the title '*The Pioneer Group: Sundry*' indicates the residual problem: 'these vases belong to the Pioneer Group, but cannot be said to be by any of the painters described hitherto' (*ARV*, 33). In other words, group identity can conceal its individual members. And when one painter – Hypsis – has just two surviving vases to his name, we may be forgiven for worrying about what became of his career within the group.

There is of course the danger that we impose upon antiquity a model of art history that we know from modern times, and project our Athenian 'Pioneers' of 2,500 years ago as if they were the 'Pre-Raphaelites', 'Wiener Werkstatt' or 'Fauves' of their time. This author does not dissent from the claim that a certain Euphronios, however humble his medium and métier, shows the technical ability, imaginative range and grandeur of vision that we associate with all 'great artists'. The minor issue that arises regarding his oeuvre is how far this Euphronios can be distinguished from one of the other Pioneers in particular, namely 'Smikros'. That name is put in inverted commas because it sounds very much like a nickname – translating as 'the small one', 'Tiny' or 'Titch'. It was not uncommon, as a nickname, in ancient Athens: but does it really denote another painter? For there is an observable overlap between the diagnostic styles associated with Euphronios and 'Smikros' – and variation of judgement, as to whether 'Smikros' should be classified as an incompetent copycat or a careful disciple.*

A glance at one of the vases attributed to 'Smikros' reveals the dilemma of identification (Fig. 12). Whoever painted it shows 'insider knowledge' of the Pioneer Group: among several scenes of homoerotic courtship, there is one in which a figure labelled 'Euphronios' makes advances towards a nervous-looking lad with the nearby inscription 'Leagros kalos' (see p. 95). Facial features around the vase incline to caricature, and an athlete scratching

* Thus a 'wretched follower', *'kümmerlicher Nachahmer'* (Beazley, *Attische Vasenmaler des rotfigurigen Stil* [Tübingen 1925], 62); or *'l'imitateur scrupuleux'* (Denoyelle in Denoyelle ed. 1992, 11). Beazley's scorn was expressed before his knowledge of an amphora with twisted handles, now in Berlin (inv. 1966.19), signed *Smikros egraphsen* – so close in style to Euphronios that it is suggested that Euphronios painted the vase, then allowed 'Smikros' to sign it (a somewhat bizarre scenario).

Fig. 12 Psykter attributed to 'Smikros', decorated with a gymnasium scene. A figure labelled 'Andriskos' ('Little chap') is approached by a slightly older boy; to the right of them, an athlete ('Ambrosios',) gesticulates with his right arm while 'rubbing down' with his left. H 33 cm (13 in). Malibu, J. Paul Getty Museum 82.AE.53.

his backside with a strigil seems flagrantly to parody the 'new drawing' which earns the Pioneers their modern status. Is this some kind of joke?

The answer is 'quite possibly, yes'. If so, where does it leave us? The vase is attributed to 'Smikros' because, while showing 'Euphronian' traits, it lacks the anatomical care and general attention to detail associated with Euphronios. But what if Euphronios designed it in a spirit of careless levity, encompassing the socially absurd notion that he, a mere craftsman, could make amorous overtures to an aristocrat such as Leagros – surely his social superior, and possibly his employer? Since the vase was very likely intended to serve an Athenian drinking-party, such levity would not be inappropriate; if, on the other hand, it was always destined as a 'bespoke' export to the faraway Etruscans, then what would those barbarians care?

A sophisticated solution to the problem is the proposal, from Guy Hedreen, that Euphronios used 'Smikros' as a sort of artistic alter ego. 'Smikros' may be careful, he may be careless – either way, 'Smikros' is the sobriquet of a painter enjoying the poetic licence of a self-conscious, self-effacing persona. A more basic possible explanation is that Euphronios, being slight of stature, was nicknamed 'Smikros', and occasionally used that nickname (rather as Paul Gauguin would sometimes sign himself as 'Pego' instead of 'P. Gauguin'). Ultimately, perhaps, it does not matter very much: in any case, for present purposes, we shall consider at least one vase attributed to 'Smikros' as typifying (if derivatively) the style of Euphronios (see Figs. 19 and 20). It may be significant that when Euphronios depicts a figure named 'Smikros' on a symposium couch, that figure looks the epitome of handsome manhood (see Fig. 3): conceivably a (self-flattering) self-portrait?

Euphronios is one of the few ancient Greek vase-painters to have been given (c.1990) the honour of an international 'one-man show'. The accompanying catalogues from that exhibition – staged, with variations of content, in Paris, Berlin and Arezzo

– constitute a valuable resource for grasping the painter's style. (Beazley's list of works, though later amplified by the creation of an online archive in his name, are forbiddingly unillustrated.) The salient features of that style are summarized here, under two headings: first, according to various aspects of pictorial technique, and second, by reference to the representation of human anatomy. The latter category may seem strange, as an index of style – but it has become something of a tradition in the study of Greek art, especially of Greek art as it changes from 'archaic' to 'classical' (e.g. the development of the *kouros* statue-type) – and there are reasons, as we shall see, for believing that naturalistic accuracy was a criterion of artistic success in Athens at the time.

Following the example of Psiax, Euphronios played with the medium of painting vases in the 'reserved' method of red-figure – which essentially involved blocking out a background in black, then using a fine brush and diluted dark glaze to add 'interior' detail. One early work (the Sarpedon kylix) allows, painstakingly, for inscriptions to be reserved, instead of being added later with red or purple paint (the usual way). By the 520s BC, the black-figure technique – which entailed painting 'silhouettes' of black figures upon a buff terracotta background, then adding detail by scratching on the figures with a sort of stylus – had largely passed from favour. Yet it continued to be used by certain Athenian workshops, and for certain types of vase, such as the prize-amphorae awarded at the Panathenaic Games: Euphronios probably painted some of these.* He knew about gilding (see Fig. 10), and he left some delicate examples of painting in semi-outline upon a white background. Working perhaps as potter and painter combined, he also exploited the orange-red gloss finish known as 'coral red' or 'intentional red'.

* A single sherd from the Acropolis has been attributed: Athens, National Museum Akr. 931.

Work in red-figure is normally referred to as 'painting'. But really it was more like drawing, or print-making, being essentially linear, with little or no tonal gradation, and using a very restricted 'palette' of colours (a black to sepia glaze, sometimes applied 'neat' as a relief line, sometimes diluted; reddish or purple paint, sparingly applied; occasionally some added white). For a vase such as the Sarpedon krater, Euphronios would have drawn (with a fine brush) outlines of the figures, and followed those outlines where they continue naturally within the 'interior' space – so, for example, Sarpedon's admirable 'iliac crest' – the ridge of muscle bulging at the top of the thighs and running down into the groin – fluently makes the transition from outline to inner detail. Anyone who examines the vase closely will notice that, within the compartments of abdominal muscle, Euphronios has very faintly added some shading, to give his hero some 'bulk'. But mostly the artist relies on line.

Reliance upon line can seem simple, even easy – like the mature drawing-style of Matisse. But it requires a very sure touch. Mistakes are not easily rectified, and reconsiderations are all too apparent. Like other red-figure painters, Euphronios will have sketched a basic design upon the surface of a vase before the clay was entirely dry, using something like a piece of sharpened charcoal. After that, there was little margin for error. What we term 'subsidiary decoration' – the ornaments that generally frame or fringe the figured scenes – could have been delegated to a junior assistant. Euphronios rarely departs from various arrangements of scrolls and palmettes, which in the painter's early work may also occupy an independent space (e.g. the interior of the Sarpedon kylix). Lotus-buds also appear. Arguably, more attention should be paid to these patterns – the ways in which they complement the tectonics of the vase, for example, and their integration with the purpose of the vessel – such as a continuous garland of schematized vine-leaves running just below the rim of

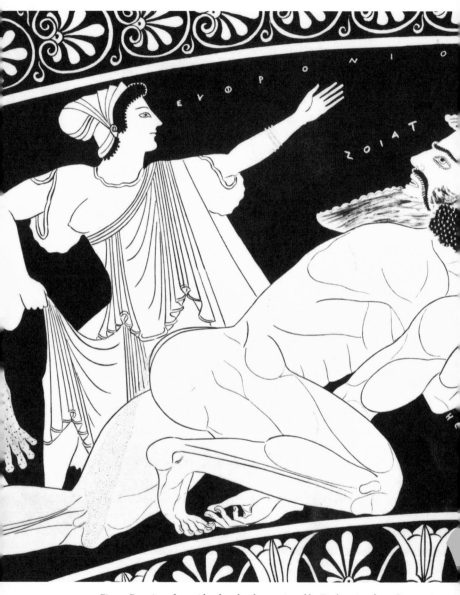

Fig. 13 Drawing of one side of a calyx-krater signed by Euphronios, from Cerveteri, *c*.515 BC. The other side of the vase shows an apparently unrelated scene of musical contest. H of krater 44.8 cm (17.6 in). Paris, Louvre G 103.

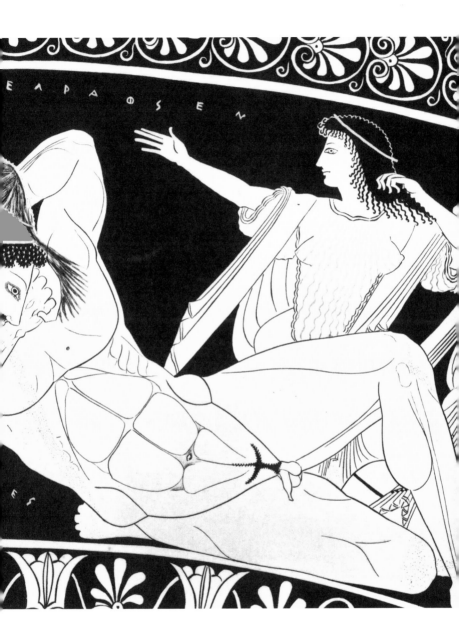

a wine-mixing bowl (see Fig. 1). Our focus upon the figure style is justified primarily by the historical attention given to figures as conduits of individualized style.

In that respect, further justification perhaps ought to be claimed here for the use of modern drawings derived from vases – in particular those produced in the early twentieth century by Karl Reichhold. In a sense, these are distortions, effectively flattening compositions created for and upon a curved surface. But since it is impossible to photograph or view a vase without performing some act of revolution or circumnavigation, the compromise seems necessary – and Reichhold was as faithful to original detail as any draughtsman could be. It is thanks to his 'unfolding' of one side of a krater in the Louvre that we are able to grasp the compositional method characteristic of Euphronios (Fig. 13); a natural view of the vase cannot be sufficient.

The subject, typically, is ambitious, for such a relatively small space. Herakles, the Greek strongman par excellence, is shown confronting the murderous Libyan giant Antaios. Flanking female onlookers help to calibrate the relative enormity of the contenders, firmly braced against each other. Herakles is looking

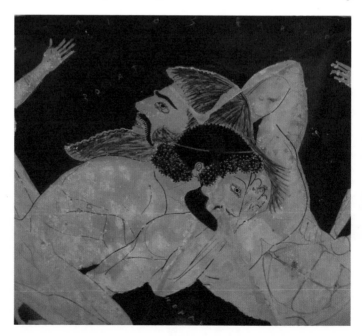

for the grip that will enable him to lift Antaios off the ground, thereby depriving the giant of the power he derives from Mother Earth (if that is the version of the story Euphronios intends). The heads of the opponents form the apex of a triangle in the centre of the scene. Striations of muscle in their bodies indicate that both wrestlers are equally 'ripped'. But the posture of Antaios is twisted – his right leg bent double, with a foot appearing behind his lower back – while Herakles, applying a complex armlock, squeezing fingers into flesh, is steadily crouched. The respective expressions, so closely juxtaposed, are telling: the Libyan frowning, head tilted, eyeballs rolling, lips parted, tongue protruding – about to lose consciousness; in marked pathognomic contrast to the resolute composure of Herakles. The pitted concentration of the two hulks is only heightened by the dynamic motion of the two attendant females – 'attendant', yet moving rapidly away while gesticulating back to the contest. Their motion/emotion is indicated by folds of drapery, some of it awry – yet their essential mirror-symmetry also makes a neat containing frame, which the artist caps horizontally by adding, in capitals, his epigraphic seal: *EUPHRONIOS EGRAPHSEN*.

The hair and beard of Antaios are done in a light wash, deliberately messy. The coiffure of Herakles, by comparison, is a mass of tidy curls, for which Euphronios deploys another of his artistic tricks: the use of white points, or minuscule relief-dots of clay, to show volume, or to catch highlights on a bunch of grapes. The same detail shows a further characteristic of his style. Like other late-archaic painters, Euphronios is content to show an eye in profile as if it were an eye front-on. But he is unusual in adding eyelashes. Not all of his figures have them – but heroes and deities seem specially favoured, among them of course Sarpedon (see Fig. 78). (Interestingly, 'Smikros' gives eyelashes to just one figure on his Getty vase – the precious Leagros.)

Francophone scholars have invoked the word *écorché* with re-

Fig. 14 Photographic detail of the calyx-krater
shown in Fig. 13: Herakles and Antaios.

gard to certain renditions of male muscle structure by Euphronios. Literally the term means 'flayed'; in the Western art tradition, it evokes the practice of drawing either directly from dissected bodies (as practised by Leonardo da Vinci), or (more often) using a three-dimensional model, made of wax or some other material. Curator François Villard, analysing fragments of an amphora in the Louvre that depicted on one side a javelin-thrower, on the other a discobolus, wondered if Euphronios had studied anatomy, in anticipation of Leonardo, directly from a corpse ('*une observation attentive du cadavre*').* Villard's reasoning was that on these and other figures Euphronios indicated the so-called *linea alba* – the fibrous connective tissue that runs vertically between the abdominal muscles, down to the pubic area; and this could only be known by dissection. In fact, the full extent of the *linea alba* may be superficially visible on bodies that are extremely 'toned' (and on pregnant women), so there is no need to conjure up the (historically improbable) notion of an ancient vase-painter conducting a post-mortem investigation. Still, the point remains that Euphronios took an 'ostentatious pride in his knowledge of human anatomy' – to the extent that he shows calf muscles even when a figure (e.g. Sarpedon) is wearing greaves, i.e. the pieces of armour designed to cover and protect the lower leg.

Euphronios did not dissect – but he must have observed. How directly he was able to observe is a question we shall address presently; in any case, it seems that the artist was so proud of his observations that he sometimes lost sight of the imperative to render anthropomorphic forms 'naturalistically'. So Sarpedon's lower legs, for all that they are greaved, show both a frontal and sideways view – frontal knee and tibia, yet sideways peroneal muscle (within greave). A similar peculiarity of markings may be observed in the arms of the figure labelled 'Smikros' on the

* Inv. Cp 11071: see Villard 1953.

Munich krater (see Fig. 3), where the painter has introduced a forearm muscle quite foreign to normal anatomy. The explanation is that a side-on view has been conflated with the front-on view – which of course could easily happen, if (as is likely) Euphronios had no models actually holding a fixed pose for him.

It is facetious to say that women, anatomically, were an enigma to Euphronios. (As an incidental matter of social reality: if the artist had a wife, he may not often have seen her unclothed, in the gender-segregated space that was the Greek house.) 'Topless' females elicit, again, a compromise of side-on and front-on perspective, at least with regard to their breasts (see Fig. 23). Otherwise, however, the economy of line that Euphronios shows in his mature work serves equally well for men and women, youths and adults, deities and mortals, heroes and monsters.

Readers may be wondering, at this point, whether there is one invariable anatomical mannerism by which they might recognize the artist. That is, after all, the basis for the Morellian method of attribution. Alas, no single clue or body part can be supplied – not even the ear, which on figures within the signed work of Euphronios is hardly ever exactly the same in shape or execution. Hooks for clavicles, lunate curves for biceps, ankles marked with three short strokes triangles for toe-nails – there are some recurrent features, indeed, but none of them alone constitutes a failsafe attestation of Euphronios. So – as Beazley more or less admitted – a degree of subjective judgement is ultimately required. And an important part of that judgement lies in a sensibility towards overall composition in the signed works, and a sensibility towards the subjects of those compositions. Regardless of minor details, Euphronios found a style, and a mode of composition, that enabled him to broach grand themes of drama and epic – themes that would suit large-scale painting well enough, but required skill and distillation if they were to fit upon a vase. At the same time, he was not above the trivial

'banter' of a collective workplace, with all its little rivalries (perhaps some sibling rivalry too); nor aloof from the gossip concerning his immediate clientele, some of them probably the gossip-generating 'celebrities' of the day. In the end, a biography of Euphronios remains impossible to construct. But traces of his personality are not entirely lost.

The Pioneers were literate, if erratic in their spelling (Phintias may give his name as Philtias, Phitias or Phintis). Several of the painters sometimes put meaningless Greek upon their vases – which for some scholars is a sign that these Athenian artists were aware of non-Greek clients abroad. If Euphronios and the others did not formally go to school, then somehow they became learned in mythology, and acquainted with the themes of epic and lyric poetry. They were unafraid to depict those violent scenes of myth which on stage would be devolved to some messenger's report – Theseus stabbing the Minotaur, for instance, or the murder of Aegisthus. But Athenian vase-painters had already shown, long ago, that their thematic 'reach' extended to such mythography: witness Sophilos, one of the first black-figure artists to sign his name, or Kleitias and Ergotimos, creators of 'the François Vase' (see Fig. 30). What precisely, then, did 'the Pioneers' pioneer? Beazley's summary reply would be: 'the new drawing'. Alternatively, one could contrast the output of the Pioneers with other Athenian ceramic workshops of the late fifth century, such as the black-figure 'Leafless Group' – repetitive, uninscribed, iconographically unadventurous: commercialized dross.[†] Before

* A signal of Beazley's categorization comes in his *Greek Vases in Poland* (Oxford 1928), 15 – describing as 'pioneer-studies of movement' two figures on an amphora by Euthymides: a youth pouring wine, a prancing satyr with pipes, each rendered in a three-quarters view.

† See Beazley, *ABV* 632ff.

we attempt to define the Pioneer novelty as perceived by modern archaeologists, however, it seems wise to commence an exposition by citing two distinguished ancient intellectual sources.

Aristotle was active at Athens some two centuries after the Pioneers, but a line from some transcribed lectures he probably delivered at his Athenian school, the Lyceum, provides a starting-point: 'We take pleasure in looking at careful likenesses of things which are objectively painful to regard, such as monstrous beasts, or dead bodies' (*Poetics* 1448b). This dictum has obvious importance for the present study, since the Sarpedon krater so prominently shows the representation of a dead body; and there is an aesthetic significance of deriving 'pleasure' that deserves further exploration (see p. 226). Meanwhile it is worth stressing the phrase 'careful likenesses'. 'Careful' in the Greek is *êkribômenos*, which could also be translated as 'accurately executed'. But to understand what Aristotle means by that, we must refer in turn to his Athenian teacher, Plato.

A sentiment preserved in what survives of Plato's dialogue, the *Critias* (datable to *c.*350 BC) indicates the critical sensibility of ancient viewers with regard to representations of the body. So far as artists attempt 'the big picture' – 'the earth and mountains and rivers and forests and the great heavens, along with everything that exists and moves within' – 'we are content if an artist is able to convey them with just a suggestion of likeness', because that matches our own impressionistic knowledge of such things. By contrast, 'when a painter attempts a likeness of human form, we are quick to pass judgement upon any failure to produce an accurate rendition – because of our close acquaintance with the original model' (*Criti.* 107). Naïve as this generalization now seems (and Plato intended it only as a philosophical analogy), it points us towards the possibility that a group of vase-painters at Athens might have worked with a similar sense of priority: being conscious, that is, of 'getting it right' with the depiction of bodies.

(We may note in passing that 'landscape' as a subject was not apparently within the repertoire of any Greek vase-painter; and that when representing drapery, Euphronios shows little interest in seeking realistic effects.) In other words, could it be that the Pioneers were aware of the 'advances' in anatomical accuracy with which they have been credited by modern scholars?

A vase in Munich signed by Euthymides is often cited in respect of that question, and cannot be bypassed here. This is the amphora celebrated in the pages of E. H. Gombrich's *The Story of Art* as an announcement of 'the greatest discovery of all, the discovery of foreshortening [...] It was a tremendous moment in the history of art when, perhaps a little before 500 BC, artists dared for the first time [...] to paint a foot as seen from the front' (Fig. 15). Gombrich's handbook is perhaps now losing the popularity it once enjoyed. Yet the absolute claim made for a Greek vase-painter has never been controverted. A worldwide

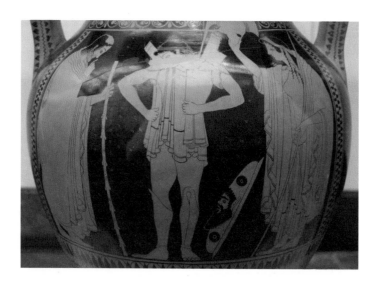

Fig. 15 Amphora by Euthymides, from Vulci, *c.*510 BC. Hector is arming, with his father Priam and mother Hecuba either side. . H 60.5 cm (24 in). Munich, Antikensammlungen 2307.

survey of art yields no earlier example of the representation of a human foot as seen from the front. And Euthymides, it seems, was aware of his innovation (elementary as it might now appear); at least, he repeated it, on another Munich amphora (inv. 2308), for the figure of a lesser-known warrior called Thorykion ('Breastplate-wearer'), similarly donning a corselet.

One unifying (and endearing) feature of the Pioneers is that they evidently liked to make reference to one another when inscribing their work. So, on a hydria (water vessel) also at Munich (inv. 2421), Phintias not only shows Euthymides as an earnest youth attending a music lesson, but also being toasted by a bare-breasted courtesan with a flick of her wine-cup. And Euthymides gives as good as he gets – if not more. On the other side of the vase, showing Hector posed half front-on as he slips into his armour, Euthymides depicts a trio of 'revellers' (*kômastai*) – protagonists of a drinking-party that has got to the point where dancing begins (Fig. 16). That these revellers are 'respectable' Athenians is indicated by the central figure, who is swinging the knotted stick that citizens customarily carry (and will raise in the Assembly when they come to vote: so in the democracy this stick becomes a sort of egalitarian sceptre). All three display the stocky proportions typically favoured by Euthymides. Since they are similarly bearded, similarly garlanded, and similarly semi-draped, a sophisticated suggestion is that the artist may have intended a sequence of several moves performed by one figure. In any case, the dynamic effect is clear: with a few deft lines, Euthymides is able to render this trio in 'three-quarter' view – that is, somewhere between front-on and side-on. The central dancer most conspicuously exemplifies this: stepping to the right, he looks directly backwards, and so shows us an angled spine, and two broad solid shoulder-blades. How easy it would have been to get this posture 'wrong' is shown both by the strigil-wielding athlete on the psykter attributed to 'Smikros' (see Fig. 12), and by

some drunken dancers painted by Euphronios, on a fragmentary krater in the Louvre (G 110).* Here Euthymides – conceivably, as noted, an elder brother to Euphronios – shows a sure touch. His lines are few but adroit. He sprinkles letters rhythmically around the figures, in line with their movements. And vertically, behind the lead figure holding a drinking cup, he adds a piquant message: HOS OUDEPOTE EUPHRONIOUS, 'AS NEVER EUPHRONIOS'. The literal translation is easy enough. But the meaning is ambivalent, and has caused much scholarly discussion. Is Euthymides saying that Euphronios has never danced like this? Or is he saying that Euphronios could not *draw* dancers like these? With regard to the first option, there is some debate as to whether artisans in the Kerameikos were admitted to the formalities of the Athenian symposium: this is a possibility which we shall address in the next chapter (p. 97), but most commentators remain sceptical. The force of the message would then be not so much that Euphronios lacked elegance when it came to dancing, but rather that as a potter-painter he could 'never' aspire to be a *kômastês*. He might depict the handsome, well-born types who attended symposia – occasions that gave rise to the (reportedly often inebriated) performance of the *kômos*-moves – but socially he lacked the rank to participate. If, however, the second option is accepted, then our quest for an answer to the question '*what did "the Pioneers" pioneer?*' edges closer to a conclusion. Euthymides is making a boast about his own proficiency at representing the three-quarter view – and a put-down directed at one of his workshop colleagues.

We have no evidence of a riposte to Euthymides by Euphronios. But the figures on his vases speak out in their way. Many examples might be cited, not least the central eponymous figure of

* The latter vase carries the inscription *Euphronios egraphsen tade,* 'Euphronios paints [like] this' – implying some satisfaction on the artist's part.

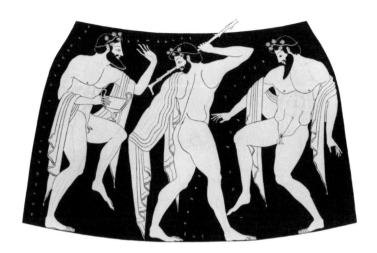

the Sarpedon krater, which is shown neither completely side-on nor completely front-on. A personal favourite is the impeccable foreshortening of a javelin-thrower, as traced by Beazley (Fig. 17).

There is little doubt that Ernst Gombrich would have favoured this latter explanation of the challenge issued by Euthymides. Gombrich, following a tradition of German scholarship extending back to the eighteenth century, and the writings of J. J. Winckelmann, patriarch of modern art history, moreover favoured a broadly political explanation of why Euphronios, Euthymides *et al.* were disposed to 'new drawing'. An artist 'dares' to show a foot front-on: this comes from a liberty of artistic expression enabled by the advent of democracy at Athens *c.*510 BC. Certainly that date matches the heyday of the Pioneers – although in their surviving work there are no allusions whatsoever to the events and personalities associated with democracy's foundation (e.g. the assassination of the tyrant Hipparchus in 514 BC).

We may be inclined to be more circumspect when it comes to invoking some sort of egalitarian zeitgeist prevalent in late

Fig. 16 Drawing of the scene on the reverse of the amphora by Euthymides. The figure on the left is labelled KOMARCHOS ('lord of the dance'). Munich, Antikensammlungen 2307.

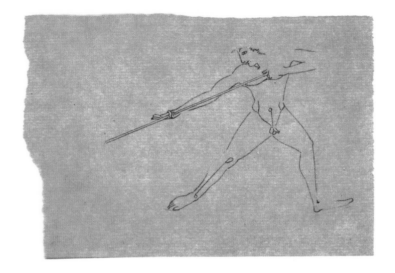

sixth-century BC Athens. 'Progress' towards naturalistic modes of representation, in both two- and three-dimensional art, is evident enough in sixth-century Athens under the tyrants. In any case, one final consideration, of a practical nature, remains to be mentioned. Anyone who has experience of 'life drawing' will know that the human foot is – along with the human hand – difficult to 'get right': it demands practice. But how would an ancient vase-painter get practice; and if naturalism arises from observation – 'making' an image, then 'matching' it to the object represented – then where and how do our Pioneers do their observing?

The krater by Euphronios in Berlin (see Fig. 1) can be titled 'Scene of a *palaistra*' – i.e. a designated place of wrestling, and other athletic activity, of the sort that became a normal part of civic life at Athens and elsewhere during the sixth century BC. 'Unwrapping' that scene with a Reichhold drawing (Fig. 18)

Fig. 17 Tracing of the figure of an *akontist* (athlete with javelin), from a fragmentary *kalpis* (two-handled water vessel) painted by Euphronios. The athlete's right foot is angled at three-quarters, and seen slightly from above. Folio in Oxford, the Beazley Archive; original vase in Dresden, Skulpturen Sammlung [*sic*].

compels us to query if Euphronios was ever able to enter such premises and do some sketching – perhaps asking certain athletes to 'hold it right there' when necessary?

Dietrich von Bothmer, whose admiration for Euphronios began with this vase, noted that here we see 'the earliest successful three quarters view in red figure' – i.e. the athlete with his back to the viewer, shown turning to see a boy extracting a thorn from his foot. Bothmer also commented on the manner in which Euphronios depicts oil being shaken from an alabastron by one of the athletes: 'an undulating red line' indicating the 'sluggish trickle' of oil from a small, narrow-necked flask, quite different from the pouring of wine or water from a larger vessel. The implication is that Euphronios has recorded the figures, and the oil-pouring, in a documentary spirit. However, the evidence of social history in ancient Greece offers nothing to support the notion of an artisan being admitted to a gymnasium where leisured young citizens spent many hours of their time.

We can therefore only wonder how they did it, these Pioneers. Possibly the boundaries of social class were less rigid than we think. Historians would say that artisans also had scant access to the ancient aristocratic institution of the symposium. But that ambience, too, is represented in fascinating detail by Euphronios – as we shall now see.

overleaf Fig. 18 Drawing of a krater by Euphronios in Berlin (Antikensammlung F 2180; see Fig. 1). The athletes are named (including Hegesias, Antiphon, Hipparchos and Hippomedon) and also one of their slaves/valets (Trianon).

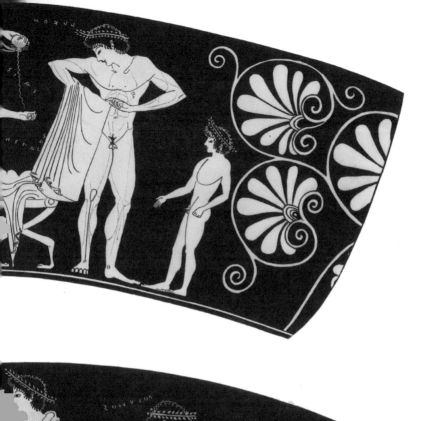

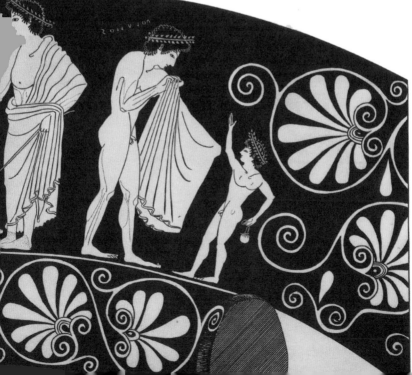

Athens and the Symposium

The Primary Cultural Context of the Krater

The literal meaning of the concept of the ancient symposium (*syn-posis*: 'together drinking') is an obvious way of starting this chapter. But the Greek understanding of what might or should happen at a symposium encompasses a good deal more than the convivial quenching of thirst. A typical image of the occasion indicates several characteristic features: not just the use of wine-cups (*kylikes*), but the playing of music, relaxation upon cushions and couches, heads adorned with ribbons, and overtly amorous behaviour (Fig. 19). Not evident, yet well attested elsewhere, is the custom of sharing diluted wine. As prescribed by various Greek authors, the proportion of wine mixed with water was variable; nonetheless, the principle of dilution remained culturally significant. Greek commentators tended to disapprove of societies where dilution was not customary, such as (reportedly) the Celts, the Scythians and the Macedonians. Libations of unmixed wine could be poured to the gods; mortals should exercise caution. Wine, categorically, was a *pharmakon* – at once cure and poison, blessing and curse. It came as a gift from Dionysos, 'the god who causes stumbling'. 'To a man spent with toil, wine renews his strength' was an adage of Homer's heroes (*Il.* 6.261), warriors whose personal risks upon the battlefield earned them the right to relax with cups kept filled. Yet Pindar, the poet par excellence of athletic success in the Greek world, proclaimed *ariston men hydôr*, 'the best [of all things] is water' (*Ol.* 1.1). Implicitly, then, the principle of combining wine with water assisted drinkers to abide by one of the maxims enshrined in the sanctuary of Apollo at Delphi, *mêden agan* – 'zero too much', or 'nothing in excess'.

From this overture, we can identify several lines of inquiry about the symposium that are relevant here, i.e. relating to the elaboration of a particular vase created in Athens *c.*500 BC. Statistically it appears that about 5 per cent of Athenian vases produced during the period 525–475 BC directly represent aspects of communal drinking – a peak of such self-reflexive images. The

Fig. 19 Watercolour reproduction of a scene on a *stamnos* (short-necked jar) signed by 'Smikros'. 'Smikros' is named as one of the symposiasts, and a flute-playing girl is named as Helike ('Twister'). In front of the couches, on low tables, are flowers and dessert-sweetmeats (*tragêmata*). Brussels, Musée du Cinquantenaire A 717.

Sarpedon krater shows us no drinkers upon couches: nevertheless, it is morphologically one type of *kratêr* – the mixing-vessel that was instrumentally central to the formal conduct of 'sympotic' business. It is reasonable to suppose that the decoration of a krater should possess a certain iconographic logic, or decorative suitability, for its original purpose. So what connects a scene of violent death with an occasion of mellow celebration? Are other figures on the vase in any way related to that social occasion? Was Euphronios commissioned to produce this mixing-bowl for a particular symposium? Did he, as an artist, have direct experience of such gatherings? (He might at least have recognized the echo of his own name in the Homeric epithet *oinos euphrôn*, 'wine that gladdens the heart': *Il.* 3.246.)

Before we attempt to answer those questions, one important preliminary problem needs to be addressed. A glance at the reverse of our 'typical symposium' scene is enough to alert us to the issue (Fig. 20). This side of the vase seems to offer a 'pendant' to the image of banqueters, showing how they are supplied at their couches. A man and a youth, both wearing loincloths, converge at what looks like a sort of cauldron. Since they are hauling heavy two-handled jars (*amphorae*), it is assumed they are of servile status; both, however, appear to be in 'the party spirit', their heads adorned with leafy garlands. Presumably the vessel – set upon a stand because it has no base otherwise – is one in which wine

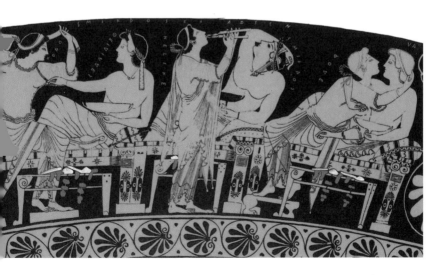

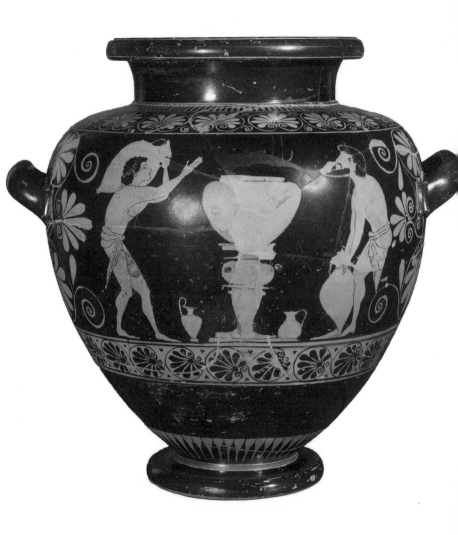

Fig. 20 Stamnos signed by 'Smikros', *c.*510 BC, probably from Cerveteri. In the centre of the scene is a large mixing-bowl or basin, mounted upon a stand, and at the foot of the stand are two *oinochoai* (wine-jugs). One figure is named Euarchos ('Rules well') – a young house steward? – the other (in retrograde) is named Euelthôn ('Well-arrived' or 'Ready'). H 38.5 cm (15.2 in). Brussels, Musée du Cinquantenaire A 717.

will be combined with water. But what is this capacious container made of? Beyond the carinated edges of its shape, no surface decoration is indicated. The likelihood is strong that a metallic vessel is represented here.

Ideally, a symposium was furnished with a set of metal accoutrements. All sorts of literary sources testify to that ideal, including not only the descriptions of ceremonial drinking we find in Homer (e.g. *Il.* 11.624ff.), but also the numerous allusions to metallic objets d'art in works of later writers – for example, the historian Herodotus indicating the wealth of the Lydian king Croesus by telling us that he dedicated a number of enormous gold and silver kraters to the sanctuary of Delphi (Hdt. 1.50). Such metal objects rarely survive in the archaeological record, for they were always subject to predators. A clear hierarchy of value can however be stated: gold first, silver second, bronze third – and then pottery. It is hard to calibrate exactly by how much the worth of one medium exceeded another, especially since supplies of such commodities were subject to historical and regional variation. However, it is safe to say that the differences could be considerable; and fair also to suppose that no Athenian *c.*500 BC would have dreamed of paying a fortune for a terracotta pot, however elaborate its decoration.

Some scholars regard the evidence for the superior prestige of metal vessels in antiquity as a damnation of the modern connoisseurship of Greek vases. The phenomenon of an ancient pottery vessel fetching a million dollars betrays, they argue, a perverse fetish for the handiwork of humble craftsmen who were never held in much esteem by patrons of their time, let alone well rewarded for their efforts; efforts which were (so the argument proceeds) largely derivative from metalworkers, or from artists employed on grander projects (such as pictures for public spaces, including stage sets – all that the Greeks termed *megalographia*).

If so many of these terracotta vases ended up in Etruscan

tombs, that happened because Etruscans wanted 'simply to provide the appearance of a respectable funeral without the expense'. But this attitude can be misleading too. Painted pottery may not have been hugely expensive: nonetheless it was customarily reserved for special occasions – weddings, festivals, visits to the family tomb, formal symposia and suchlike. As finds from ancient deposits of household detritus tend to show, the pottery in everyday domestic use was mostly undecorated – not necessarily 'coarse ware', but rarely the sort of object that 'the Pioneers' and other vase-painters produced. Fragments of two 'intentional red' cups attributed to Euphronios have been recovered from a household well in the Agora; but in this deposit (comprising, it seems, items damaged during the Persian occupation of Athens in 480 BC) the other vessels were mostly of plain black-glaze, and that is typical.

Black-glaze vessels would of course have a surface sheen, similar to and perhaps imitative of metallic effect. Beyond reflecting the lavish lifestyle of a host, a service of drinking vessels actually made of metal had particular aesthetic appeal. The properties of 'gleaming' and 'shining' were celebrated in lyric poetry, associated with divine epiphany and (in the word *aglaia*) emblematic of human merriment. Figured decoration might also add to the lustrous finish. The gilded bronze relief-work on the famous krater from Derveni in ancient Macedonia shows what was possible in the classical period; closer in time to our vase is the equally famous *Trésor de Vix*, an enormous bronze krater found among the grave goods of a Celtic 'princess' in Burgundy (Fig. 21). With a capacity of over a thousand litres (280 gal.), this almost makes the large kraters painted by Euphronios look puny by comparison.

Grand in capacity it may have been: yet an object such as the Vix krater, or the colossal gold bowl dedicated at Delphi by Croesus, was of limited utility. Even when empty, the Vix krater weighs around 200 kilograms (approx. 441 lbs); when full, even the

notoriously 'binge-drinking' Celts would need to gather in large numbers to do it justice. The Athenian symposium, by contrast, was more often than not a homely affair, held in the 'men's room' (*andrôn*) of a private house. The term *triklinion* (better known to us as the Roman *triclinium*) literally entails just three couches (*klinai*), set along three walls of a more or less square room. In practice, more couches could be accommodated, allowing parties of up to a dozen or so guests. In these domestic circumstances, painted pottery had its place. It did not flaunt individual wealth – arguably an important consideration, given the egalitarian ethos of democratic Athens. It was attractive in a way comparable to nicely worked textiles: generically, decorated ceramics and fine-woven or embroidered stuff could both be classed as *poikilia*, things 'intricately wrought', 'variously coloured'. And, however intricate, such painted pottery was within the economic means of an Athenian citizen. The attested original cost of a 'standard' red-figure drinking cup is a drachma, which was about an average day's wage for a workman; assume that a larger vessel such as the Sarpedon krater fetched proportionately more, and an ancient price estimate for our 'million-dollar vase' might be five drachmas – something like £300, or $400, in today's terms. It is conceivable, then, that vases could be commissioned ad hoc for one symposium or another. If so, their decoration could be tailored to the occasion, complete with 'in-jokes' and contemporary references. That the artists mixed socially with their patrons remains unlikely: but that does not rule out acquaintance – acquaintance with both principal symposiasts and the female *hetairai* or 'companions' employed to entertain them.

What it means for Euphronios/'Smikros' to represent a handsome young man called 'Smikros' taking his place at a symposium couch is a question we shall address presently. What it means for an Athenian sympotic vessel to be found carefully conserved among 'prized possessions' in an Etruscan tomb is a

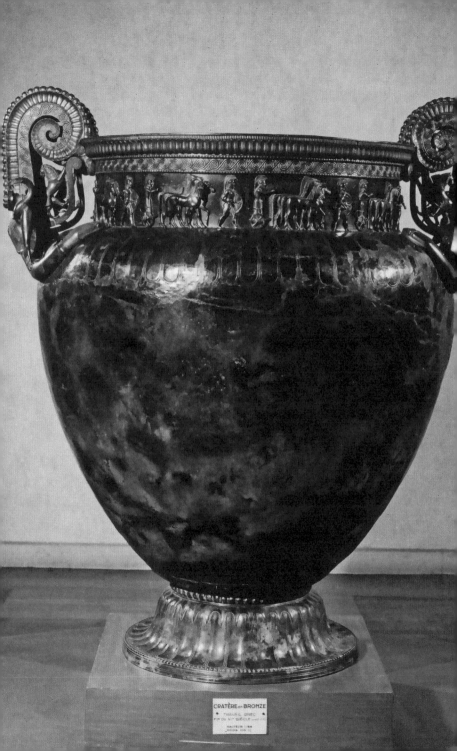

CRATÈRE EN BRONZE
· TRAVAIL GREC ·
FIN DU VIᵉ SIÈCLE (env. 500)
HAUTEUR 1.64

rather different question, and a discussion we shall postpone (to Chapter 5). The theory that painted vases were used once for the occasion of a symposium at Athens, and subsequently transported across to Italy in some kind of 'second-hand trade', is not without difficulties. For now, we shall focus upon the local culture of the symposium, exploring not only aspects of the visual evidence but also certain implications of the pre-classical literary tradition.

Chronologically, the symposium as an institution in the Aegean region may be traced back to the Bronze Age; geographically, its origins lie in the Near East. A lingering echo of the ancient protocol of mixing wine with water, the process known as *krasis* in ancient Greek, may be caught as the word for 'wine' in modern Greek – *krasi*. For present purposes, what matters to us is that the mixing-bowl, as the most capacious vessel within a sympotic 'service', was something like a centrepiece of the occasion (even if, for logistical reasons, it may sometimes have been placed in an adjacent room, or courtyard). Several types of krater are distinguished in the Athenian repertoire: the 'column-krater' has handles formed of miniature columns; the 'volute-krater' elaborates those columns into scrolls; the 'bell-krater' looks like an inverted bell, its handles often reduced to lugs; while our 'calyx-krater' takes its name merely by virtue of botanical resemblance, with handles placed like sepals supporting the flared 'petals' of the krater's bowl. Evidently, Euphronios and his fellow Pioneers – or their patrons, whether at Athens or Cerveteri – favoured this type. They also produced, for sophisticated drinkers, a complementary vase, shaped somewhat like an elongated mushroom, which we take to be an ancient cooling-device – hence the name given to it, *psyktêr* (see e.g Fig.12).[*]

[*] Whether the psykter was filled with ice and set within a krater full of wine, or the psykter filled with wine and set among ice or snow or chilled water in the krater, is debatable.

Fig. 21 'The Treasure of Vix': bronze volute-krater, made *c.*520 BC. The workmanship is Greek, the source perhaps one of the Greek colonies in South Italy, and the vase probably connected to the wine trade between Greeks, Etruscans and Celts. H 1.64 m (5' 4"). Châtillon-sur-Seine, Musée du Pays Châtillonnais.

What happened 'around the krater'? Often cited as an evocation of sympotic decorum is a passage ascribed to Xenophanes, a long-lived itinerant poet-philosopher of the sixth century BC. Originally from Colophon in Ionia, Xenophanes was conceivably at Athens when he addressed the following instructive verses as if to a group of symposiasts:

> 'The floor is freshly clean, so too the cups, and everyone's hands. One attendant sets woven garlands upon our heads; another comes around with a bowl of fragrant perfume. The krater stands full of good cheer, with more wine to hand – wine which promises to keep us going, gentle in its jars, with a floral bouquet. Among us frankincense exudes its clear scent, and there is chilled water, sweet and pure. Golden loaves are laid out for us, and a splendid table laden with cheese and dense honey. The altar in the centre of the room is covered in flowers, the house resounds to hymns and gladness. Right-minded men should make the praise of God their priority, with reverent stories and decent words. Once they have poured libations, and prayed for the power to act in a just way – for that is surely what everyone wants – then there is no harm in drinking as much as enables one to get home without assistance (excepting those advanced in years). Honour above all that man who, after enjoying his wine, relates noble sentiments, as his memory serves, and who invokes the aim of excellence. He will not sing of battles involving Titans, or Giants, or Centaurs – such fantasy-tales of the old days – nor of civil strife: there is nothing to be learned from them. What is good is showing regard for the gods – always.' (Xenophanes fr. 1 [Ath. 11.462c])

There is a strong sense here of the poet as *ho potarchôn* – 'lord of the drinking', or 'master of ceremonies' – and we must remember that these verses occupy a genre of 'hortatory elegiac', tending towards the puritanical. Not everyone might have agreed with the

strictures about subject matter suitable for recitation. Surviving samples of Athenian drinking-songs (*skolia*) indicate that political allusions were not off-limits. Yet the stress Xenophanes lays upon *euphêmoi mythoi*, 'reverent stories', or 'uplifting legends', along with *katharoi logoi*, 'pure words', may eventually help us to understand why certain poetic topics were deemed suitable for the decoration of vessels used at a symposium. Reverence did not necessarily preclude violence. The poet's injunction against 'fictions of the past' (*plasmata tôn proterôn*) seems severe, as a piece of literary advice; in any case, it evidently went unheeded by the painters. One of the most impressive vases ever produced at Athens, the black-figured column-krater we know as 'the François Vase' (see Fig. 30), invites its viewers into a dense weave of mythical narrative, including a detailed scene of fighting between Centaurs and Lapiths. As for the numerous occasions of combat between Herakles and some extraordinary opponent, Euphronios was only one of many artists who found such encounters thematically irresistible.

Many vases represent, of course, 'the world of Dionysos'. This encompasses not only images of the god and his boisterous entourage – including satyrs, maenads and assorted animals – but also the representation of theatrical antics, drinking-games, sexual (mis)behaviour and so on. By contrast to the image of Apollo – regular, orderly, temperate – Dionysos was visually signalled by unpredictability, playfulness and frenzy. Merely a trail of foliage associated with Dionysiac garlands – ivy-leaves or vine – may suffice to evoke the licence associated with the god's cult. On two kraters in the Louvre – both from Cerveteri – Euphronios illustrates his grasp of the requisite iconography, and injects it with characteristic vivacity. One vase (G 33) shows, as it were, the 'mythic' aspect: maenads in full fling, waving castanets and plant-staves (*thyrsoi*); satyrs capering among them with pipes, supplies of wine, and exuberant erections. The other

(G 110) represents a scene of 'actual' festivity: the dance known as *askoliasmos*, a feature of the Rural Dionysia – rustic festivities staged during wintertime in villages throughout Attica. This dance involved hopping across a carpet of slippery wineskins: as a challenge, it perhaps reminded everybody of the importance of drinking while staying 'upright' (*orthos*).

Ancient practice was to harvest grapes rather late in the year, compared to a modern vintage. This produced a juice that fermented rapidly, with correspondingly higher levels of alcohol and sweetness. Xenophanes alludes to the potential shame of over-consumption (or under-dilution), and he is certainly not alone in that – even Anacreon, the lyric poet famed for his fondness of wine, deems drunkenness a form of *hybris*: over-indulgence, then, akin to 'over-reaching'. By a nice verbal coincidence, Greeks were easily able to relate the drinking of wine 'unmixed' (*akrātos*) with the state of being 'without control', or 'powerless' (*akrasia*). Epic lore was instructive, too. Homer refers to the rich dark wine from Maroneia (*Od.* 9.209) that Odysseus has stowed aboard his ship, which must be treated with particular respect, i.e. mixed with water at a ratio of 1:20. This is the wine he offers to the Cyclops Polyphemus – a monster beyond civilized custom. 'In his foolishness', Polyphemus does not moderate his intake – and the consequences are catastrophic. So there were *nomoi sympotikoi*, 'rules for shared-drinking'. But sobriety was not the purpose of these rules – rather, a state of harmonious conviviality in which replenished wine-cups supplied a flow of 'easy conversation' (*hêdea kôtillein*), the raising of toasts (*proposeis*) and, eventually, a 'revel' (*kômos*) that might lead to dancing in the streets, or at least some graceful moves to music (see Fig. 16). Somewhere within this programme of merriment we can locate the game of *kottabos*. Apparently invented in Sicily, it may have been popularized at the Athenian symposium by the likes of Anacreon, during the second half of the sixth century; at any rate, it is visually well

Fig. 22 Detail from the 'Tomb of the Diver', *c.*500 BC. Paestum, National Archaeological Museum.

attested around Greece and Etruria by *c.*500 BC. Played 'in honour of the Bromian god' (i.e. Dionysos), its basic form consisted in projecting wine-dregs (*latax*, or *latagê*) towards a bowl, or some other target. A throw from the symposiast's cup might be made with an exclamation of erotic interest; sometimes, it seems, the cup-contents were directed at the object of erotic interest. The game can hardly *not* have created a mess of the symposium-precincts, and we suppose it took place in the latter stages of the evening. The modicum of dexterity required is shown within a painted tomb from the western Greek colony of Poseidonia (Paestum): the symposiast makes his shot by a flick of the index finger curled into the handle of a kylix (Fig. 22).

Fig. 23 Drawing of a psykter signed by Euphronios, from Cerveteri. H of vase 34 cm (13.4 in). St Petersburg, Hermitage B 1650.

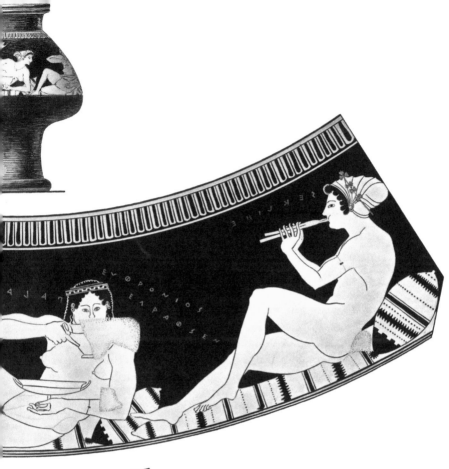

Whether Euphronios ever played this game we cannot know. But he knew about it; and was evidently privy to other particulars of the symposium as it took place in the Athens of his day. On a psykter recovered from a tomb at Cerveteri (where it may once have accompanied a 'matching' krater), the painter 'edits out' the male symposiasts, and shows us four courtesans relaxed not upon couches but rather mattresses and cushions, apparently spread on the floor (Fig. 23). Their names are piquant: Smikra ('Small' – perhaps even 'Babe'), Palaisto ('Grappler'), Sekline ('Bedworthy' – or suchlike) and Agapa (i.e. Agape, 'Love': as Beazley noted, an unusual pre-Christian instance of the word). Sekline plays the pipes; each of the other three has two large cups to hand, presumably a sign of formidable drinking prowess. If Euphronios himself took the sobriquet of 'Smikros', that was easy enough to feminize as 'Smikra'. In any case, he chooses Smikra as the one 'speaking' figure here, with a phrase (inscribed in retrograde) to accompany her *kottabos* gesture: *tin tande latasso Leagre*, literally 'to you this one I throw, Leagros'.

The words evoke the sound of Doric – the dialect of Greek characteristic of the Peloponnese and Sicily. (Had the artist transcribed local Attic parlance, the phrase would be something like *soi tênde latagô*.) Since the four courtesans seem 'decisively manly' in shape (especially the broad-shouldered Palaisto), the suggestion has been made that a quartet of Spartan women is here caricatured. But their names are not markedly Spartan, nor indeed the verb-form (Spartans, as Aristophanes indicates, would have said *lataddô*). Perhaps Euphronios is only relaying customary usage for the game of *kottabos*, with players acknowledging its Sicilian origins by quoting in Doric mode. In any case, this piece of sympotic 'banter' invokes a name that we find inscribed frequently among the works of Euphronios, and by other painters too, and it is a name to conjure with in the scholarship: *Leagros*.

LEAGROS KALOS: 'LEAGROS [IS] BEAUTIFUL'. This is how the name most often appears: not only on both sides of the Sarpedon krater, but on a total of over eighty surviving Attic vases (some of them black-figure). Perhaps the first thing to note about the address is that while it seems like a piece of graffiti, it is regularly painted on as part of the original decoration. Second, the name is sufficiently singular to be connected with an Athenian individual cited as one of the city's commanders for an offensive campaign in Thrace in 465 BC. This Leagros may well have died in that campaign: if so, since the inscriptions celebrating his (presumably youthful) good looks begin to appear on vases *c.*520 BC, he would by then have been a veteran general.*

Apostrophizing personal beauty upon a vase intended for use at a symposium is usually related to the practice of paederasty. Paederasty used to be defined (in the original *Oxford English Dictionary* of 1933) as 'unnatural connexion with a boy; sodomy'. That definition will not serve us here. In the past half-century, our understanding of the ideals and realities of paederastic systems at Athens, Sparta and elsewhere has deepened – while our attitudes towards homosexuality have (on the whole) broadened. The ancient literary attestation of paederasty at Athenian symposia has been known for a long time, notably in the form of works by two near-contemporaries at Athens *c.*400 BC, Xenophon and Plato – both works entitled *The Symposium*; the visual evidence, however, has been either suppressed or else treated rather coyly until recent times. A 'landmark' study of 1978, Kenneth Dover's *Greek Homosexuality*, took a lead in discussing *kalos*-inscriptions on vases not only within the context of formal erotic behaviour in Athenian society, but also in comparing them with the sort

* Leagros left a son called (after his own father) Glaukon: this may be the same Glaukon who is in turn hailed as *kalos* on a number of red-figure vases of *c.*470 BC, e.g. by the Providence Painter.

of graffiti that might be scrawled on the walls of a gymnasium changing-room, or the entrance-tunnel to a stadium (as at Nemea). The upshot of such scrutiny is that the implications of the declaration '*Leagros is beautiful*' are both more and less than they might seem.

The salutation can be anonymous: a figure may simply be labelled *ho pais kalos*, 'the beautiful boy'. (Girls are also addressed, in which case the image of some *hetaira* unclothed, or a woman collecting water at a fountain, may be labelled *kalê*.) Undoubtedly, however, some *kalos*-tags were intended as compliments to particular Athenians of the time. Successful young athletes were obvious candidates for adulation, and the late sixth century was the period in which victory at the games – above all the Olympics, but other occasions too, including the Panathenaic festivals – began to signify virtual, if not actual, hero-status. So the names of certain historically attested athlete-heroes appear on Pioneer vases, alongside images of suitably admirable bodies – names such as Antias, Eualkides and Phyallos. Antias seems to have been a particular favourite with Euphronios, Phyallos with Euthymides: 'portrait-features' of both are hard to discern beyond the lineaments of the generically handsome – but of course the painters may only ever have seen such 'stars' at a distance, if at all.

As with celebrities of the modern age, some characters labelled on vases may have been notorious simply because they made exhibitions of themselves, or did whatever was necessary to get themselves talked about. Is this a case of the pseudo-intimacy typically associated with 'celebrity culture', or were some of these types invited to a symposium for the sake of importing glamour to the occasion? If so, might vase-painters be primed to add the names of 'A-list' guests at a particular gathering? Possibly: a speculative case for special commissions has been made, and it is plausible that a Euphronios or a Euthymides knew his clientele well enough to produce 'bespoke' vases for this or that

symposium. From what we know of Athenian demographics, it seems unlikely that the potters and painters were ever part of the same social circles as their patrons. It is therefore rash to surmise (as certain scholars have) that Euphronios was himself involved in some kind of relationship with Leagros. It may be noted, however, that the Kerameikos area had a reputation for being a part of Athens where the courtesans – 'marginalized' women, many of them foreigners by origin – tended to reside, or work in brothels. So it is not beyond belief that Euphronios may have known those *hetairai* identified, if impudently, upon his vases. (Their clients, of course, may also have been his.)

We have briefly alluded (p. 73) to the political revolution that took place at Athens while Euphronios was at work in the Kerameikos. Given that the symposium is often typified as an essentially 'aristocratic' or 'elite' institution, readers might be wondering how it was affected by the democratic reforms associated with the name of Cleisthenes. For Plato, the notion of potters enjoying the formalities of the symposium was grotesque (*Rep.* 420e); that does not mean, however, that it was beyond their economic means. If they could afford dedications on the Acropolis, they could surely afford the occasional drinking-party too? Yet when we see Euphronios depict himself/'Smikros' as a handsome young symposiast (see Fig. 3), it is hard not to suppose that there is an element of fantasy here. The pose of reclining upon one's left elbow while raising the right arm to command more wine, or call for a different tune, was traditionally part of royal imagery in the ancient world. Inlaid couches, cushions, decorated vessels, servants – and 'crowns', if only ribbons or leaves – these all give the symposium a pseudo-regal air. These are symbols of leisure and privilege – the stuff of dreams to a 'banausic' craftsman, however skilled and successful.

Literary evidence indicates that the symposium at classical Athens was reserved for male citizens, and institutionally

provided a place for peer-groups to 'bond' in various ways –
officials of the *polis*, soldiers who fought alongside each other
in a phalanx, athletes who trained together. Paederasty was part
of the scene; but when assessing the imagery that accompanies
kalos-inscriptions, we should bear in mind that by the end of the
fifth century, an ideology had evolved that would equate physical
beauty with moral and political virtue – the Socratic credo
of *kalokagathia*, 'beautiful goodness'. Xenophon's *Symposium*
describes how a party is organized by a group of Athenian citizens
– all of them explicitly defined by Xenophon as *kaloi kagathoi*,
inadequately translated as 'gentlemen' – to celebrate a victory at
the Panathenaic Games (probably of 422 BC) by one Autolycus,
whose father will be present at the gathering. The men, including
Socrates, are all ensconced on their couches when the boy makes
his appearance. 'Not one of those who gazed at Autolycus', the
narrator observes, 'failed to be stirred to his innermost by the
boy's beauty'. The commotion registered here is as much aesthetic
as erotic.

In consideration of aesthetics, we may accept that any *kalos*-tag
by an image may carry the sense that the image per se is pleasing
to regard; so too the vase that carries the image. Moreover, while
kalos usually entails beauty of form, it can also mean 'admirable'
in other ways, or just 'nice', or 'proper'. So where does this leave
Leagros? One suggestion is that he was the proprietor of the
workshop where Euphronios and others were employed. Leagros
may be invoked several times upon a vase – e.g. the Geryon cup
(see Fig. 8), and without apparent pertinence to any particular
figure; his name may be written alongside images that are not
always flattering (for example, by the figure of a man vomiting);
and as we have noted, a scene of 'Smikros' making advances to
a diminutive 'Leagros' appears to be an irreverent caricature
(see Fig. 12). The best explanation for the frequent appearance

Fig. 24 Detail of the Sarpedon krater: Hermes, with painted inscriptions of
LEAGROS KALOS (right to left) and EUPHRONIOS EGRAPHSEN (left to right). The
lettering for HYPNOS (left to right) and THANATOS (right to left) creates similar
symmetry, appearing almost to issue from their mouths.

of *Leagros kalos* on the vases painted by Euphronios and the Pioneers may then be that Leagros was a benevolent employer who could take a bit of mockery.

In any case, the position of his name upon 'Side A' of our krater is central and prominent (Fig. 24). By writing it in retrograde to one side of the head of Hermes, Euphronios can juxtapose his own name on the other side, as if to signal parity. The admirable qualities of Leagros thereby mirror and complement the artistry of Euphronios – and vice versa.

Here, as on many other vases, Euphronios exploits the decorative possibilities of inscriptions. His writing may not count as 'calligraphy', but it is neat and deft, and often arranged in such a way as to accentuate the tectonics of the vessel and the compositional logic of its imagery: see, for example, how the figures of Sleep and Death seem to 'announce' themselves; and how the angle of the name 'Sarpedon' forms a diagonal balance to the blood pouring from the wound below his clavicle. Nevertheless these inscriptions also convey important information; their presence is enough to force us to concede that the Sarpedon krater is an art-object in which images do not exist independently of words. 'Text' was always part of the krater's appearance, and purpose. The letters on the vase conspicuously identify its predominant image as an epic casualty. It is worth repeating the point that, on the face of it, this seems peculiar. Who today would want a wine-container if its label featured graphic details of a dead soldier? 'In life men marvelled when they saw him, and women found him lovely, and he is still beautiful when he falls in the front line.' The seventh-century Spartan poet Tyrtaeus supplies one sentiment by way of understanding ancient aesthetics (*Fr.* 10.19–30W). Bravery on the battlefield was a defining element of the 'good man' (*anêr agathos*). Another archaic poet, Alcaeus, tells us that the space for a symposium should be brightly festooned with the accoutrements of combat – helmets, greaves, weapons and more

(Fr. 140V). Both poets may have sung their songs at drinking-parties. Both, however, derive from the senior tradition of epic verse. It was Homer who described how Sarpedon acted bravely, and paid with his life – and Homeric epic, ultimately, will tell us why, at a symposium, the sight of the maimed Sarpedon counted as *kalos*, beautiful and admirable.

Epic as Education

Homer and the Sarpedon Theme

The most important thing to know about Sarpedon is that he is a hero. Sarpedon *is* a hero. There is a reason, beyond literary style, for using the present tense. The purpose of this chapter, however, is to explore the historical value of that statement. Sarpedon, after all, does not count as one of the 'well-known' Greek heroes. His is not a 'familiar' name, like that of Achilles, Ajax, Odysseus or Agamemnon. Indeed, he is technically not a *Greek* hero; and it seems legitimate to ask how Sarpedon, a devout enemy of the Greeks in the epic narrative of Troy, comes to be celebrated as a hero in the city of Athens – arguably the city most emblematic of 'Greekness'?

So the case for Sarpedon as hero needs to be assembled. We need also to consider why it should be edifying, aesthetically or otherwise, to contemplate an image of the hero not only dead, but still bleeding (Fig. 25). In physiological terms, this is anachronistic. If Sarpedon has died – which is visually suggested by his partial nakedness, and his closed or semi-closed eyes – then of course his heart will have stopped, and blood should have ceased to pulse through his veins. Yet his wounds are gushing, with red paint added almost violently, impulsively, as if by a child with a crayon. Why has the artist represented a hero like this? There is now an academic discipline of 'vulnerability studies', and

a burgeoning science of cognitive response to images of bodies in pain and distress; such modern developments may help us to answer that question in our terms. At the same time, we ought to consider whether 'pity' or 'empathy' are innate, trans-historical virtues. As we shall see (in Chapter 8), the *motif* of Sarpedon's maimed and lifeless body borne away will be 'recycled' expressly to represent a figure to engage the viewer's emotive reflexes – 'the man of sorrows', no less, in morbid extremes. But Euphronios created this image as a party piece, not liturgy. The 'death of the hero' must once have raised spirits – as a spectacle upon a drinking vessel, no less than an event upon the tragic stage. Can we reconstruct the ancient logic by which it did so?

A premise to that question comes easily. Suppose a symposium was organized at Athens, and a poet 'booked' to perform by way of entertainment. Suppose that poet promised a rendition of a certain episode from the *Iliad*. (We know that professional rhapsodes specialized in epic recitations, or lyric adaptations, from Homer.) If Euphronios was privy to the plan, why should he not have produced an appropriate image? The notion is speculative. Still we are left, however, with the project of understanding why the Sarpedon episode was deemed (if we follow the rules laid down by Xenophanes) as an 'uplifting myth'.

Certainly, the vase-painters knew about the integral place of poetry at a symposium. Euphronios shows us a symposiast reclining, somewhat languidly, with the large lyre known as the *barbiton* – which emitted low notes suitable for lovesick verses (Fig. 26). From the lips of the figure curl the letters *mamekapoteo* – presumably *mame[o] kai poteo*, 'I desire and I crave'. Euphronios may here be citing from an ode accredited to Sappho, whose homoerotic sentiments resounded well in the paederastic circles of the Athenian symposium. And however limited their own formal education may have been, the painters also knew about the centrality of Homeric epic within the curriculum of the time.

Fig. 25 Detail of the Sarpedon krater. The spot of added red (encircled) may indicate the scar of a spear-wound sustained previously, according to Homer's narrative (*Il.* 5.660).

Systematic schooling hardly existed; however, by the late sixth century BC, modes of 'upbringing' (*paideia*) at Athens made Homer an instrument of literacy for young citizens.

The epics of Homer are generally thought to have been composed in the late eighth or early seventh century BC. A vase-painter might conceivably have gained access to a subsequent transcription of the poems – some sort of public library (*bibliothêkê*) is among the achievements of the tyrant Pisistratus – but it is more likely that his knowledge of the Trojan saga came from listening; and listening not only to public performances of poetry, but perhaps also to words delivered on the stage. For it was during the heyday of the Pioneer painters that the Athenian drama-festival known as the City Dionysia developed as a civic institution, with Aeschylus, first of the Athenian playwrights to be counted as a 'classic' author, presenting his debut tragedy in 499 BC. For our purposes, it may be incidental that Aeschylus

Fig. 26 Detail of an amphora attributed to Euphronios, from Vulci. The lyric citation recalls a fragment (no. 36) of Sappho, *kai pothêô kai maomai* – with the verb *pothein* implying that the object of desire is unattained, or unattainable. LEAGROS KALOS is also inscribed (retrograde). Paris, Louvre G 30.

is said to have defined tragedy as 'left-overs from the great banquets of Homer'; more pertinent that among the listed works of Aeschylus is a tetralogy (i.e. a sequence of three tragedies, plus a 'satyr-play' in lighter vein) based upon books 16–24 of the *Iliad*; and separately, a play called either *Carians* or *Europa*, of which a few fragments survive to indicate that it was set in Lycia, and told Sarpedon's tale from a Lycian perspective.

We shall return to Aeschylus later (p. 163). Meanwhile, for readers unfamiliar with Homer, a basic summary of the *Iliad* may be useful at this point. Homer at the outset announces his theme as 'the wrath of Achilles', and begins by describing a feud that has beset the Greek forces mustered outside the city of Troy. Led by Agamemnon, the Greeks (usually referred to in Homer as the 'Achaeans') are attempting to retrieve Helen, the wife of Menelaus (Agamemnon's brother). Helen has been abducted by Paris, one of the sons of Priam, king of Troy: Paris had claimed her as a prize for choosing Aphrodite, in a beauty contest between three goddesses mischievously staged during the wedding celebrations of Peleus and Thetis (who become the parents of Achilles). When Homer picks up the story, the Greek mission is evidently taking longer than predicted – as is the way with wars – and there is a crisis of command. Achilles has fallen out with Agamemnon, over what seems a relatively trivial matter (a division of spoils, and in particular a handmaiden called Briseis), and threatens to leave, taking with him his army, the Myrmidons. Fighting proceeds without him, and it looks as if the Trojans might prevail: with Sarpedon to the fore, they break through Greek defences, and set about burning the fleet of 'a thousand ships' that brought the Greeks across the Aegean.

This is the point at which Patroclus intervenes. His intervention is such a distinct part of the epic that it is sometimes referred to as if it were an independent poem, the *Patrokleia* – signifying not only his leading role, but also 'the glory of Patroclus'.

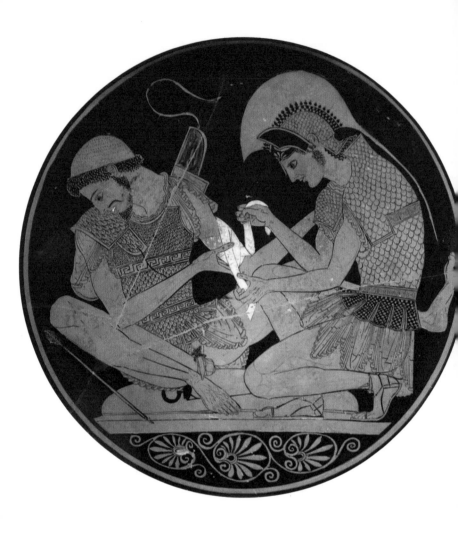

Fig. 27 Detail of a red-figure kylix, *c.*500 BC, from Vulci. Signed by Sosias as potter, and variously attributed – 'Sosias Painter', Berlin Painter, Euthymides. The cup's interior image does not illustrate any particular episode in the *Iliad* as we know it, but suggests Patroclus (bearded) as the lover, and Achilles as the beloved, in a paederastic partnership. Achilles has removed an arrow from his partner's arm; the absence of anaesthetic is implied by the way that Patroclus turns his head, and braces his foot against the edge of the tondo space. Berlin, Antikensammlung F 2278.

Patroclus has been brought up almost like a brother to Achilles; his relationship with Achilles must be very close, for reasons of narrative cogency, but Homer leaves it vague; other sources are more explicit about the homoerotic bond (Fig. 27). (A play within the tetralogy by Aeschylus, entitled *The Myrmidons*, was one of these sources.) Following advice from the veteran Nestor, and deploring his friend's implacable vendetta, Patroclus tells Achilles that he intends to show everyone that it is not cowardice that keeps the pair of them in their tent. Let him sally forth with the Myrmidons, to drive the Trojans back; and let him do it clad in his friend's armour, so causing the Trojans to panic at the thought of death-dealing Achilles re-entering the fray.

Achilles gives his consent to the venture. However, it comes with a cautionary proviso. Patroclus can save the Greek ships (those belonging to Achilles should be at anchor offshore, preparing to sail away). But Patroclus must not get carried away in his quest for glory. He must not pursue further combat with the Trojans. Achilles knows that he himself is doomed to a premature end, if he stays with this siege of Troy. He has already announced (*Il.* 9.415–6) the option of a return home (*nostos*) to Thessaly, there to live out his years, foregoing heroic renown (*kleos*). At heart, Achilles does not care much about Troy, still less what happens to 'Helen of Troy'.

The Myrmidons are likened to a swarm of angry wasps. Sub-human, never individualized, they may not even be aware that it is Patroclus, not Achilles, who leads them exultantly, driving the Trojans headlong from the Greek encampment. It is a bloody rout – and of course Patroclus cannot resist the chase. Hector, the Trojan champion, has already turned and fled in his chariot when his Lycian ally Sarpedon makes a stand. A duel between Patroclus and Sarpedon must be the next set-piece. The fight itself does not last long – but, as we shall see, it gives rise to a crisis among the divine powers that are also involved at Troy. Sarpedon falls. By

now Patroclus has killed at least a dozen Trojans or Lycians – but, far from satisfying his bloodlust, the death of Sarpedon increases it. The poet reminds us of the warning from Achilles. Patroclus is now acting as if foolishly blind to his own doom. If this were tragedy, such aggressive vehemence would count as *hybris*.

Patroclus has added nine further names to his massacre-tally, and seems intent on assailing the very citadel of Troy, when Hector catches up with him. Immediately Patroclus kills Hector's chariot-driver with a stone-throw. In the scrummage that ensues over the charioteer's body, Patroclus loses some of his armour, and is struck between the shoulder-blades by a young Trojan called Euphorbus. He is crawling away when Hector finally despatches him, and seizes the armour. If we had forgotten that this armour belongs to Achilles, we will be reminded now. Hector's appropriation of it is described as *ou kata kosmon* (*Il.* 17.205), a phrase of ancient Greek that translates curiously like modern idiom – 'out of order'. With his dying breath Patroclus predicts that Hector's death is coming soon – 'death at the hands of Achilles, the peerless son of Peleus'.

As it must: for the wrath of Achilles towards Agamemnon will be as nothing compared to his wrath towards Hector. So, the poem proceeds. Its conclusion is not the taking of Troy: many more must die, including Achilles, before that happens. Other poets will take up the various narrative threads (how much of the Sarpedon–Patroclus–Achilles–Hector storyline existed before or beyond Homer remains unknowable, and need not detain us). Homer is content to follow his theme to the violent vengeance exacted by Achilles, and a sort of resolution, with the funerals of Patroclus and Hector. In the parabola of action he has described – about fifty days, within a campaign that lasted over a decade – the death of Sarpedon may be seen as an apex, or at least a cardinal moment, setting off an inexorable sequence of vengeful events. When Sarpedon dies at the hands of Patroclus, it is then

necessary that Hector kill Patroclus; then that Achilles kill Hector – which is, ultimately, an act of passionate suicide.

When we examine the characterization of Sarpedon in the *Iliad*, it is not complex. A catalogue of Trojan manpower, plus allies, cursorily establishes his presence in the contest (*Il.* 2.876–7). Thereafter, from the outset, Sarpedon never appears other than as brave and bold – and given to exhorting others to act likewise. We first encounter him as the Trojans are about to take the offensive to the Greeks, while Achilles is still sulking. Sarpedon's first words are a reprimand to Hector, and the (numerous) other offspring of the Trojan king Priam: they appear to have held back in the fray. So Sarpedon introduces himself as not only an ally of the Trojans, but one who has travelled far from his kingdom of Lycia, and the banks of the river Xanthos, leaving behind his wife, his baby son, 'and a great many possessions too, which many a poor neighbour is itching to get hold of' (*Il.* 5.481). The message is that he is a family man, fighting at Troy by way of a great favour to the Trojans – only incidentally, and gratuitously, adding to his own *kleos*.

Sarpedon is himself a son of Zeus: indeed, he is the only offspring of Zeus involved at Troy (if we do not count the cause of the war – Helen, result of the union of Leda with Zeus disguised as a swan). One of Homer's regular epithets for a hero, *antitheos* – usually translated as 'godlike', though perhaps more literally understood as 'god-matched' – has special meaning when applied to Sarpedon. The Lycian king has godlikeness in his genes. And Homer soon makes us aware of the parental crisis that will arise as a result of Sarpedon's voluntary presence at Troy. For Sarpedon's first confrontation, as described by Homer, is with Tlepolemus, leader of a Greek detachment from Rhodes (geographically not far offshore from Lycia) – and Tlepolemus is a son of Herakles. Since Herakles too is a son of Zeus, the antagonists are therefore kinsfolk, just a generation apart. But there is no love lost between

them. Tlepolemus, absurdly, yet within the conventions of epic challenge, accuses Sarpedon of cowardice. The pair hurl their spears simultaneously. Sarpedon's hits Tlepolemus in the neck, proving to be a fatal blow. Sarpedon himself is struck in the thigh (see Fig. 25), and this is a serious wound, which causes him to faint when removed from the battlefield. The poet uses the episode to give an important narrative signal. Sarpedon, revived by draughts from the north wind Boreas, will survive; however, while appealing to Hector for help, he has a premonition of his eventual death at Troy. And to the sentiment that 'his Father [Zeus] saved him from destruction' (5.662), Homer supplies the telling little adverb, *eti* – 'yet', or 'for the time being'. Fate is postponed, but not averted. It is a sort of *proekthesis* or 'advance presentation'. We know what Sarpedon fears: that he will never again see his wife, his little son or the fertile plains of the River Xanthos.

The next occasion we encounter the Lycian king, he is pictured as a lion lately deprived of prey, and emboldened by hunger to attack even a well-guarded herd (*Il.* 12.299). But will he assail the Greek encampment alone? Sarpedon meets a fellow-countryman called Glaucus, son of Hippolochos. This Glaucus must be wavering – for Sarpedon is moved to a stirring address:

> 'Glaucus', he said, 'why do the Lycians at home distinguish you and me with marks of honour, the best seats at the banquet, the first cut off the joint, and never-empty cups? Why do they look up to us as gods? And why were we made the lords of that great estate of ours on the banks of Xanthos, with its lovely orchards and its splendid fields of wheat? Does not all this oblige us now to take our places in the Lycian attack and fling ourselves into the flames of battle? Only so can we make our Lycian men-at-arms say this about us when they discuss their kings: "They live on the fat of the land they rule, they drink the mellow vintage wine, but they pay for it with their glory. They are mighty men of war, and where Lycians fight you will see them in the

vanguard." Ah, my friend, if after living through this war we could be sure of ageless immortality, I should neither take my place in the front line nor send you out to win honour in the field. But things are not like that. Death has a thousand pitfalls for our feet; and nobody can save himself and cheat him. So, in we go, whether we yield the glory to some other man or win it for ourselves.' (*Il.* 12.310–28)

Those who enjoy the status of 'aristocrat' do not often justify their access to such status. Sarpedon's speech is remarkable for its stark calculus of risks taken for benefits received. Land, wealth, 'privilege': these are not inherited, but earned. To be pre-eminent in socio-economic terms depends directly upon being pre-eminent in strength, courage and military skill. And there are further implications. The reference made by Sarpedon to fighting as one of the 'foremost' (*prôtoisi*) has its sense within 'Homeric' warfare, with champions from each side advancing, usually by chariot, to meet one another. But this will also have resonated with any citizen obliged to do service in the infantry formation known as the 'hoplite phalanx' – the mode of combat prevalent throughout the Greek world from the eighth century BC until the ascendancy of Macedonia *c.*330 BC. The phalanx depended upon collective resolve for its success. However, such scope for individual heroism as it offered naturally commenced with those soldiers who fought 'foremost' in the ranks – especially those who volunteered to do so. Just a decade or so before the Sarpedon krater was produced, a young Attic warrior called Kroisos was commemorated by a statue (see Fig. 29) with an inscribed base relating that he died 'in frontline fighting'. In this sense, the stirring words addressed by Sarpedon to his cousin Glaucus could serve as a rallying-call to any recruit or combatant. The message does not present a choice – 'Death or glory'; rather, a supreme commitment: 'Glory at any price – including death'.

We perceive that it would be utterly alien to Sarpedon's sense

of noblesse oblige if he were to make an exceptional appeal to his divine parentage. Death will come as it must: in that respect, he is equal to everyone else. So, this passage is also important in preparing us for the divine crisis that Homer will describe in Book 16. Sarpedon, evidently more aware of his mortality than of his immortal father, has suffered two 'near-death experiences' when Zeus himself predicts an imminent end, at the hands of Patroclus (*Il.* 15.167). It is imminent – and, it appears, *immanent*.

Patroclus, with the Myrmidons in support, is on the rampage, and Trojans fleeing before him, when Sarpedon, characteristically, makes a stand. Sarpedon deplores the shame (*aidôs*) of those who flee or who have gone weak at the knees. But does anyone else have the guts to join him?

It is at this point that Homer shifts his narrative attention to the gods. (They take a view of the battle from an eminence on the nearby island of Samothrace; it is understood that nothing happens at Troy, or anywhere else, without their knowledge.) Zeus cries out, '*Oh my son, my Sarpedon*' – hailing him as *philtatos andrôn* – 'most beloved of men', or even 'my favourite human being' (*Il.* 16.433) – fated to die at the hands of Patroclus. Yet Zeus is omnipotent, and the most powerful of the gods. If he has twice saved his beloved son from death, why cannot he save Sarpedon again?

Homer's dramatization of this question is fascinating, partly because we can sense him as narrator 'playing god'. Shall he, the poet, let Sarpedon live or die? The strategic choice intrigued the twelfth-century scholar Eustathius of Thessalonica, who recognized its pivotal importance: a key episode for anyone seeking to comprehend a central paradox – i.e. (in the words of Richard Janko) 'that nearly every event in the *Iliad* is the doing of a god, and that one can give a clear account of the poem's entire action

with no reference to the gods at all.'* Some commentators in antiquity (beginning with the Alexandrian critic Aristarchus in the second century BC) wondered whether Homer was really the author here, since the theological sense seemed so obscure. Clearly, we should avoid a pseudo-Christian explanation: nowhere does Homer suggest that Zeus makes a gift of his son for the sake of all mankind. Homer does however portray Zeus as subject to 'pity' (*eleos*: *Il.* 16.431); and prone also to grief – though whether the shower of blood-drops (*haimateoessas psiadas*) that occurs just before Sarpedon's clash with Patroclus is an omen, or the sign of Zeus weeping, is left undefined. Zeus the all-powerful is shown stricken, in two minds. The dramatic dilemma is that Zeus *feels* as a father, but *acts* as part of a pantheon. His wife Hera does not resort to accusing him of adultery (Sarpedon's mother may have been Laodameia or Europa, but certainly not Hera). Hera does not seem motivated by any active dislike of Sarpedon (as she was, notoriously, with regard to Herakles). Rather, her argument is that if Zeus now declares his special interest for Sarpedon, then other deities with parental interest in the battle will follow his lead; and so there will be divine anarchy, with all sorts of combatants rescued from their mortal fate. She therefore counsels her husband to let Sarpedon die. He may – if he cares so much for this mortal – send Sleep and Death to pick up the body and take it back to Lycia for the proper rites of funeral.

For Plato, the problem with this episode was that it attributed too much emotion to the gods (*Rep.* 388B–C). For later philosophers in the Stoic tradition, it had a more positive lesson: what we call 'fate' is cosmic order, not only divinely ordained but also divinely obeyed: so, Zeus himself shows the utmost fortitude when allowing the death of Sarpedon to happen (Cicero *Div.* 2.25). Most readers of the *Iliad* will perhaps content themselves with the

* Janko 1992, 4

acceptance that in Homer's 'worldview' – more specifically, his 'anthropomorphic theodicy': a world ruled by gods resembling humans – even Zeus is bound by obligations to heed advice from a divine 'council' (*boulê*).

The action resumes. As mentioned, the encounter between Sarpedon and Patroclus is hardly an 'epic' struggle: it is almost an anti-climax. Sarpedon's first spear-cast misses Patroclus, striking one of his horses instead; a second throw flies harmlessly over his opponent's left shoulder. For his part, Patroclus begins by killing Thrasymelos, Sarpedon's valet. Then he sends a spear firmly into Sarpedon's chest. The Lycian's collapse is likened to a mighty tree – oak, poplar, pine – felled for ship-timber; or, if that was too inanimate, to a bull dragged down by a lion. Sarpedon's last words make a further plea to his cousin Glaucus to fight on, and prevent the Greeks from taking his armour. (It is surely a deliberate narrative twist that Sarpedon's panoply will become a prize, for mock-combat, at the funeral games of Patroclus: *Il.* 23.798–80.)

Glaucus himself is unable to do much, having been wounded by an arrow. But he relays news of Sarpedon's end to the Trojans. With Hector and Aeneas prominent, they rally to defend Sarpedon's body. Now Homer reaches for a disgusting simile: the warriors battling over the corpse are like flies in a stable, buzzing in clusters round buckets of milk. The state of the corpse is accordingly dire: 'not even the most discerning eye could now recognize Sarpedon the son of god' (*Il.* 16.638). It is time for Zeus to intervene; acknowledging as much, Hector sounds a Trojan retreat (so Patroclus, gloating, carries off Sarpedon's arms). Echoing the words of permission spoken by Hera, Zeus instructs Apollo by way of delegation:

> 'Quick, my dear Phoebus; go and take Sarpedon out of range,
> and when you have wiped the dark blood off, carry him to some
> distant spot where you will wash him with running water,
> anoint him with ambrosia, and wrap him up in an imperishable

robe. Then, for swift conveyance, put him in the hands of Sleep and his twin-brother Death, who will make all speed to set him down in the broad and fertile Lycian realm. There his kinsmen and retainers will give him burial, with a barrow and a monument, the proper tribute to the dead.' (Il. 16.667–75)

We now understand what Euphronios must compress into the visual register afforded by a single vase. We can remind ourselves that he is producing a vase, not an illuminated manuscript. Classical archaeologists have long debated the question of how much Homer influenced Greek figurative art, from its earliest 'Geometric' beginnings, in the eighth century BC: one obvious problem here is that we cannot assume that the event of Sarpedon's death was textually 'canonized' by the time of Euphronios. But let us suppose that the narrative details were pretty much as we know them from the *Iliad* as later established (by about the second century BC). How far has the artist 'deviated' from the text – and why?

It is a measure of Homer's genius that he will proceed to combine two separate narrative requirements arising from Sarpedon's violent end. First, Sarpedon's body will be rescued – by way of paternal consolation to Zeus; second, the body deposited in Lycia for perpetual worship – so fulfilling Sarpedon's own hopes and forecast of undying glory. It is a measure of the genius of Euphronios that he finds ways of synthesizing these requirements, and more besides. But let us begin with the most obvious question: why does he change Apollo for Hermes? Apollo is pro-Trojan, and a deity associated with healing; he is also a deity with strong links to Lycia as a region, and as such ideally suited to the role assigned by Zeus in Homer. For the artist, however, there is a basic problem of compositional logic. Within the canons of Greek anthropomorphic representation c.500 BC, the god Apollo is usually represented as young, handsome and athletic, with long hair streaming over broad shoulders – in other

words, rather like Sarpedon as envisaged by Euphronios. For reasons we shall soon address, Sarpedon must here be shown as physically huge. Then Apollo might appear ridiculously small by comparison. So Euphronios takes the liberty – if that is the right way of putting it – of substituting Apollo with Hermes. (For all we know, another artist, or indeed some rhapsode of the time, may already have done so.) In any case, it is an adroitly chosen alternative. Hermes is visually and theologically the perfect candidate. Visually he is easily recognized (see Fig. 24): bearded, clad in the wayfarer's cloak and broad-brimmed hat, with wings on his heels, and carrying a distinctive staff (the *kerykeion*, or *caduceus*). Theologically, his service to travellers extends beyond death: his epithet of *Psychagôgos* means that he will escort souls (*psychai*) on their journey from this world to the next.

As for the deployment of 'Sleep' and 'Death', their iconographic tradition as such can await further discussion (p. 148). Here it may merely be observed that Homer does not describe their appearance, and indeed gives them no role in lifting Sarpedon's body from the Trojan plain. Euphronios, by contrast, visualizes them in painstaking detail – the scales and pinions of their wings are picked out – and depicts them operating like paramedics on active service. Though their Corinthian helmets are pushed back – they need to be able to see what they are doing – they are nevertheless armed as if subject to attack. They have no stretcher for the body, so their task is not easy. Both are hunched over with the effort of raising Sarpedon's corpse: to judge by the fingers of his right hand, Sleep is actually losing his grip (Fig. 28).

Sarpedon still has his greaves on, but the rest of his body is in clear view, not concealed 'in an imperishable robe': the painter wants us to see it. The diagonal direction of Sarpedon's gushing wounds helps to add a sense of swift movement, upwards and to the right; the hand gesture of Hermes may also be read as one of urgent encouragement, as he too moves to the right. But why

Fig. 28 Detail of the Sarpedon krater: Hypnos. Cerveteri, Museo Archeologico.

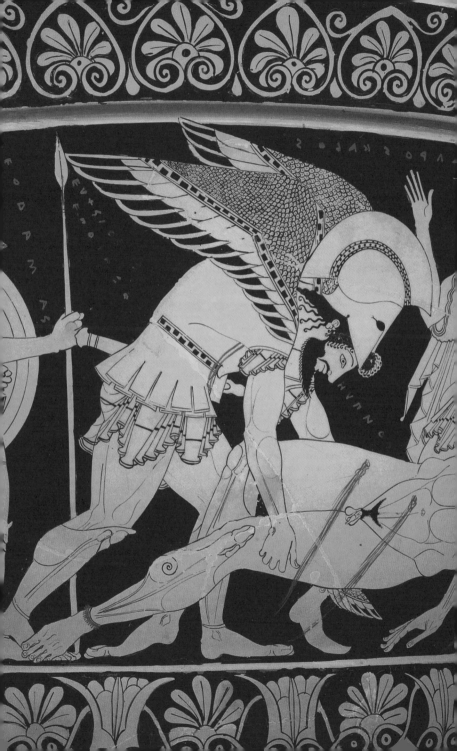

the multiple wounds, and why so gushing? The answer lies not so much in the text as in the way that an artist creates a synopsis of narrative stages. Homer specifies that Sarpedon's body was mutilated beyond recognition. How should an artist convey that degradation – if he also wants to show us the wondrous form of a hero? One resort, evidently, will be to add some streaks of blood. According to the modern science of cognitive response, every viewer will automatically and empathetically wince with pain at the sight of these wounds. But let us also admit that Euphronios has 'posed' Sarpedon most unnaturally for our attention. A body lifted up without a stretcher is awkward enough. This body has been manipulated in such a way that we can see it mostly front-on – while horizontally extended, miraculously taut. The right arm dangles down, yet diagonally, in line with the blood-streaks; Sarpedon's long hair, however, resists gravity, so that we can appreciate his noble profile. As for the rest of his physique, it is a wonder to behold. The six-fold division of an athlete's abdominal section is central to the image – like the cover of any *Men's Health* magazine today – while the proportions of all other parts, including the compact genitals, assimilate closely to a sculptural genre that Euphronios will have seen displayed at Athens, and beyond – the type we call the *kouros*, or 'youth' (Fig. 29).

There is no such thing as an elderly or even mature *kouros*: that would be a semantic paradox. So even when it marks the grave of a senior citizen, the *kouros* statue represents the deceased in the prime of masculine vigour, taut and unbearded. This is part of the transfiguration involved in posthumously attaining heroic status; and it may be why Euphronios has here chosen to show Sarpedon as if he were an ephebe, hardly out of his teens (for a contrasting option, see Fig. 37).

*

Fig. 29 'The Anavysos kouros' – marble statue of Kroisos, from Anavysos, *c.*530–520 BC. The inscription on the base reads: 'Stay and mourn by the monument of dead Kroisos, whom furious Ares destroyed one day as he fought in the front ranks [*eni promachois*]'. H 1.94 m (6' 4"). Athens, National Archaeological Museum 3851.

The same process of heroic transfiguration may explain the enormity of Sarpedon's corpse. Obviously, if Sarpedon were raised vertical, he would tower above all other figures on the vase; indeed, he would be off the scale of the decorative field. Several points of ancient history and terminology may serve us when pondering the implications of this size-difference. First, we could note that in the Homeric vocabulary the word for 'body' is not quite as we might understand it. *Demas* implies 'form' or 'frame'; it would be rarely applied to women, and almost never to an animal. Second, also reserved predominantly for male appearance is the word *phyê*. Both words allow for a certain latitude of physical 'effect' – an effect most palpable when a man is stripped (the Greek word *gymnos*, which is the etymological base of any 'gymnasium', means 'naked', but also 'without armour', and therefore 'vulnerable').

In the climactic encounter between Achilles and Hector, the sign to all onlookers that Hector is dead comes when Achilles starts stripping Hector's armour. Then the other Greeks cluster round. Their immediate reaction is to 'gaze in wonder at the size and marvellous good looks of Hector' (*Il.* 22.370). They will proceed to add gratuitous wounds to the corpse. 'Gratuitous' – but not without poetic sense: for it has been shown that 'the mutilation of the corpse' is a modulated theme with the *Iliad*, first voiced by Glaucus as a fear on behalf of Sarpedon (*Il.* 16.545), culminating with the extreme outrage of Hector's body by Achilles, and finally subsiding after the funeral of Patroclus, when Priam comes in supplication to Achilles for his son's remains. An attunement to this theme may explain why Euphronios has added extra gashes to the body of Sarpedon: if he knew that Patroclus killed Sarpedon with a single spear-thrust, he also knew that further damage was sustained before Zeus intervened; and this is *why* Zeus intervenes. Honouring the dead with proper deposition is a central joist of Greek culture from protohistoric times.

The portage of Sarpedon is a supernatural event, and as such should not be interrogated literally. But readers may be wondering: why *Sleep* and Death – apart from their usual pairing (see p. 149)? That question occurred to the learned commentator Philostratus, who *c.*AD 200 produced a dialogue about Homeric heroes and hero-cults: the *Heroikos*. Philostratus knew about Sarpedon's Lycian origin and divine pedigree; he vouches for a death 'as Homer describes it', and puts Sarpedon's age at 'about forty' at the time. Sarpedon's fellow-countrymen, he says, made a funerary procession between Troy and Lycia, exhibiting the body en route: it had been cleansed and treated so delicately, adds Philostratus, that Sarpedon 'seemed to be only asleep – which is why the poets say that Hypnos carried him away' (*Her.* 39.4).

Euphronios seems to anticipate this 'rationalizing' explanation: at least, the features of his Sarpedon are set in beatific calm, not some rictus of final agony. That the established husband and father is shown as a pre-bearded adolescent is not an anomaly: for death is a form of transfiguration and rejuvenation when it comes as the hero's 'beautiful death' (*kalos thanatos*). As for the size of the corpse, Philostratus gives us some further insight. One of the participants in his imaginary dialogue is sceptical that there was ever a time 'when men were over ten cubits tall'. A cubit is the generic distance of elbow to tip of middle finger, usually reckoned as 46 centimetres (18 in): the size of an Homeric hero, then, would be 4.6 metres (15 ft). Scepticism would seem natural. But it is soon dispelled by reference to the finds of colossal skeletons in the Troad region and elsewhere. The learned emperor Hadrian, we are told, had seen the bones of a figure eleven cubits tall, deemed to be Ajax, found by the seashore near Troy, and piously reburied there (*Her.* 10.1). Philostratus (himself from nearby Lemnos) also knows about a celebrated event *c.*AD 170, when some enormous bones emerged from collapsing cliffs on

the promontory of Sigeum. Since this was legendarily the burial place of Achilles, the remains were taken to be those of the hero.

We may smile at the naïvety of credence here. But in antiquity there was no science of dinosaurs, and no chronology of fossilized megafauna. Given that Homer had specified that his heroes were huge in size (Ajax especially so: *Il.* 3.226), it was natural enough that when relics of extinct great vertebrates were discovered, these seemed like proof of former existence: the reality of colossal types, who in Homer's imagination were able to lift and toss enormous boulders as if they were pebbles (see e.g. *Il.* 12.445). Certain bones looked similar enough to those of humans: so what we would catalogue as the patella of a Miocene mastodon was earnestly reckoned as a knee-cap of Ajax (its dimensions given as those of the discus used in the junior pentathlon: Paus. 1.35.3). The same reasoning was applied to monsters of mythology: thus some massive skeleton unearthed by a Roman general in Morocco supplied historic attestation of the existence of the giant Antaios (Plut. *Sert.* 9; see Fig. 13). A tale of this sort in Herodotus (1.67) indicates that Athenians *c*.500 BC shared such notions about the 'reality' of the heroic past.

To claim genealogical descent from protagonists of the heroic age was not bizarre. The Pisistratid tyrants of sixth-century Athens linked themselves to Homer's most venerable warrior at Troy, Nestor; perhaps there were remains of his great palace at Pylos still visible. There was political advantage in making Ajax a founding-father of one of the ten voting 'tribes' of the Athenian democracy, for Ajax came from Salamis, an island appropriated by Athens during a dispute with the city-state of Megara. Meanwhile, at the level of metaphysics, the philosopher-guru Pythagoras was indoctrinating his followers with the concept of *metempsychosis*, the reincarnation of souls: he declared himself the re-embodied spirit of Euphorbus, the young Trojan who was first to inflict a wound upon Patroclus, and he claimed to recognize as former

Fig. 30 Detail of 'the François Vase', *c*.570 BC: Ajax (AIAS) carrying the body of Achilles (ACHIL[L]EUS, in retrograde). The full story of how Achilles died was told in the *Aethiopis* – one of the (mostly lost) poems of the archaic 'Epic Cycle'. Florence, Archaeological Museum.

'personal property' the alleged shield of Euphorbus, on display in the Argive Heraion (Paus. 2.17.3).

We know nothing of the personal beliefs and family affiliations of either Euphronios or his patrons. But the background of hero-literature and hero-cult is necessary knowledge for understanding the images of the Sarpedon krater, and the iconographical repertoire of Athenian vase-painters around the time of Euphronios. It was a black-figure predecessor, Exekias, who showed how a hero's 'life-story' could be epitomized in a single visual moment – witness his study of Ajax, on the verge of lonely suicide; while several red-figure successors – notably Onesimos and the Kleophrades Painter – managed to choreograph, on a limited vase-surface, multiple events of an epic scene such as the 'Fall of Troy' (see Fig. 6). Two of the earliest Athenian artists known to us by name, Kleitias (painter) and Ergotimos (potter), had shown how the krater, as ceremonial vessel, could accommodate complex strands of poetic tradition: their celebrated masterpiece, 'the François Vase', provides viewers with a 'feast' of thematic possibilities – among them, the contemplation of a hero's corpse (Fig. 30).

Fig. 31 Fragment of a calyx-krater attributed to Euphronios, *c*.515–510 BC. A poorly preserved kylix in the Getty Museum (77.AE.20) indicates that Euphronios tried the same subject earlier in his career, with a composition involving Achilles' mother Thetis and his tutor, Phoenix. Here, just the last two letters of the name [AI]AS, 'Ajax', are visible. Approx. 15 cm (6 in) high. Formerly Princeton University Art Museum; now Rome, Museo Nazionale di Villa Giulia.

Euphronios is unlikely to have seen this piece. But he took up the vignette of Ajax retrieving the fallen Achilles, on a vase that must have been of similar dimensions to the Sarpedon krater. Only minor fragments survive, yet one of these is enough not only to make an attribution to Euphronios, but also to envisage a significant portion of the decoration (Fig. 31). Ajax has the body of the bearded Achilles draped over his shoulders, in the manner of a fireman's lift: supporting himself with his two spears, he kneels to pick up Achilles' helmet with his free right hand, while retaining his shield. The impression that this is happening in the midst of combat is strengthened by parts of a figure striding forward, and of another sliding to his knees.

Repeatedly, Homer's heroes either threaten to leave the bodies of their opponents as carrion for dogs and vultures, or else implore one another to be spared that horrible end. On the Sarpedon krater, we note that two senior warriors stand aside, as if respecting or guarding an act of pious decency. Their names are inscribed: to the left, LEODAMAS; to the right, in retrograde, HIPPOLYTOS. The former may connect to a 'Laodamas, son of Antenor', named as a Trojan victim of Ajax in fighting by the ships (*Il.* 15.516); interestingly, a post-Homeric author identifies this Laodamas as Lycian (Quintus Smyrnaeus 11.20–1). For the latter, it is suggested that Hippolochos, father of Glaucus, is intended. In either case, then, these would represent comrades or allies on Sarpedon's side. But what of the other side of the vase? How do the figures there relate – if at all – to the image of our hero?

It has been suggested that we are wrong to think of the Sarpedon image as 'heroizing', and that it is rather the spectacle of 'a desecrated or defiled corpse', visually gratifying to Greeks because it shows the vanquished body of a non-Greek enemy, moreover visually gratifying to an Etruscan viewer because Etruria was where 'such gory scenes were savoured'. There are several reasons why this proposal is unconvincing. To begin with, there is no for-

getting that while Sarpedon, as a Lycian ally of the Trojans, is non-Greek, he is nonetheless a son of Zeus: as such, he could hardly be cast in a hostile role, like some kind of barbaric threat to Greek civilization; he is not quasi-Persian. And although Troy was sometimes used as an analogue for war with the Persians, there is little evidence that the Greeks of any period were inclined to be partisan in their 'reading' of the Trojan saga; even a slight knowledge of classical Athenian tragedy is enough to alert us to the cultural implausibility of making Greeks against Trojans a paradigmatic struggle between the forces of good and evil. Equally, just a slight knowledge of Greek art will warn anyone away from supposing that the Etruscans were ethnically predisposed to be connoisseurs of representations involving bloodshed.

Still it is worth asking what makes Sarpedon a 'hero' – beyond his unequivocal sense of aristocratic honour. In the tripartite structure proposed as an ancient Greek 'worldview' by some scholars (in the wake of J.-P. Vernant), there are animals, humans and deities: a basic way of expressing the hierarchy is that humans kill animals to sacrifice to the gods. Yet while these categories are fixed, intermediate entities are also allowed, not to mention sexual intercourse (thus, for instance, if a god takes the form of an animal to copulate with a human). The *hêrôs* is one of those intermediate entities, a 'lesser divinity' – however, as Homer makes plain, though heroes ascend to be 'half divine' (*hemitheos*), they may also descend, terrifyingly, to the level of brutes; acting not only like courageous animals, such as lions, but also impulsively, like dogs, or stubbornly, like donkeys.

A 'heroic code' is sometimes invoked, as if each of Homer's heroes exemplified a 'complete and unambiguous' set of values, often asserted but never reasoned. The legendary protagonists at Troy can be made to seem like modern urban gang-members, obsessed only with garnering 'respect' (*timê*, in ancient terms) from their peers – or rather, their inferiors, since every hero

Fig. 32 Detail of 'Side B' of the Sarpedon krater. Note, above the figure of Hipp[a]sos, the sign of an ancient repair. Cerveteri, Museo Archeologico.

wants to be truly excellent, i.e. 'superior to other men'. ('Achaeans', as we have noted, was one broadly ethnic mode of referring to the Greeks at Troy; to be 'best of the Achaeans', then, was a basic statement of heroic aspiration.) 'Strive always to be the best': Sarpedon's cousin Glaucus states as a simple precept the parting advice given to him by his father Hippolochos, before joining the Trojan campaign (*Il.* 6.208). But readers attentive to Homer's characterization know that there are plentiful nuances of individual personality to animate his tale: without them, indeed, the *Iliad* would be a tedious catalogue of homicide (and the *Odyssey* a bore's travelogue). Historically, it is not altogether clear whether Homer's poetry inspired his contemporaries to worship heroes, or an existing cult of heroes inspired Homer to flesh out the identities of these heroes. In any case, the formal veneration of a hero, 'Homeric' or not, was a religious practice well known and much observed in the Greek world at the time of Euphronios. It is possible that Euphronios knew of a cult to Sarpedon, in Lycia (see p. 234); it is possible that Homer, too, knew of such a cult. But where does that leave the other figures on the vase (Fig. 32; see also Pl. 2)?

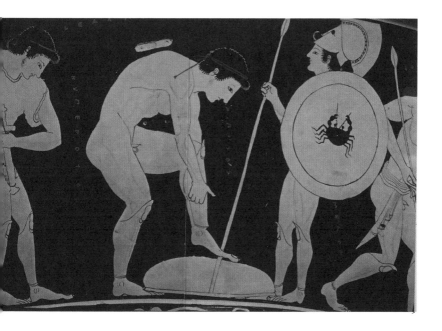

Four youths are gathered, in some undefined space. Their youthfulness is signalled by lack of beards; some sport a little fluff by way of 'sideboards'. With them stands, to the right, a single more senior figure. From left to right, each is labelled. The first, named Hype[i]rochos, holds a short sword in his left hand; with his right hand, he adjusts a long ribbon tied around his head. The next, Hipp[a]sos, leans over to fit a bronze greave to his left leg, using a *hoplon* shield as footrest. He is otherwise naked. The legend *Leagros kalos* is inscribed above him. A third, Medon (or possibly Megon), appears ready and waiting for the others. We see his shield as if central to the group, emblazoned with a curious motif – a crab playing the pipes. A fourth, Akastos (written in retrograde), crouches as if to pick up his shield (which in the hoplite phalanx was intended to overlap with a fellow-fighter). It is worth observing that apart from greaves, and a full helmet (tipped back), he wears only a loin-cloth – no corselet.

The fifth figure, Axippos (written 'Achsippos' in retrograde), seems ready like Medon, with his helmet tipped back. That he is older than the others is signalled by his beard. We see just the fringe of his tunic below his shield, which carries the emblem of a scorpion. His lips seem slightly parted – as if he was speaking? As a figure, he appears rather like a mirror image to Leodamas on 'Side A', with Leodamas shown left side-on (so that we see his shield interior, and the mechanics of how it is held).

So much for what there is on view. What could it mean? A range of possible interpretations may be listed:

(1) Both sides of the vase share unities of time and place. That is, on 'Side A' of the vase, Sarpedon dies in the mythical battle at Troy, and is seen stripped of his armour (except greaves); while on 'Side B' of the vase, we see some young Trojans, or Trojan allies, putting on their armour, as if mustering to take Sarpedon's place in the battle-lines. They do not, however, appear to be Lycians: at least, as a group they do not resonate with the Lycian

'foot-soldiers' to whom Homer alludes (*Il.* 5.677–8); only 'Medon' coincides with a Trojan ally mentioned by Homer (*Il.* 17.216).

(2) The vase offers no chronological narrative. That is, 'Side A' shows a scene of heroic death at Troy, and 'Side B' shows a group of young Athenians, perhaps not only contemporaries of Euphronios but also known to him.

Alternative readings then subdivide:

[a] These young Athenians are putting on their armour for some impending call to military service. If so, their corselets are conspicuously absent.

[b] They are shown in training for such service. (Every young Athenian citizen was supposed to keep himself in readiness for active combat.) The following two options arguably constituted such training.

[c] They are preparing for some paramilitary athletic event for *epheboi* (cadets). The *hoplitodromos* – the 'race in armour' – might seem a possibility; but representations of that event indicate that participants were not encumbered with weapons. More likely is some sort of mock-combat (*hoplomachia*), which became part of Athenian civic education (*Ath. Pol.* 42), with cadets 'graduating' at a ceremony where they were awarded a shield and a spear. In this scenario, Axippos would be the senior instructor.

[d] A further possibility is that here we see the protagonists of the *Pyrrhikhê*: an armed dance, performed at various occasions by boys and men.

Interpretation (1) is not easy to sustain. The names are problematic. 'Leodamas' on 'Side A' of the krater might echo the name of Sarpedon's mother (when called Laodameia: see p. 230), or else recall a captain of the Trojans, listed as a casualty to Ajax in the fighting by the ships (*Il.* 15.516–7); with 'Hippolytos', his opposite bystander on the same side, perhaps evoking Hippolochos, father of Sarpedon's cousin Glaucus. But the names of figures on 'Side B' seem largely extraneous to Homer's narrative. Matters are

complicated by the fact that two of them, Medon and Akastos, are homonymous with protohistorical chief magistrates of Athens (*Ath. Pol.* 3.3). Does Euphronios intend them to be typical, or particular? For some scholars, all five figures would be credible as Athenian citizens of the late sixth century BC – in which case they could be contemporaries, even clients, of the painter.

The central shield-blazon (*episêma*) is intriguing. It has been pointed out that both crab and scorpion possess a protective carapace – something that Sarpedon markedly lacks. Both creatures can be aggressive, and an image of the crab with its extended claws nicely occupies the *tondo*-space of a *hoplon* shield. But a musical crab? Euphronios may be alluding to an idiomatic phrase for playing the pipes, 'to make the crab' – a metaphor reflecting the extended 'nipping' fingers of a fast player.* Though unusual as a shield motif, this is not the only image in Greek art of a sea-creature piping (tuneful scorpions are also known). But does it help us decide a meaning?

The crab has its natural armour; the crab can attack; the crab can scuttle in all sorts of directions; and here, extraordinarily, the crab can sound the *aulos* – the double-reed instrument that supplied the music for the armed dance in ancient Greece. Could this be the 'giveaway' detail? It was Dietrich von Bothmer who aired the hypothesis of armed dancers as an explanation of the figures on 'Side B' of the krater – though he did not elaborate upon it. For Bothmer, it was enough to cite a piece of information gleaned from Aristotle (Fr. 519 Rose) to the effect that the *Pyrrhikhê*, a lunging and leaping dance-routine associated with Pyrrhus-Neoptolemos, the ultra-violent son of Achilles, was first

* Antiphanes, PCG fr. 57.15. The connection of our image with a fifth-century dramatist called 'Crab' (*Karkinos*) and his dancing sons is, alas, chronologically implausible (*pace* Bothmer in Hoving *et al.* 1975, 49). One other piping crab is known, on a near-contemporary volute-krater, New York Metropolitan Museum inv. 59.11.20 (ARV 224.1 – hence the 'Karkinos Painter').

performed by Achilles himself; and that he performed it around the funeral pyre of Patroclus.

This specific tradition about the Pyrrhic dance may be recondite to us – but perhaps not always so. If Euphronios knew it, then it allows him to suggest a sort of mythical 'ring composition' to his vase. One side shows the magnificent Sarpedon, slain by Patroclus; on the other side, viewers find young Athenians preparing to re-enact the dance that Achilles created as an expression of grief for Patroclus, slain in turn. The link might seem a strained example of 'paradigmatic extension'. But – as Bothmer saw – Euphronios had made the connection before, on a drinking cup he painted about a decade earlier (see p. 147, and Figs. 37 and 38). The cup is fragmentary, yet enough survives to show the hands of a figure playing the *aulos*, and a near-naked youth with spear, helmet, greaves and shield, 'shaking a leg' (and a nicely shaped frontal foot).

Suppose a group of Athenian symposiasts saw themselves on 'Side B' of the Sarpedon krater. Whether or not they connected the routines of an armed dance with Achilles and Patroclus, surely they saw in the spectacle of Sarpedon's heroization a model of manhood – the embodiment of a sort of virtue that had not altered between the semi-remote times of Homeric warfare and their own militaristic codes of citizenship: so enduring was epic as a form of education. The krater showed an exemplary way to live. It was exemplary, too, of how to die: and that was a message it delivered far beyond Athens in the late sixth century BC.

An Image for the Afterlife

The Sarpedon Krater as a Prize among the 'Grave Goods' of the Etruscans; Hypnos and Thanatos on Attic Funerary Lekythoi

The Sarpedon krater has not survived because it is an artistic masterpiece, and nor has it survived because it makes a visual statement about ancient Greek heroic values. It has survived because some anonymous Etruscan – or certain members of an unknown Etruscan family – decided that it was appropriate to be placed in a tomb, hoping, presumably, that it would stay there for eternity.

The Etruscans have a reputation for being enigmatic. Without wishing to bolster that reputation, it may be admitted straightaway that we do not know why some inhabitant(s) of Etruscan Cerveteri took the decision to remove the Sarpedon krater from 'circulation' – or rather, to remove it from the society of the living, for deposit among the community of the dead. We do not know if the vase was acquired with that funerary destination in mind, nor whether Euphronios and Euxitheos had any inkling that their creation would be carried abroad, let alone consigned to a tomb. We do know, however, that at some point in antiquity the vessel was broken, and repaired using several inset bronze staples. Beeswax may also have been used to seal the joint: so, although cracked, the krater might still have served as a liquid container. It may have been placed in the grave of its first Etruscan owner, or else passed on to a subsequent generation. As noted (p. 28), the chronology of tombs at the site where the vase was allegedly found may indicate a delay of at least a century between acquisition and deposition. As also noted, we do not know exactly where in a tomb the vase was found. So what can be said about its Etruscan 'reception'?

Cerveteri was demonstrably a city open to the wider Mediterranean, connected to the seaboard by its port-emporium, Pyrgi – a name signalling that the Greeks knew the site as Pyrgoi, 'the towers'. Patient excavation of this site – which is about as close to the seashore as any site could be, before becoming underwater archaeology – reveals that it received plentiful quantities of

Athenian pottery during the late sixth century, and was visited by Greek traders; but also that *c*.500 BC the city of Cerveteri (known to the Greeks as Agylla) may have been more closely aligned, politically and economically, to the Phoenicians – probably in the form of their ('Punic') colonists at Carthage, on the North African coast. Almost contemporary with the Sarpedon krater is a famous trio of inscribed gold plaques, recording a joint Etrusco–Punic dedication within a sanctuary that honoured the Etruscan goddess Uni (equivalent to the Greek Hera) and the Phoenician goddess Astarte. These tell us that the ruler or chief magistrate of Cerveteri was then one Thefarie Velianas. Velianas does not appear in any written history of the Greeks, or the Romans: for all we know, he may have been the leading protagonist of a political revolution at Cerveteri. The archaeology of the city's main cemetery, nicknamed the 'Banditaccia', suggests some sort of radical change at the end of the sixth century BC: if not democracy as such, then a distinct 'levelling out' of family tombs, into quasi-'egalitarian' units.

What did not change was the Etruscan custom of creating a posthumous 'home from home'. The Banditaccia cemetery is usually referred to as a 'necropolis', or 'city of the dead' – with 'streets' and 'houses' laid out in a fashion that is still quite comforting and familiar to the modern visitor. There are couches, chairs, even domestic appliances, still visible inside the tombs, carved in relief. Originally each grave was also furnished with an assemblage of free-standing 'grave goods' – ranging from weapons and weaving utensils to mirrors, jewellery and foodstuffs – and including, as elsewhere in Etruria, the vessels and accoutrements of ceremonial drinking.

Two questions confront us about this funerary custom. First, what was the thinking behind it? (After all, most of us today would not consider interring precious or useful objects with deceased relatives, however much we loved them – the relatives,

that is.) Second, how special were these 'grave goods'? To be more specific, regarding our vase: might Etruscans have acquired Greek painted pottery with a view to supplying their tombs?

Answers to those questions are potentially entwined. If the dominant ideology of Etruscan burial was based upon a reflexive motive – that is, a tomb essentially recreates or resembles a house – then there is no need to suppose that vases in tombs carry particular funerary significance. The occupants of the tomb will be surrounded by possessions they used and cherished while alive. Alternatively, if beliefs about an afterlife called for distinctive objects and certain iconographic choices, then we will be tempted to invest the archaeology of Etruscan 'grave goods' with ritual function and eschatological meaning. No handbook survives of Etruscan tenets regarding the 'last things' – death, possibly judgement, 'the next life' – but references in ancient texts, and the imagery of painted tombs at a number of Etruscan sites (especially Tarquinia, to the north of Cerveteri), suggest that a theological system most certainly existed. What an Etruscan may have seen in an image of the dead Sarpedon, therefore, is open to some speculation.

Without over-simplifying the problem, but for the sake of managing speculation, the line of argument we shall take here is that the Sarpedon krater came to Cerveteri as a mixing-bowl for wine and water – and that its Etruscan owners not only used the vessel for its proper purpose, but also shared, to some extent, the cultural package offered by its decoration. The claim is, then, that they practised a version of the symposium; they knew about the stories of Homer and the epic cycle, and were entertained by po-etic performances; and while Greek was not their first language, the inscriptions upon the vase were more or less legible by them.

One of the first Greek artefacts to be signed by its maker is a vase found at Cerveteri, 'the Aristonothos krater' of the mid-seventh century BC (Fig. 33). To judge by the alphabet he used,

Fig. 33 Krater inscribed (in retrograde) *Aristonothos epoi[e]sen* ('Aristonothos made [me]'), from Cerveteri, *c.*650 BC. On the side of the vessel shown here, the subject appears to be the blinding of the Cyclops Polyphemus, told as an adventure of Odysseus by Homer (*Od.* 9). The other side depicts a naval encounter. H 36 cm (14.2 in). Rome, Capitoline Museums.

Aristonothos was Euboean by origin; and it is generally supposed that he made his way to Italy at a time when fellow Euboeans were establishing themselves in the Bay of Naples. It cannot be proven that Aristonothos settled at Cerveteri; but it is reasonable to suppose that his handiwork was comprehensible to the local clientele (whose own language, though radically different from Greek, was written using letters borrowed from Euboean script). That aristocratic Etruscans in the seventh century BC were attuned to the storylines of Greek mythology is highly likely; that they would use this krater for some symposium-style formal occasion equally credible. Although there are historical episodes of conflict, e.g. with the Ionian Greeks who had set up a colony in Corsica (see Herodotus 1.166–7), Cerveteri may nevertheless be characterized as a 'primary contact zone' between Greeks and Etruscans: a powerful Etruscan city whose powerful citizens were manifestly 'Hellenized'.

The tombs of Cerveteri have yielded a great quantity of Greek vases: an impression of their quality may readily be gained by paying a visit to the Louvre, which acquired a substantial part of the spoils of exploration by Giampietro Campana in the Banditaccia cemetery during the 1840s. The museum's collection includes, for example, 'the Eurytios krater' – a famed example of the archaic style of vase-painting at Corinth, showing Herakles at ease in the banqueting-quarters of King Eurytios (or Eurytos). Again we are obliged to suppose that the Etruscan patrons of such a vessel recognized the figures shown (and named) on the royal couches; knew also that a story attached to the scene (an archery contest for the hand of the king's daughter, Iole, which led to deaths among the hosts); and, more generally, that they were able to relate to the 'lifestyle' evoked by the imagery of the vase – feasting, hunting, horse-ownership, and of course acquaintance with heroes such as Herakles (and we recall that a cult of Herakles at Cerveteri was in existence from at least the

Fig. 34 Detail of the 'Tomb of the Ship' (Tomba della Nave), *c*.500 BC. Suspended on the wall are two kylikes; on the table are an amphora (right) and a hybrid of amphora and column-krater (left). Tarquinia, Museo Archeologico Nazionale.

sixth century BC: see p. 38). Like the Sarpedon krater, the Eurytios krater is unusually large and ambitious in its decoration. But it is not an absolute 'one-off'. Of all archaic Corinthian kraters with a known export-provenance, 40 per cent come from the same site – Cerveteri.

A painting from a tomb at Tarquinia illustrates, conceivably, the typical 'reception' of Greek vases in Etruria. On the left-hand wall, a merchant ship is depicted, giving the tomb its name; then there is a display of several vases (Fig. 34). A scene of sympotic revelry on the central back wall may suggest a logistical sequence:

the ship brings vases (and wine?) – so the lyre-player takes up his instrument, and the festivities begin. Another Tarquinian tomb of the period similarly juxtaposes painted vases with some sort of *kômos* (Fig. 35). We resort to the Greek word for such dancing partly because we do not know the Etruscan term for it, partly because Dionysiac rites were demonstrably interwoven with the Hellenization of Etruria, and partly because the artist who painted this tomb was probably of Greek origin.

The process of 'reading' the images of Etruscan tombs is always haunted by an interpretative dilemma. Do the paintings hold up a mirror to the actual 'lifestyle' of elite Etruscans – who were notorious, in Greek and Roman literature, for their love of luxury – or do they project some vision of an afterlife filled with feasts and celebrations? (An intermediate option is that we see in these tombs evocations of feasts held in honour of the dead.) So far as the imported Greek vases are concerned, the relevant observation to make here is that while these fragile objects survive primarily thanks to the Etruscan habit of storing them in tombs, the archaeology of Etruscan cities and sanctuaries

Fig. 35 Drawing of a detail in the 'Tomb of the Painted Vases' (Tomba dei Vasi Dipinti – very deteriorated since its discovery in 1867), late sixth century BC. Tarquinia, Monterozzi necropolis.

indicates regular usage above ground too. During the 1990s, for example, a campaign of excavation in one area of the city of Cerveteri (the Vigna Parrocchiale site) investigated the debris that had accumulated in a large cistern by around 500 BC. Numerous small fragments of imported Corinthian and Athenian painted pottery, mostly drinking cups, were lodged in the layers of urban spoil. The usage (and breakage) may have happened in a setting broadly styled as 'sacred', not domestic – but, in any case, it was at a distance from the cemetery.

Exactly where and how the Etruscans conducted their ceremonial drinking remains archaeologically obscure. Literary references, along with many tomb-paintings, indicate that women joined their husbands on the couches – a major departure from Greek practice. (We may wonder if the *hetairai* shown drinking on Attic vases were perceived as such in Etruria.) It is likely that some sort of 'funerary banquet' was held in honour of the dead. Yet this concept no longer dominates our interpretation of paintings such as we find in, for example, the 'Tomb of the Lionesses' (Fig. 36). In the last century, it was possible for Massimo Pallottino, the patriarch of Etruscology as a modern academic discipline, to claim of the tomb's central scene that it showed a 'dance for the dead': accordingly, 'the large *crater* in the centre of the frieze obviously represents the cinerary urn' with the ashes of the deceased, and 'the black jar is probably the vessel containing the water for extinguishing the pyre'. Reasonable as this explanation seems in a funerary context, most Etruscan specialists today will prefer to see the vases shown here as serving their sympotic purpose: the krater for mixing wine and water, the *oinochoe* for distributing the mixture.

The fact remains, of course, that the Sarpedon krater was placed in a tomb – and that it shows a hero being transported to *his* tomb. There is also the possibility, as noted (p. 29), that one tomb of the Greppe Sant'Angelo necropolis contained two vases

Fig. 36 Detail of the 'Tomb of the Lionesses' (Tomba delle Leonesse), late sixth century BC. Both krater and oinochoe look to be metallic. The wine-ladle (*simpulum*) hanging to the right of the krater would suggest that the vase contained wine, not ashes. Tarquinia, Monterozzi necropolis.

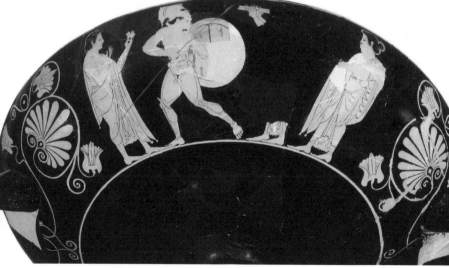

Figs 37 and 38 Detail of a kylix by Euphronios (signed on its foot), *c*.520 BC.
Top: Thanatos and Hypnos – both wingless – lift the body of Sarpedon. The
dejected-looking warrior leading them is labelled Akamas. *Below:* flanked by
onlookers (one male, one female; each holding a flower), an armed youth
moves to the music of the pipes (see p. 132). H 11.5 cm (4.5 in); d. 33 cm (13 in).
Rome, Museo Nazionale di Villa Giulia.

depicting this heroic conveyance – both by Euphronios, albeit at different stages of his painting career. Even to non-expert eyes, 'the Sarpedon kylix' by Euphronios presents a less assured composition (Figs. 37 and 38): there may be ten years between the kylix and the krater. For development of subject and style, the two vases make a valuable pair. But how might they have become a pair? Did their Etruscan patron acquire the kylix first, and the krater some while later? If so, did the krater appeal because it showed the same subject, or because it was signed by the same painter?

Bald statistics have their place. Of vases by Euphronios with a provenance, 50 per cent come from Cerveteri. This could be by chance; or we may suspect a pattern of commerce and taste. To pose questions about taste courts the risk of assimilating the ancient 'market' for Athenian vases to something like the world of modern collectors. We are limited, too, in how far we can reconstruct any awareness of Etruscan 'market demand' among the Athenian potters and painters. Ever since the discovery of abundant Greek vases at Vulci (see p. 46), scholars have endeavoured to make sense of the non-Greek findspot, searching for signs of local preference in shape and style, and analysing traces left by the 'middlemen' – the maritime merchants who called at ports such as Pyrgi. The consensus is that during the sixth century BC there was some awareness, on the part of Greek producers of painted pottery, about what was favoured in Etruria. (A black-figure workshop associated with the name of Nikosthenes provides important evidence.) The archaeology of Mediterranean shipwrecks, however, suggests that cargoes were usually mixed, with merchants (as likely to have been Phoenician as Greek) picking up what was available wherever they called. Decades ago, the proposal was made that many Athenian vases came to Etruria by second-hand trade. Though impossible to prove, this theory has not been dislodged by academic scepticism.

If accepted, it means that the Sarpedon krater would have been used, perhaps just once, at an Athenian symposium – then, having served its ceremonial purpose, was released, or sold on. (Self-evidently, the price it fetched from an Etruscan buyer made the journey worth undertaking: see p. 83.)

Historical instances of 'acculturation' among peer-groups across the Mediterranean tend to support the model favoured here, which allows an Etruscan owner of the Sarpedon krater to recognize its eponymous hero. But it seems to be stretching credibility to imagine that our Etruscan, however Hellenized, even knew who Leagros was, let alone whether he merited the salutation of *kalos*. So what if our Etruscan owner was illiterate, and without any knowledge of the Trojan saga? The scene then becomes one in which the body of a young man, violently killed, is collected by two angels of death. 'Sleep' and 'Death' as represented by Euphronios appear rather gentle of demeanour, when compared to the winged demons that feature in Etruscan iconography – the stern-faced female figure known as Vanth, or her male counterpart Tuchulcha, with his beaked nose, pointy ears and a head bristling with snakes. Yet in a basic way, no special cultural priming or *paideia* is required to give meaning to the Sarpedon image. A mortal body is being carried away by two supernatural beings. It is hard to think of any documented human society in which such an image would be totally incomprehensible.

Without a knowledge of written Greek, however, the identity of the two winged figures might be obscure. Euphronios appears to have been a pioneer in this particular respect: there was no established image for Hypnos and Thanatos in the archaic repertoire, and we sense that the artist himself was unsure how they should be represented. On his kylix (see Fig. 37) they are shown as if fully equipped warriors: Hypnos armed with a sword, and carrying the large circular shield of a hoplite, Thanatos managing to grip with one hand not only a spear, but

also a hefty, old-fashioned sort of shield, perhaps approximating to the Mycenaean 'figure-of-eight' shape. Had Euphronios not added labels, any viewer might well have assumed these figures to be comrades of Sarpedon. We recall that the text of Homer as we know it (see p. 118) makes Apollo the deity who removes Sarpedon's body from the battlefield; Hypnos and Thanatos take over subsequently, to escort the body to Lycia. Homer gives no indication of where they come from or what they look like; he merely notes that they are twins, and that they move fast. The figures devised by Euphronios are similar enough to be taken as twins (note however that hair and eyelashes are rendered contrastingly); and wings were sufficient to indicate speed.

In Hesiod's poetic account of cosmology, usually dated to *c.*700 BC, Hypnos and Thanatos are among the several offspring of Night, and dwell somewhere near the entrance to Hades or the 'Underworld' – a geographical location not specified by either Homer or Hesiod, but profoundly dark.

> 'Never does the bright sun shine upon them with his rays, not
> as he rises in the sky, nor as he makes his descent. Of the pair,
> one roams peacefully across the earth and the broad surface of
> the sea, and is soothing to mankind; as for the other, his heart is
> hard as iron, and his soul like bronze, void of pity. He will not
> release those he has seized; the very immortals detest him.'
> (*Theog.* 758–66).

Again, that Sleep and Death are airborne is only implied by their mobility; otherwise there is little here by way of descriptive detail. Though Sleep can come sweetly, Death is not characterized as malevolent: he simply does what he must, and by definition he will be abhorrent 'to the deathless ones' (*athanatoisi*).

It is always possible that an artist working in some more prominent medium had preceded Euphronios in devising an image for the obscure yet ubiquitous brothers. Certain statues are

Fig. 39 Athenian red-figure kylix dating to 510–500 BC, from Vulci. One
of the two female figures present carries the herald's wand associated with Hermes.
D. 42 cm (16.5 in). London, British Museum 1841.0301.22.

attested, but of undefined date. The celebrated cedarwood Chest of Kypselos, on view at Olympia since the early sixth century BC, and carved by a sculptor who apparently knew Hesiod's verses, showed Sleep and Death as nurslings of Night: one asleep, the other showing resemblance of form, but dark in complexion (Paus. 5.18.1: interestingly, Pausanias says that he would have recognized them even without inscriptions). But this image of the abstractions as infants cannot have guided Euphronios. He may well then have been the first artist to show the mature Hypnos and Thanatos in action – and that counts as a considerable achievement. It is not very clear to *us* how the 'personified' Sleep and Death relate either to mythology or to religious practice in archaic Greece: perhaps it was never very clear. So, we are left with the evidence from Athenian vases: which indicates that the prototype created by Euphronios gave a lead to his contemporaries and successors.

A kylix attributed by Beazley to 'the Nikosthenes Painter' may be the earliest act of homage – indeed, Beazley thought that this painter, inclined to be careless, must here have studied from a superior draughtsman, while other scholars have wondered if

Fig. 40 Drawing (reconstruction) of a red-figure calyx-krater attributed to the Eucharides Painter, 500–490 BC. Traces of the inscribed name 'Sarpedon' have been noted since the vase was cleaned and 'de-restored'. The scene may be one of deposition, i.e. of Sarpedon's body in Lycia. Paris, Louvre G 163.

Euphronios himself assisted here (Fig. 39). The scene of a senior warrior being lifted by winged and armed youths is not labelled, so we cannot be sure that Sarpedon is the intended hero. It could be Memnon (see p. 167). However, Sleep and Death are surely the figures doing the lifting.

Confirmation that Sleep and Death may be youthful comes on a calyx-krater in the Louvre, where one is clearly inscribed (Fig. 40). It seems, however, that their age was not determined; nor were their wings essential. What matters is their psychopompic role, as made evident by further elaborations of the motif. The draped body they are carrying on another calyx-krater (Fig. 41) may not be that of Sarpedon – an inviting case has been made

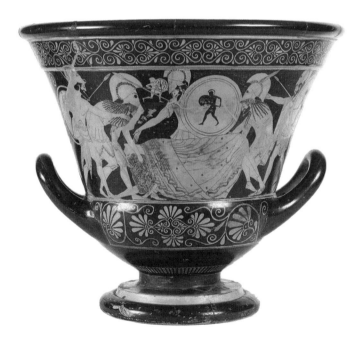

Fig. 41 Red-figure calyx-krater from the Pezzino necropolis, Agrigento, c.500 BC. Placed (by Beazley) among the Pioneers ('Pezzino Group'). On the reverse, a *komos* scene. H 43 cm (17 in). Agrigento, Museo Regionale C 1956.

that here we should rather see the transport of Patroclus, with an anguished Achilles present – but what is most fascinating in this scene is the minuscule figure shown armed and in a running posture. It is interpreted as the *eidôlon* of the deceased: his 'phantom', or 'spirit-image'. How artists convey metaphysics is always fascinating; but of course we cannot know the intentions of this anonymous painter (who, again, is very close in style to Euphronios). What can be shown, however, is that the visual strategy of conjuring a supernatural concept – the close kinship of Sleep and Death, which would be famously evoked by Socrates (Plato *Ap*. 40d) – added to the funerary application, or suitability, of the Sleep and Death image. So, the image of an epic moment developed as part of the classical 'iconography of death'.

The generally indifferent quality of Athenian black-figure vase-painting by the end of the sixth century has been noted (p. 68). But the output of mediocre artists can be a useful source for observing the development of visual clichés. Two small amphorae attributed to the same hand indicate the sort of routine reproduction we associate with clichés (one is shown in Fig. 42). Both are taken to show the transport of Sarpedon: on neither vase, however, do the inscriptions make any sense – which may reflect the painter's haste, or cynicism (if he knew his work was going direct to a foreign market). In any case, we see how the motif derived from Euphronios is becoming schematized, and confirmation of its quintessential decorum and utility as a funerary image comes soon enough – within the iconography of a particular shape and style of Athenian vase produced in the fifth century BC, the 'white-ground lekythos'.

Athenians were never buried like Etruscans, in tombs resembling homes. Periodically, authorities at Athens imposed legal restrictions upon funeral expenditure. But local mortuary customs never prohibited the deposition of certain objects with the deceased. Among those objects were oil-flasks, or lekythoi.

Fig. 42 Black-figure amphora attributed to the Diosphos Painter, *c*.480 BC: Hypnos and Thanatos carry the body of Sarpedon (?), whose *eidôlon* ('spirit-image') is shown in a running pose. A similar piece is in Paris (Louvre F388). H. 18.4 cm (7.2 in). New York, Metropolitan Museum 56.171.25.

Generically these vases were of various size and appearance, and indeed utility; their association with funerals came from the practice of embalming a corpse prior to cremation or interment, and also of offering oil and unguents to the dead – a sort of moisturizer for the soul. A quantity of such liquid was poured where burial took place; the vessel (which did not always contain as much as it might seem to) would then be left at the grave, or in a small trench nearby. Why the production of white-ground lekythoi belongs to a limited period at Athens, *c.*470–400 BC, is debatable: it may have something to do with the tension between private and public burial within the norms of Athenian democracy. What is clear, however, is that the imagery upon the lekythoi has a dedicated purpose: to assist in the process of

Fig. 43 Drawing of an Athenian white-ground lekythos, *c.*470–460 BC: Thanatos (bearded) and Hypnos bring a youth to the grave (decorated with garlands). The acclamation 'KALOS' runs vertically and horizontally. H of actual vase 26 cm (10.2 in). Athens, National Museum 17294.

bereavement, and give some graphic definition to the mysteries of mortality.

The technique of painting upon pottery covered with a chalky white or cream slip was not a fifth-century innovation (see p. 68). But it proved especially appropriate for funerary lekythoi, which did not need a durable finish. Figures drawn in outline, and elaborated with a coloured wash, appear somewhat spectral – an effect compounded by the tendency for the paintwork to flake off or fade over time. Some lekythoi show scenes of domestic activity, as if to say that 'life goes on'; others depict family members, especially the females, in attendance at the grave (conventionally signalled by a carved pillar or *stêlê*); on others, meanwhile, painters attempt to choreograph 'the spirit world'. This may include Charon, gloomy gondolier of the Underworld, as well as Hermes, in his 'psychopompic' role. But a significant function is reserved for the figures of Hypnos and Thanatos. Some sixteen of the known Attic white-ground lekythoi evidently feature the pair, with the seniority or more 'serious' status of Thanatos signalled by his beard. The brothers are not armed – their epic glory is over – but they sometimes gain an extra set of wings, attached to their heels or sandals. The wraith-corpses they carry do not seem like great burdens: of adults or children alike, the load looks light, to be set down by the grave tenderly (Figs. 43 and 44).

These vases may not count as 'mass-produced' – but there is a certain formulaic aspect to their imagery. And that, for the purposes of the present study, is good news. For it implies that the motif of Sleep and Death lifting a dead body – the motif created by Euphronios *c*.515–510 BC – has become 'stock' within the fifth-century iconographic repertoire. White-ground lekythoi may look small next to certain monuments contemporary with them, such as the Parthenon. But these vases join the Parthenon in stating what came to be regarded as the canons of classical form and style – thereafter a point of reference for artists throughout

the Graeco-Roman world, and revived as such in the Renaissance. The basic composition – one prone horizontal figure, two vertical figures lifting it – was easily recognized, yet adaptable. Its precise cultural associations varied – but a basic significance endured, and that was cross-cultural. Human beings, uniquely among the world's species, like to bury their dead. The Greeks may have been particularly obsessed with this idea (the story of Antigone, who risks her own life by seeking to perform last rites over the body of her shamed brother Polynikes, is indicative); however, concern for the formal deposition of a corpse is universal. The Sarpedon krater provided a motif germane to this concern – the bringing home, the laying to rest, of a fellow mortal. As such, its consolatory power was valid, and valued, for ages ever after.

Fig. 44 White-ground lekythos attributed to the Thanatos Painter, from a grave in the Ampelokipoi district of Athens, c.440–430 BC. That this represents a war casualty is suggested by the armour on the deceased, and a helmet placed (or carved) on his tomb. H 49 cm (19.3 in). London, British Museum D 58 (1876.0328.1).

The Afterlife of an Image (I)

Sarpedon and the Motif of 'the Beautiful Corpse' in Antiquity

Helios, the Sun-god, lost his son Phaethon. Hermes lost his child (the charioteer Myrtilos). Thetis could not save Achilles. Zeus mourned Sarpedon. And the Egyptian Zeus, Zeus Amun, saw that his offspring was mortal – the young man known to posterity as 'Alexander the Great'.

This list of divine parents affected by bereavement comes in a poetic epitaph inscribed upon a tombstone from Alexandria, in the early first century AD. Like many epitaphs from the Graeco-Roman world, the verses commemorate the 'virtue' (*arête*) of the deceased. They also specify that 'he quitted the sweet light of the sun before the full span of his years was complete'. In other words, it is a memorial of a premature death.

'Did not the lord of men and gods shed tears, did he not moan for Sarpedon?' Our anonymous poem invokes Sarpedon as exemplary of a cosmic rule: that even divine ancestry cannot divert the *Moirai*, the 'death-fates'. So much was made clear by Homer. Logically, the immortal parent of a mortal offspring must eventually experience the loss of that child. But this inscribed grave adds a further exemplary aspect. By linking his name with Phaethon, Myrtilos, Achilles and Alexander, the epitaph reckons Sarpedon as an archetype of particularly unfortunate transience. He was beautiful and brave – and too young to die.

'Untimely death': the concept was recognized as a phrase in both Greek (*thanatos aôros*) and Latin (*mors immatura*). Its representation in art and myth is part of the continuity we address in this chapter, as chronological boundaries move from 'classical' to 'Hellenistic' and then 'Roman'. By way of preamble, however, it seems obligatory to give some estimate of what would count as 'untimely' in classical antiquity. Life expectancy rates were of course generally much lower than those of today; but in principle it was nonetheless possible to reach a grand age – Sophocles, for example, was active as a playwright up to his death at about ninety years old. Early in the sixth century BC, verses

from the Athenian statesman-poet Solon divided human life into ten units of seven years, so reckoning a death at seventy as *ouk an aôros*, 'not premature': equivalent, then, to A. E. Housman's definition of due lifespan as 'threescore years and ten'. Yet, as countless ancient epitaphs confirm, the pangs of mortality were felt not so much in terms of actual age, but rather as relative experience. The worst thing that could befall any parent was to bury an adult or adolescent offspring.

'But Ares ever loves to pluck the fairest flower from an armed host'. That sentiment is a rare surviving line from the lost tragedy by Aeschylus that dramatized Sarpedon's story (Fr. 51). It adds a crucial element to the iconographic chain we have seen extending from sympotic vases to funerary lekythoi. As noted (p. 121), Euphronios may consciously have 'rejuvenated' Sarpedon, for the hero's 'final journey' to the tomb – the Lycian prince to be venerated like a *kouros*, as if in his physical prime or *akmê*. Aeschylus, it seems, put theatrical focus upon the death of Sarpedon as a family loss. A further fragment from the play relays impassioned lines from Europa, Sarpedon's mother, pleading with Zeus to save their son (Fr. 50). This is supported by a South Italian vase that very probably alludes to the staging of the same play (Figs. 45 and 46). On one side of the vase, we see a female figure in elaborate 'Oriental'-style robes addressing an enthroned couple. By their poses, and from surrounding props, this couple is taken to be Zeus and Hera. A winged figure distracts Hera: it could be Hypnos, who loves Hera's daughter Pasithea (see *Il.* 14.231ff.; Pasithea is perhaps the figure in the background here). The other side must refer to a subsequent scene. Europa's maternal concern is fulfilled: back in her own palace, she looks up to see the figures of Hypnos and Thanatos descending with Sarpedon's body. The hero's children may be among those who also witness the event, which would have been theatrically possible using something like the deus ex machina contraption.

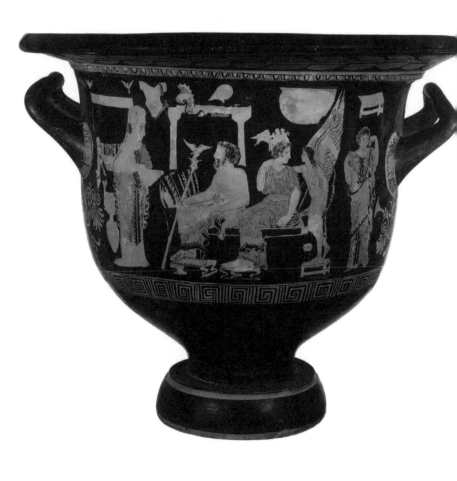

Fig. 45 Apulian red-figure bell-krater, attributed to the Sarpedon Painter, c.400–380 BC. Europa (left), fearing that her son may be killed and abandoned at Troy, implores Zeus and Hera. H 49.9 cm (19.7 in). New York, Metropolitan Museum 16.140.

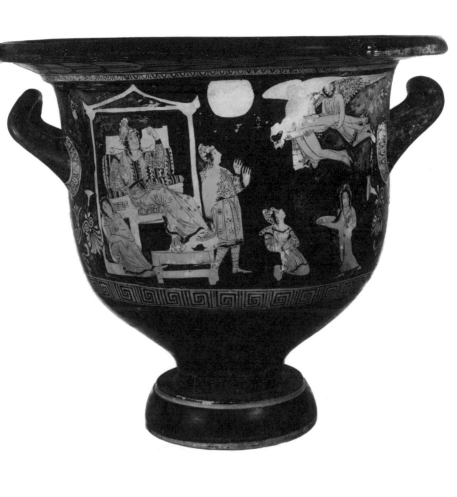

Fig. 46 Reverse of the same vase. The central male figure may be one of Sarpedon's brothers (in the Hesiod–Aeschylus story, these were Minos and Rhadamanthus).

Fig. 47 Athenian red-figure mug, *c.*425 BC. The assembled fragments appear to show a warrior being lifted up or set down by Hypnos and Thanatos; robed figures occupy the rest of the vase. H 30 cm (11.8 in). Port Sunlight, Lady Lever Art Gallery 5060.

A fragmentary Athenian drinking-mug of the late fifth century BC may also owe its imagery to this dramatic tradition (Fig. 47). 'Sarpedon brought home' is here manifest by a pair of winged and bearded figures descending with the hero's body to an assembly of 'Lycian elders', one of them perhaps Sarpedon's mother in a dark *himation* of mourning. Aeschylus' *Europa/Carians* evidently opened with a speech from Sarpedon's mother, full of fatalistic concern for her son at Troy; very likely the climactic scene was the aerial arrival of the body. Again, a tenuous little figure in added white appears as Sarpedon's spirit-representative – the *eidôlon* that must hover until a tomb (its 'home') is found for the body.

Homer did not elaborate on the particular anguish of parental loss for any casualty on the Trojan plain – except that of Zeus for Sarpedon, and Priam for Hector. Whether the *Aithiopis*, as a 'sequel', showed more concern in this respect we cannot say (too few fragments of the epic remain); we understand, however, that it recounted the fate of another foreign ally at Troy, the Ethiopian hero Memnon. Memnon was the son of a divine mother, Eos, the goddess of Dawn; his father Tithonos, a brother of Priam, had been made immortal too – but alas, not also unsusceptible to ageing (so he gradually shrivelled, and had to be shut away). Memnon caused parental grief when he killed Antilochus, Nestor's son. Then Memnon in turn fell to Achilles, and the lament from his mother was tremendous – to judge by several visual evocations. One black-figure vase, in the Vatican, depicts a female figure standing over a warrior's stripped and lifeless body, tugging at her hair; while a red-figure cup by Douris, clearly labelled, shows a winged Eos retrieving her son (Fig. 48).

The fates of Memnon and Sarpedon were sometimes 'twinned' in antiquity: on the painted walls of the Meeting-Room (*Leschê*) of the Cnidians at Delphi, the two were placed together in a scene of the Underworld (Paus. 10.31.2), and Aristophanes made the pair a joint occasion of divine mourning (*Nub.* 622).

A fragment of a krater attributed to Euphronios (in New York) indicates that the artist may also have attempted the scene of Eos with Memnon: as Bothmer remarked, 'we would give a lot to have more of a Memnon krater by Euphronios'. We would be glad, too, to know how Aeschylus dramatized the Memnon story and beyond, in a trilogy of which the first instalment was reportedly entitled *Memnôn*, and the second *Psychostasia* ('Weighing of Souls'); a third probably dealt with the death of Achilles. It is conceivable that Eos was matched in some kind of debate with Thetis, as both mothers lobbied Zeus to show favour for their son – though neither, alas, can be successful.

Aeschylus presented his plays originally to an Athenian audience. Within a century, however, his works had become 'classics' of the repertoire, and as such were performed throughout the colonies of Magna Grecia – the 'Great Greece' of southern Italy and Sicily. Eventually such plays would be translated into Latin, facilitating mythographical traffic between Greece and Rome. So, Homer's epic was not the only conduit for the Sarpedon narrative as it 'migrated' westwards; and nor were South Italian vases the sole medium of visual transmission. A play is portable, and a troupe of players could travel – but the lack of 'mass media' in the ancient world does not mean that images were much less mobile by comparison. There is abundant evidence to prove that artists were peripatetic around the Mediterranean, particularly artists trained in Greek workshops. The 'diffusion of classical style' beyond Greece is not some fantasy of modern scholars. This is why it is legitimate to register visual 'echoes' of the Sarpedon motif across considerable distances of space and time, and in various forms. Sometimes it appears that the motif does indeed denote the story of Sarpedon – but not necessarily. Part of the power we sense in the prototype as presented by Euphronios is that while there are labels identifying a particular epic occasion, this image is potentially universal. Its adoption by the painters

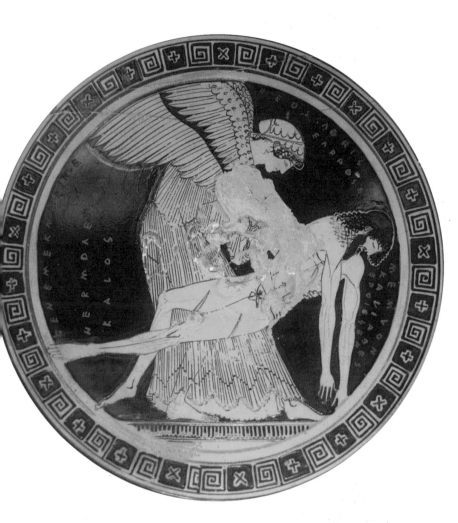

Fig. 48 Eos with the body of Memnon: interior of a kylix by Douris, from Capua, c.490–480 BC. Paris, Louvre G 115.

of Athenian white-ground lekythoi has already demonstrated that potential: over succeeding centuries the image goes 'from strength to strength'. It has, in today's jargon, transferable skills.

Before we turn to other media, it is instructive to observe that transferable quality as evident in South Italian vase-painting. A large volute-krater of the mid-fourth century BC shows what happened to the body of Hector after the vengeful fury of Achilles was subsiding. King Priam, according to Homer (*Il.* 24.229ff.) collected a generous ransom, including ten talents of gold, and approached Achilles directly to persuade him to release the body. The episode was elaborated by a number of Greek playwrights, beginning with Aeschylus; the Latin dramatist Ennius also produced a script. What we see on the vase may be indebted to one of these plays – but it surely also owes something to the Sarpedon motif (Fig. 49). The two figures carrying Hector are not labelled. There is no sign that they are Hypnos and Thanatos – and yet it is hard to resist the suspicion that the artist has seen something like the motif of Hypnos and Thanatos with a corpse. (A completely naked body is unlikely to have been exhibited on the stage.)

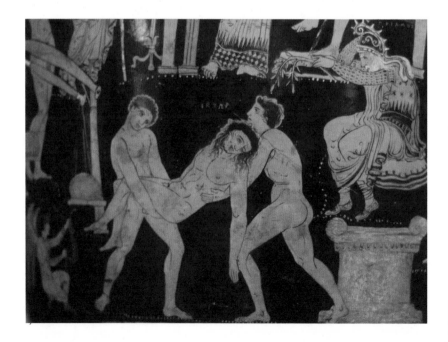

Homer's narrative provides the logic that would underpin the iconographical transfer here. When Priam – at some risk to his personal safety, though he will have certain divine assistance – beseeches Achilles for Hector's remains, a significant part of the largely benign response from Achilles is based upon paradigmatic likeness. That is, Achilles calls to mind his own father, Peleus – with 'only a single son doomed to untimely death'. Achilles then attempts to comfort Priam by citing the precedent of Niobe, who lost all twelve of her children to slaughter (and by a contorted twist of 'paradigmatic extension', Achilles claims that Niobe consequently did not lose her appetite, and therefore that Priam should stay for supper). So, we see how the example of Sarpedon is thematically related to Hector's fate. Priam is in the same position as Zeus: powerless to save his son's life, but acutely concerned to retrieve the body and ensure a proper burial.

The essential simplicity of 'the Sarpedon theme' as epitomized by Euphronios could only favour its diffuse application. Two uprights with a horizontal bar: the formal reduction of the scheme makes it almost inevitable that it served various imaginative applications. A nice example occurs within a series of bronze containers of a type known by the Latin term *cista*, and traditionally associated with the Latin site of Praeneste (Palestrina). These *cistae* have been recovered from tombs; what they contained appears to have been small items precious to the deceased. The sheet bronze forming the cylinder would generally be given incised decoration, often mythological scenes (and often with Etruscan inscriptions), while the lid was supplied with a solid bronze handle formed of some figurative motif. The shapes can be ingenious (e.g. an acrobat caught in a backflip), but also sombre, as if befitting the funerary purpose. So the motif of a rigid (dead) body raised by two bearers became a useful accessory (Fig. 50).

Fig. 49 Detail of an Apulian red-figure volute-krater, attributed to the 'Circle of the Lycurgus Painter', from Ruvo, *c.*350 BC. Priam gestures from his throne, and a set of scales is also visible (by one version of the story, Hector was worth his weight in gold). St Petersburg, Hermitage 1718 (St. 422).

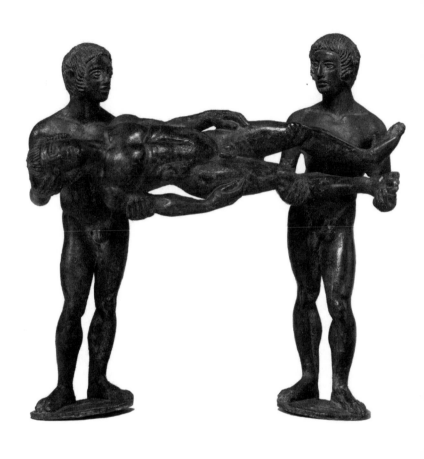

Fig. 50 Handle of a bronze *cista* from Praeneste (Palestrina), fourth century BC. H 13.3 cm (5.25 in). New York Metropolitan Museum 13.227.7.

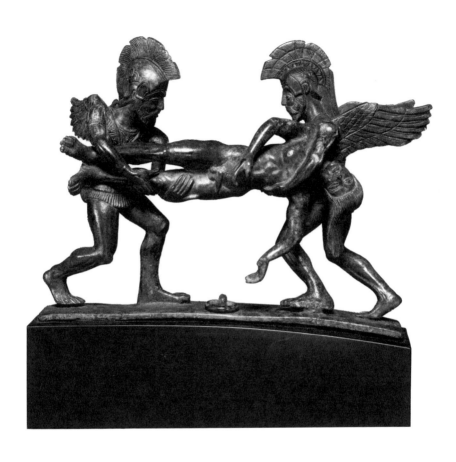

Fig. 51 Bronze *cista*-handle, 400–375 BC. H (without base) 14 cm (5.5 in).
Cleveland Museum of Art, J. H. Wade Fund, 1945.13 (ex-Castellani collection).

This deployment of the motif occurs on over half a dozen of surviving *cistae* but is never identically similar. The figures lifting the body may be winged, and female – in which case reckoned as 'Etruscan death demons'; on one example (in the Villa Giulia) the group appears to represent two female warriors or Amazons, raising the naked body of one of their number. Is Memnon sometimes intended? Quite possibly – though it may be safer to conclude, with Beazley, that here we have 'a decorative type without any mythical significance'. On one example, however, the case for recognizing Sleep and Death with the body of Sarpedon seems strong (Fig. 51). One could believe that whoever made this little group had seen something like the Sarpedon krater: two winged figures in hoplite armour, with bent knees; their charge a muscular youth, his long hair hanging down.

It is testament to the potency of the motif that it retains essential significance even when subject to variations of detail – and when reduced to a miniature scale. An Etruscan scarab of the early fifth century BC exhibits both qualities (Fig. 52). It may seem strange to us that an item of personal adornment should be invested with an epic theme. But many Greek and Etruscan finger-rings are engraved with heroic vignettes. They served rather like heraldic devices – especially when used as sealstones – and as such, may express heroic aspirations and aristocratic values on the part of those who wore them. Portable, small-scale objects naturally assist in the broadcast of a motif. Within that size category belong those carved reliefs famous for conveying the great theme of the Trojan saga 'in a nutshell' (Figs. 53 and 54).

There are over twenty surviving pieces of such 'Iliac tablets'. Once they were regarded by classical scholars as somewhat banal epitomes of the several epics relating to Troy, i.e. the *Iliad*, *Aithiopis*, 'Little Iliad' and *Ilioupersis*, concocted as a sort of ready-reference for Romans with intellectual pretensions yet no time (or inclination) to study the texts. But it has been persuasively

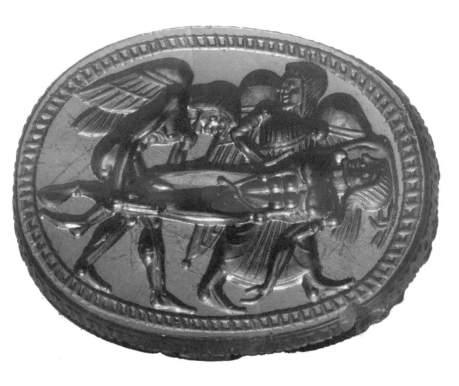

Fig. 52 Carved sardonyx, *c.*500 BC. Body of a warrior carried by two winged figures, male and female. Length 16 millimetres (0.6 in). Boston, Museum of Fine Arts 21.1200 (ex-Tyskiewicz/Lewes House collections).

Fig. 53 Tabula Iliaca Capitolina: marble relief of the late first century BC. H 42 cm (16.5 in). Rome, Capitoline Museums 316.

Fig. 54 Detail of the Tabula Iliaca (section omega). The legend (from left to right) identifies Hector; '*kai lutra Hektoros*' ('and the ransom of Hector') – evoking the title of *Iliad* 24 (omega); then Hermes, Priam and Achilles.

argued that whoever owned these productions (where ascribed, their makers are evidently Greek) must have cultivated a subtle and flexible comprehension of the Trojan saga-cycle. The details of the reliefs are not as clear as once they were: in section 'omega' of the Capitoline tablet we see that a body (which must be that of Hector) is being carried – but whether by three figures (as a nineteenth-century drawing suggests) or by two figures with a third (old Priam?) holding the hand of the corpse (as later imagery suggests) we cannot now determine. Juxtaposed is a scene of a waggon, loaded with the gifts brought by Priam as ransom for his son; and then Priam, who has been guided by Hermes (see *Il.* 24.457), begging for mercy in the tent of Achilles (see Fig. 54).

Conceptually there is no problem about reading right to left here – should we be wondering about the sequence of events. And if we let our eyes wander further down the registers, we cannot help but notice the corpse-carrying motif recurring in section 'rho'. Is it mere coincidence that here it represents the dead Patroclus? Or does the visual repetition propose (in the words of Michael Squire) 'a semantic relationship' between the deaths of Hector and Patroclus? And could both representations owe their form to a semantically related original – the rescue of the body of Sarpedon?

One factor aiding the recognition of the motif is the so-called '*braccio della morte*' – literally, the 'arm of death': the limb hanging down as signifier of loss of consciousness. The Italian phrase is ambivalent – it can mean the 'death row' of a prison; but whether or not the phenomenon has physiological validity, it served artists for centuries after Euphronios. And not only artists – as

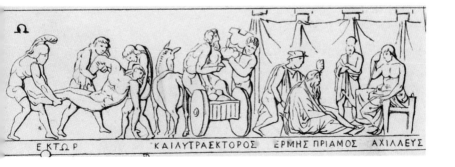

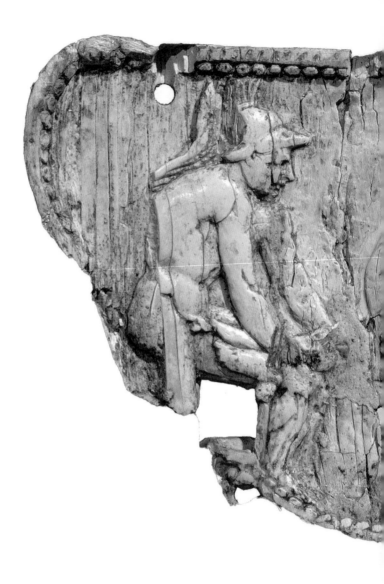

Fig. 55 Ivory relief, mid-first century BC, from Pompeii (Regio I.2.5). The other side of the piece – of uncertain function – shows a wounded figure (Adonis?) being tended. H 7.6 cm (3 in). Naples, Museo Archeologico Nazionale 109905.

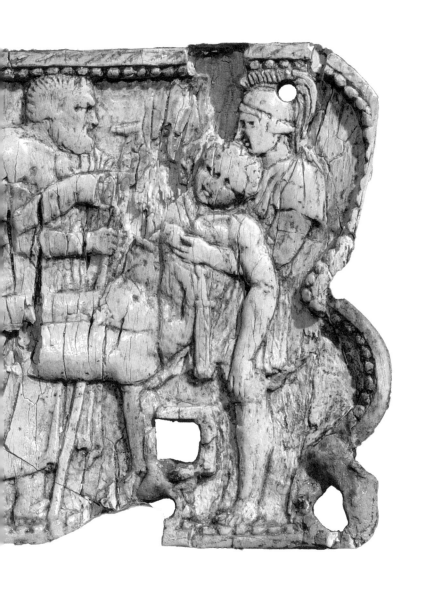

confirmed by what might seem an unlikely source, a descriptive detail in Suetonius' '*Life*' of Julius Caesar. Though composed about a century after Caesar's death (in 44 BC), this conveys a sense of eye-witness accuracy (and was probably based upon late Republican sources). In that regard, we see that when Suetonius comes to the story of the dictator's assassination, he specifies that in the immediate aftermath of the multiple stabbing, not only did all the conspirators flee the scene, but none of Caesar's family or friends came near: it was therefore left to three slaves to retrieve the body, and carry it home on a litter, *dependente brachio* – 'with one arm dangling down' (*Div. Iul.* 82). Why does Suetonius include that observation? Could it be that he wishes to evoke, in his readers' minds, the stereotypical 'classic' image of the fallen hero borne home? Whether conscious or not, that purpose would not be out of place: after all, Caesar's extremely violent end is an

Fig. 56 Detail of a fragment of a marble relief with a scene of funerary portage, early first century AD. Probably from a villa in the *ager Tusculanus*. A matching portion is conserved in the Galleria Colonna, Rome. H 93 cm (36.6 in). Grottaferrata, Abbazia di Santa Maria, inv. 1155.

essential stage of his heroicization. Within days, the Senate would vote that Julius Caesar be added as a god to the Roman pantheon.

The visual foundation for making that suggestion is not hard to find. Again, we are struck by the variety of media in which the same (or very similar) motif is deployed. Thus, by way of examples: a small curved plaquette, in ivory relief (Fig. 55); a large marble panel (Fig. 56); and a terracotta lamp (Fig. 57).

These images share certain features – for example, the elderly figure in the background, accompanying the body; but that is not to say their subject(s) should be the same. The Grottaferrata relief may represent the death of Meleager, who in one storyline dies in battle; given the prominence of the shield and helmet on this piece, a case has also been made for Achilles (whose armour will be contested as a possession by Ajax and Odysseus – another source of Trojan tragedy). For the little plaque from

Fig. 57 Antiquarian drawing of a Roman lamp (now lost). Simply titled (by G. P. Bellori) *'Soldato morto in guerra'* ('Dead Warrior'). First century BC?

Pompeii, Adonis has been proposed – though it is not clear why Adonis, a hunter, should be carried by bearers in military garb. All these suggestions, however, have something in common with Sarpedon. They are cases of premature death: and as such, they prime us for the most extensive 'recycling' or 'reworking' of the Sarpedon motif in Graeco-Roman art, which occurs in Roman sarcophagi of the imperial period.

The virtual poet laureate of Rome was Vergil. In two separate poems, Vergil imagines what it would be like to go down into the Underworld and see the multitudes of spirits there. These spirits are as multitudinous as autumn leaves. But of them all, a special category is singled out for pity: 'great-hearted heroes, boys and unwedded girls, young ones laid on the funeral pyre before their parents' gaze' (*Aen.* 6.305–12; see also *G.* 4.475ff.). For all that *mors immatura* may have been commonplace in the ancient world, its poignancy was nevertheless terrible. We should not be surprised, then, by the fact that so many of the figured sarcophagi produced for the Romans seem to focus, thematically, upon mythological instances of a premature end. The imagery of the sarcophagi may require some lateral thinking on the viewer's part: for instance, a scene of young Achilles dressed as a girl in the court of King Lycomedes, on the island of Skyros, will have to be related to the motives of his mother Thetis, who placed Achilles there (she did so in the hope that her son, doomed to die at Troy, might somehow avoid recruitment to the Greek forces). An evocation of the fall of Icarus might initially seem to be a lesson about filial (dis)obedience, not premature death; and when we see the story of Medea relayed, concern about her children, and the fate of Jason's new young wife Creusa, may not be uppermost in the viewer's mind. Other scenes, however, obviously serve as consolations in the same way as the Alexandrian poetic epitaph with which this chapter began – i.e. even heroes, and those whom the gods adore, can die young.

Over 200 surviving sarcophagi or sarcophagus-pieces feature the hero Meleager, making his story the single most favoured choice as a mythological subject for the genre. Quite why it became so favoured is open to speculation: it may have something to do with the way in which Ovid, in the early first century AD, managed to weave Meleager into the epic hexameters of his *Metamorphoses*. But like many Greek myths, the tale of Meleager has variants, which may be important when it comes to understanding the iconography. In Homer (*Il.* 9.529ff.), Meleager is a champion warrior who, like Achilles, takes umbrage and turns 'passive aggressive'; his fame, however, lies chiefly in despatching an enormous wild boar that was ravaging his father's kingdom of Calydon, in Aetolia. The best-known version of this tale, probably based upon a lost play by Euripides, is that told by Ovid (*Met.* 8.267–546): Meleager, having killed the boar, and feasted upon it with his fellow-hunters, offers its hide as a gift to his new girlfriend, the swift-footed Atalanta, who was first to spear the beast. His mother's brothers, part of the expedition, are outraged by this gesture. In the acrimony that ensues, Meleager kills both of his uncles. The news of their deaths is reported to his mother, Althaea. She has a secret: when Meleager was born, the Moirai appeared and told her that her son's life should last as long as a certain log in the hearth. Then Althaea had snatched up the log, and kept it intact. Now she is furious with her offspring. Ovid enjoys the fatal dilemma of mother and sister before relating how the log is thrown to the flames – and as it burns, Meleager, still out in the countryside with his team, mysteriously weakens and dies.

Alta iacet Calydon: 'high Calydon was laid low'. Not if his poetic powers were multiplied a hundred times, claims Ovid, could he convey the extent of widespread mourning for Meleager. Althaea commits suicide; family and friends are prostrated; and several of his sisters cry so piteously and continuously that they are

overleaf Fig. 58 Roman marble sarcophagus, showing the hunting of the Calydonian boar, and death of Meleager (upper left corner), AD 170–180. 1.24 × 2.47 × 1.10 metres (4' 1" × 8' 1" × 3' 7"). Rome, Palazzo Doria Pamphilj.

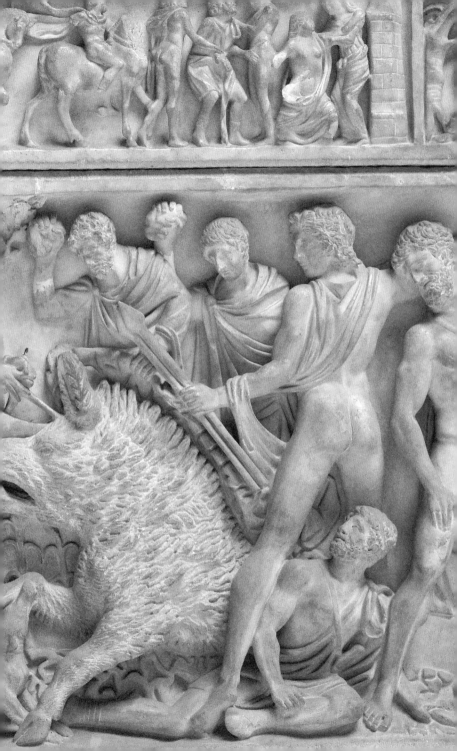

transformed into guinea-fowl. Possibly it was this superlative of grief that made the subject eminently suitable for the decoration of a sarcophagus. While the myth is fantastic, it offers (to borrow the terminology of Paul Zanker) 'bridges' for the viewer to connect with Roman funerary custom: so, for example, the boar-hunters' feast may resemble or reflect the al fresco funerary meal (*silicernium*) that families took by way of honouring the ancestral dead. And sculptors rose to the challenge implicitly issued by Ovid. How could a work of art encompass the magnitude of Meleager's loss? A number of sarcophagi show the youthful corpse laid out on a bier, with family members and domestic staff in assorted postures of distress. But a greater number display the carrying home of the body, in a sort of cortège or *thiasos*. Participants may include the Dioscuri (with their horses) and other hunters, Meleager's father King Oeneus, his sisters and his aged pedagogue, as well as his beloved Atalanta. If warriors are shown, or a war-chariot, these may reflect the Homeric version of the story – or indicate Meleager's concern (mentioned by Ovid: *Met.* 8.515–25) that his death is not gloriously located on the battlefield. Above all, however, the viewer's attention is drawn to the hero's body. Usually it is stripped, so distinct from all the armed or robed figures around (their robes furnishing strong diagonals of emotional turbulence); often it is also conspicuously oversized. According to the narrative, Meleager dies slowly, as the firebrand of his lifespan gradually burns. On the sarcophagus-reliefs, the primary sign that he has expired will of course be the '*braccio della morte*' – the inert arm hanging vertically.

A 'classic' example of the type – a sarcophagus that has been known since Renaissance times (see p. 203) – may be found at the Palazzo Doria Pamphilj, in Rome's historic centre, on display with diverse antiquities, and pictures by Caravaggio and other 'old masters' (Fig. 58). The principal scene shows the boar hunt which led to Meleager's tragedy; and on another side of the sarcophagus

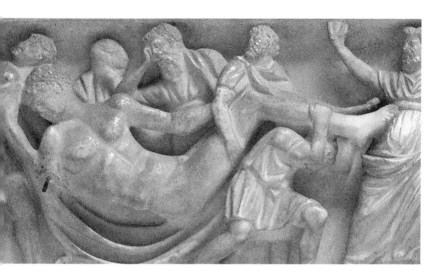

we find the huntress Atalanta, sitting on a rock, clasping one hand to her face in an unmistakable attitude of horrified loss. The death has happened within the decorative time-frame established by the sarcophagus as a whole: and so the viewer's gaze will locate the corpse of young Meleager, within a funerary procession arranged along a frieze on the front of the lid (Fig. 59). Details of carving have eroded over time – but erosion only heightens the salient features of composition. Meleager here is distinctly oversized in relation to those involved in transporting his body. A swag of drapery beneath his form may indicate a rudimentary sort of stretcher, but otherwise the three figures carrying the hero are patently struggling. One turns his head as if to call for extra hands. Another holds an awkward purchase upon Meleager's thigh. Forward direction is devolved to a figure who appears to have placed Meleager's legs over his shoulders, and is lurching along with both knees at a sharp angle.

This sarcophagus was – presumably – found in Rome. Once

Fig. 59 Detail of the sarcophagus-cover. H of lid 30 cm (11.8 in).
Rome, Palazzo Doria Pamphilj.

Fig. 60 Detail of a Roman marble sarcophagus, showing infants conducting a mock-heroic funeral scene, c.AD 160. H of entire piece 40 cm (15.7 in). Basel, Antikensammlung 434 (Züst).

– probably – it belonged to the funerary precincts of a Roman family, where it would have been on view to family members paying regular visits to honour their ancestors – the *maiores*, or 'greater ones'. We call it a 'Roman' sarcophagus. However, it was very likely made by Greek sculptors; and production of sarcophagi was manifestly a trans-Mediterranean process, with important sources of marble, and sculptural workshops, at sites in Roman Asia Minor, such as Tralles and Aphrodisias. Finishing touches may have been added once a sarcophagus reached the capital. Yet again, we are reminded of the traffic of myths and motifs in antiquity: the process of transit, across both space and time, whereby an image devised at Athens in the late sixth century BC is essentially still 'at large' during the Antonine apogee of the Roman empire.

A signal of how 'classic' the motif had now become is given by a sarcophagus reserved for a child's death. (As such, there is no doubting that it marks *mors immatura*.) It plays – and 'play' seems the appropriate verb here – a visual variation on the theme (Fig. 60). No adults are present. Instead, a troupe of cherubs, or *putti*, enact, as seriously as they can, the tableau of the hero borne home – complete with *braccio della morte*.

The Afterlife of
an Image (II)

Heroic Transfiguration:
The Pagan Prototype in Christian Service

When Theseus descended into the labyrinth, Ariadne gave him a clue. A clue, in its original sense – sometimes spelled as *clew* – was a ball of thread or yarn. So long as Theseus, on his mission to kill the Minotaur, used the clue supplied by Ariadne, he would be able to retrace a pathway through the maze by following its thread. We have reached the point in our journey with the Sarpedon krater where reliance upon a clue, or several clues, becomes essential for progress.

It is a truism that in a world full of images, one image is usually begotten by another; or, if not directly generated from the existing stock of images, then somehow indebted to that stock, whether consciously or not. We 'take a picture': but anyone who looks at the world through the lens of a camera is already primed by sensory experience of what *makes* a picture. This process of visual habituation is almost inevitable: only a most rigorous upbringing of solitary confinement, or some concerted programme of memory erasure, would allow a photographer or an artist to see the world truly 'afresh'.

So far as we know, humans began making symbolic representations in two and three dimensions something like 40,000 years ago. The history of art is therefore relatively recent, if compared to geology; nonetheless what rises from the lower reaches of time can seem overwhelming in its quantity. Faced with the proliferation of images over hundreds, then thousands of years, how can we know when one image gives birth, or shape, to another? In seeking a 'genealogical' trail for this image or that, which way should we turn?

Fortunately, there are methods in place. The establishment of methods goes some way to justify the academic study of 'art history' as a discipline; how far we want to classify these methods as 'scientific' is debatable – but it may be significant that a favoured analogy for reconstructing the afterlife of a particular image comes from the practice of *investigation*. Again, the literal

meaning of the word should be invoked. 'Vestiges' are footprints: signs that some creature passed across the earth's surface. Such tracks may include the actual marks left by feet and paws, but also other give-aways – broken twigs, or a patch of flattened grass. If recognizing these traces is an old human skill that most of us do not practise, then perhaps we will prefer to think of its modernized instance, and consider the metaphor of criminal investigation. The telling details ('clues') that lead the officers of justice from the scene of a crime to the perpetrator(s) of that crime can be similarly delicate – and easily overlooked.

It has been remarked that J. D. Beazley, on his lifelong mission to attribute Greek painted vases to the individuals who painted them, was basically motivated by the question of '*whodunnit?*' – and it may be no coincidence that the rise in popular curiosity about the investigation process, epitomized by the character of Sherlock Holmes, just pre-dates Beazley's work. The investigation metaphor also proves useful for Aby Warburg, and the art historians who eventually gathered around him at the 'Warburg Institute' in Bloomsbury. It was around 1895 that Warburg recognized his disgust for 'aestheticizing art history' – the sort of writing about works of art, often rhapsodic in tone, that is exclusively concerned with their 'beauty' – and so resolved to seek out the origins of image-making considered rather as a 'biological necessity'. Warburg was not an anthropologist as such, but he did 'fieldwork' (among 'First Peoples' in New Mexico) by way of proving his conviction that modern aesthetic responses were grounded in the pre-industrial production of images for religious purposes. Art history then became (as he put it: his fondness for striking metaphor is striking) 'a ghost story for adults' – i.e. the process of becoming aware of fundamental forces and spirits that gave rise to symbolic representation in the first place.

Warburg's followers – among them notably Erwin Panofsky and Ernst Gombrich – would refer to the Warburg approach as

'iconology': defined (by Gombrich) as 'the study and interpretation of historical processes through visual images'. Warburg – who never held an academic position, nor ever published a book (he was blessed to be born into a dynasty of bankers) – put it more simply. This was art history as a sort of investigation; it was *Detektivarbeit*, 'detective-work'.

To switch the metaphor: regarding any image that belongs to 'the modern world' – 'image' here need not be an 'art-work' as such, and historians will reckon 'the modern world' as commencing in 1492, if not before – Warburg's motto might well have been '*Achtung: Tiefen*' – 'Watch out for hidden depths'. Especially relevant for our present purpose is Warburg's pursuit of one particular manifestation of ghostly presence in images and the 'afterlife of antiquity' in European art from the late Middle Ages onwards. This is his concept (or 'tool', as he called it) of the *Pathosformel*. Rendered in English as 'pathos formula', the compound term is now relatively well known within academic discourse. Yet it is not straightforward in its application. And almost immediately it raises a question of integrity. 'Pathos' designates affect – an aspect of suffering that causes pity or sadness. 'Formula' implies some prescribed rule or procedure. For many of us, the sensation of pathos – defined in classical rhetoric as 'a movement and agitation of the soul' – is involuntary, 'moving', even irrational. How can it be 'formulaic' – a matter of fixed rules, pattern or routine? As one commentator (Salvatore Settis) has pointed out, it is precisely this semantic tension that makes Warburg's *Pathosformel* such a powerful instrument for the 'reading' of images – because it probes beyond description. Warburg did not deny aesthetic effect (nor indeed 'affect'). He wanted to know how it had been achieved; to gauge the 'hidden depths' from which an image drew its aesthetic and psychological power.

Warburg had no access to digital images and 'Powerpoint'; he does not even seem to have used slides. However, as a devoted

book collector, and proprietor of the library that emigrated with him from Hamburg to London in 1933, he felt free to use published illustrations as he pleased. One of his research strategies was to juxtapose pictures: if not by way of photographs and prints, then with his own books, opened out and displayed at the pertinent page. In this way, he constructed a *Bilderatlas*, or compendium of pictures, which as an experimental project he titled 'Mnemosyne', after the classical goddess of 'Memory'. A series of panels or 'posters' (as we would call them) resulted, of which some old photographs survive.

No. 42 of the 'Mnemosyne' series is of interest to us (Fig. 61). Warburg left little by way of commentary for this assemblage of images, which taken together do not extend very far in place and time: their sources are all Italian, and broadly they all belong to the Renaissance period. So, what did Warburg want to prove by their juxtaposition? A staccato title, transcribed by his disciple Gertrud Bing, runs as follows: 'Pathos of suffering in energetic inversion (Pentheus, Maenad at the Cross). Bourgeois death lamentation heroicized. Ecclesiastical death lamentation. Death of the Redeemer. Entombment. Meditation on death.'

These are cryptic captions, which we shall ignore for the time being – because they do not directly answer our question. The unifying principle here is left largely implicit. What these images have in common is that while most of them are Christian by theme and commission, stylistically and compositionally they all appear to relate to a single generic source: ancient pagan sarcophagi.

We looked at one of these sarcophagi in the previous chapter: the logic connecting them with the Sarpedon krater may be recapitulated. Memorandum – the vase itself is definitely out of view: sealed in its Etruscan grave, like Keats' 'Grecian Urn', 'the foster-child of silence and slow time', it exerts no direct iconographic influence. But the schematic impact devised by Euphronios is lodged within the classical repertoire, and as

such belongs naturally to the relief-registers of the sarcophagi – produced, as noted, by Greek or Greek-trained sculptors within the far-flung economy of the Roman empire. Some sarcophagi were placed in subterranean tombs; but others were kept above ground, in sites of family commemoration throughout Roman Italy (and beyond). What happened to them at the 'end of antiquity'? (By which we mean, in this context, the Christian transformation of the Roman empire, successive invasions of Italy by foreign forces, and a shift of power from Rome to Byzantium: AD 410, the year when the Visigoth leader Alaric sacked Rome, serves as a convenient date.)

Warburg, fascinated though he was by the stratified 'archaeology' of images, seems never to have given much thought to this basic archaeological question – which remains relatively understudied. Impressionistically, however, the evidence suggests that in various parts of Italy, a number of ancient sarcophagi were visible, and given honorary admittance to places of Christian worship. Some simply served as useful building blocks, or water troughs; others, however, were recognized for their original funerary function, and respected accordingly – or even reused in that way. In Viterbo, a young woman called Galiana, whose beauty was the stuff of courtly romance, died prematurely in AD 1135: her grave (its replica still visible in a church façade) was a Roman sarcophagus of late imperial date, showing a particularly spectacular boar hunt that also involved a lion. In Pisa, in the year 1076, a certain *contessa* Matilda laid her mother to rest in a monument on which the mythological decoration featured the tragic story of Hippolytus and Phaedra. Whether Matilda and her mother knew that story we cannot tell; whether a previous occupant of the coffin had to be 'evicted' is not clear; in any case, this sarcophagus was on view, with others, in the Campo Santo area of Pisa – and so it does not seem strange that a sculptor who settled in Pisa during the thirteenth century, and who made a

Fig. 61 Photograph of the '*Bilderatlas Mnemosyne*, Tafel 42', 1925–9. Top left is Donatello's *St Anthony of Padua Healing the Wrathful Son* (Padua); bottom left, a drawing by Raphael for his *Deposition* (British Museum). 1.50 × 2.00 metres (4' 11" × 6' 7"). London, Warburg Institute.

name for himself there (becoming Nicola 'Pisano'), should take inspiration from such relics.

Another Tuscan, Giorgio Vasari, who several centuries later published his celebrated *Lives of the Artists*, saw the connection. Vasari's potted biography of Nicola Pisano (along with his son Giovanni) gives immediate prominence to the influence of ancient sarcophagus-reliefs upon Nicola's style. Misled by the scene of Hippolytus hunting, Vasari says that the sarcophagus reused by Matilda showed Meleager and the Calydonian boar. But the subject, perhaps, was not so important – rather the exemplary style, the '*bellissima maniera*' of the carving, which encouraged Nicola to forsake 'the old Byzantine manner, rough and ill proportioned' (*quella vecchia maniera greca goffa e sproporzionata*).

Vasari is open enough about his predilection for classical form; his celebration of artistic excellence must after all culminate with his greatest hero, the 'divine' Michelangelo. Yet he has put his finger upon a cardinal process in the history of early modern Europe. 'The Renaissance had its cradle in a grave.' This aphorism was coined by one of Warburg's friends, the Dutch cultural historian André Jolles, apropos of Pisano's resort to Roman sarcophagi. As Jolles admitted, it was a somewhat reckless claim. And yet it encapsulates a truth about the particular iconographic trail we are following. Even without Vasari's testimony, we can see that Nicola Pisano – and his son Giovanni – adapted figures on surviving Roman sarcophagi to serve in Christian themes for grandiose marble pulpits in Tuscan cathedrals. The brooding figure of Phaedra from Matilda's sarcophagus, originally dating to the second century AD, supplied a stolid Madonna in Nicola's *Adoration of the Magi* for the Baptistery in Pisa (1260); and the sort of turbid violence captured upon a typical Roman 'battle sarcophagus' must have inspired Giovanni's *Massacre of the Innocents* at Pistoia *c.* AD 1300. This 'new-old style' evidently found

favour, for in the next generation, the two pre-eminent Florentine sculptors, Lorenzo Ghiberti and Donatello, borrowed likewise. For Ghiberti, it is judged that ancient sarcophagi provided him above all with a broad repertoire of figures in action: 'dancers, nude youths and running girls, goddesses with windblown garments, men carrying loads, figures writhing in sorrow or exuberant with bacchantic joy'. From his own *Commentaries* we know how much Ghiberti esteemed classical models, theoretically: but we should bear in mind that actual samples of such models were not then abundant. Vasari, in the mid-sixteenth century, was aware of that archaeological fact: all the more credit to Donatello, then, that he had absorbed lessons from antiquity at a time when 'antiquities were hardly yet brought to the surface'.

Vasari's account implies that it was the stylistic accomplishment exemplified by relics of classical sculpture that enchanted artists of the *trecento* and *quattrocento*, and propelled them, technically, towards emulation. At the risk of being too 'down to earth', we may mention an even more fundamental motive for resorting to classical schemes. Donatello, for example, was commissioned to decorate a high altar for the basilica at Padua, dedicated to St Anthony. It was natural enough that Donatello used the form of the altar as a space to make visual statements not only about the rite of the Eucharist but also relating to the sanctitude of Anthony, a Franciscan priest canonized in 1232, not long after his death. Those coming to the altar were invited to meditate upon the body of Christ as a 'real presence': reason enough for the sculptor to imagine what it might have been like, once upon a time, when Christ's body was taken down from the Cross and prepared for entombment (Fig. 62). But had he, the artist, ever witnessed such a scene? Its verbal description as an event, in sacred literature, provided scant imaginative detail. In such situations, models are required. Entrusted with the same subject, subsequent artists (notably Hans Holbein) proved not averse to having an actual

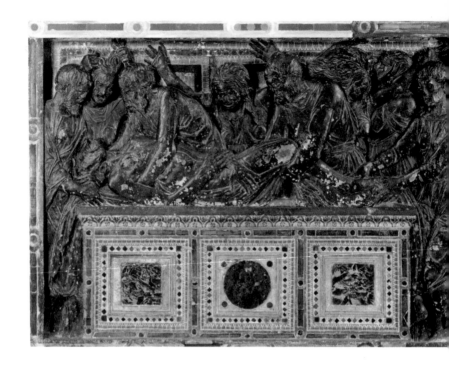

Fig. 62 Donatello, *Deposition*, 1445–49. The Biblical accounts of this event are perfunctory: St John's Gospel (19. 38–42) mentions just two individuals (Joseph of Arimathea and Nicodemus), binding Christ's body with strips of linen soaked in myrrh and aloes. Padua, Sant'Antonio.

corpse laid out in their studio. An alternative option was to use models from the past – 'second hand' they might be, but at least they were impeccable at keeping still. Though we cannot identify his sources precisely, Donatello seems to have taken this latter course. Stereotypically, in the group he assembles, there are several males, intent on laying out the body; while in the background, female onlookers display the gesticulations of grief – shrieking, raising their arms, tearing their hair. The inspiration was surely some Meleager sarcophagus. As for certain miracles wrought by St Anthony, although they were attested as relatively recent events, the sculptor 'quoted' the architectural remains of Rome in the 'wide-angle' settings he created – so before a background of imperial Roman barrel vaults, a donkey obliges the saint by kneeling in acknowledgement of the sacrament of Holy Communion; and Donatello draws (literally?) from the style of classical sarcophagi when he shows Anthony kneeling to mend the leg of a young man who had cut off his own foot, in a fit of remorse – remorse for having kicked his mother.*

It is important to note here that a stylistic choice is being made. At Padua, it might have been obvious enough. The frescoes by Giotto for the Arena Chapel, consecrated in 1305, displayed that painter's genius in many ways – and Giotto, too, is thought to have studied some ancient reliefs – yet the style is manifestly more Byzantine than classical. And reasonably so, since the tableau generically termed '*Pietà*', showing Christ's body taken down from the Cross, is indebted to a Byzantine liturgical tradition of 'Funerary Lament' (*Epitaphios Thrênos*). North of

* Warburg would have recognized here a nice case of 'energetic inversion' with the pathos formula: that is, while the classical repertoire included scenes of Bacchic frenzy leading to dismemberment, indeed of a son by his mother (i.e. the fate of Pentheus depicted on the psykter in Fig. 2), here the dramatic composition has been adapted for the opposite action: a dismembered body part restored.

the Alps, meanwhile, Gothic visions of the 'Sorrowful Mother' nursing the bloodied and broken body of her grown son became part of devotional worship – as exemplified by the well-known 'Röttgen Pietà' (c.1325). The classical option requires something different. Christ must be imagined not as a physical wreck, but a fine figure of youth, grace and athletic muscularity. This is the Christ who will appear in the young Michelangelo's version of the *Pietà c.*1498–1500, on display at St Peter's; in other words, the Christ who looks like Sarpedon.

While Donatello was working on these reliefs at Padua, a young painter called Andrea Mantegna will have witnessed the work, and absorbed its lessons. Mantegna was the apprentice and adoptive son of Francesco Squarcione, a pioneer of the craft of taking plaster casts from ancient sculptures: so it is no surprise that Mantegna continues the creative rapport with classical reliefs, developing a monochrome *grisaille* technique for mimicking their effect in two dimensions. More important, however, was the theorizing intervention of the archetypal 'Renaissance man' himself, Leonbattista Alberti. In 1435 Alberti published a short treatise 'On Painting' (*De Pictura*). Having shown that he could

Fig. 63 Detail of a Roman marble sarcophagus-lid once in Palazzo Sciarra, Rome (from an old photograph). Previously attested in the church of Saints Bonifacio and Alessio on the Aventine. Late second century AD. 29 × 227 cm (11" × 7' 5"). Whereabouts unknown.

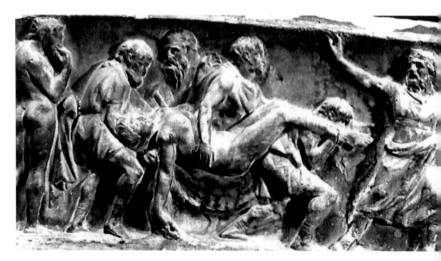

write (and elegantly so) in Latin, the following year he produced an Italian version, which in its dedication to fellow-architect Filippo Brunelleschi alludes to their mutual friend Donatello, and cordially also to Ghiberti (by his nickname, 'Nencio'). Implicitly Alberti acknowledges that both sculptors, along with Luca della Robbia, had already narrowed the gap between sculpture and painting. And what Alberti had to say about the use of ancient sarcophagi implies that painters, conversely, should take lessons from the genre of relief sculpture (*bassorilievo*). In a quotable passage, Alberti alludes to a relief that he knows of in Rome. 'Much-praised,' he says, 'it shows the dead Meleager being carried, and weighing upon those who take the load. It seems each one of his limbs is stone dead [*ben morto*]; every part droops – hands, fingers, head – every part hangs languidly; and you see clearly how difficult it is, to represent a dead body… – all the limbs of a corpse must appear dead, right down to the fingernails.'

Several sarcophagi showing the Meleager story were demonstrably visible in Rome during Alberti's sojourn in the city, *c.*1430 – including the sarcophagus in Palazzo Doria Pamphilj (see Fig. 58), and another one in the Palazzo Barberini, now in Brazil; or he may be referring to one that has since disappeared (Fig. 63).* In any case – and this is partly the point of our argument – one Meleager sarcophagus tends to look rather like another; and all (as our argument runs) ultimately derive from the Sarpedon motif – where, as we have noted, the gravitational momentum of Sarpedon's morbid weight is visibly registered in the figures of those carrying the corpse (see p. 118). The visual message is clear: that a dead body makes an awkward burden – and this seems to be the realism that Alberti approves. Yet Alberti does not recommend

* The Palazzo Barberini sarcophagus, reportedly from the church of S. Maria in Monticelli, was sketched by numerous artists. São Paulo, Museu de Arte Assis Chateaubriand, inv. 441 E.

that artists commissioned to represent dead bodies go with their sketchbooks to visit a morgue. Forensic accuracy is not the aim. Rather, Alberti prescribes the study of ancient models as a guide for how to convey, in images, a convincing *istoria*.

Alberti's Italian here sounds like Latin – *historia*: but we realize immediately that to translate *istoria* as 'history' will not work, if it applies to a myth or fable such as that of Meleager. 'Story', too, is not quite right. Modern academic usage would probably prefer 'narrative' – but Alberti's use of the term *istoria* is so idiosyncratic that some translators simply leave it as such. Whatever we choose, the advice from Alberti is unambivalent. Whether an artist was depicting a classical myth, or an event from Roman history, or a scene from the Passion of Christ, the priority must be to make it convincing – for the sake of aesthetic and emotive effect. An *istoria* contains a certain mode of truth, at once particular and universalizing. It is the artist's task to create the visual coherence necessary to deliver that truth.

Like a theatrical director, Alberti suggests certain principles of staging: for example, he does not like scenes that are too empty, nor scenes that are too busy and over-crowded. His fundamental demand is for a thinking-through of details – to an almost pedantic degree. For example, if a painter is showing a battle involving Centaurs, which as an *istoria* occurs after a banquet at which the Centaurs have become drunk – then in a scene of this melee there should be no jugs of wine still standing: disorder must be complete.

In citing a Meleager relief as exemplary of such 'convincingness', Alberti was not advocating the sort of copying that would later result in frigid neoclassicism – the style of a Canova or a Flaxman. As a 'humanist' of the mid-quattrocento Florentine milieu, he regarded the evident and reported achievements of classical antiquity as a challenge: touchstones of excellence, to be emulated, and matched – but also surpassed. As it happens

– and partly as a result of Alberti's text, which circulated widely even before the formal growth of 'art schools' around Europe – artists who visited Rome from c.1500 onwards did make careful studies (though not always faithful copies) of scenes upon ancient sarcophagi (Figs. 64 and 65), as if satisfying a requirement of their apprenticeship. But replicating the past was not an end in itself; nor would Alberti and his followers have been troubled by the crime we call 'plagiarism'. Alberti did not directly anticipate Warburg's analysis of images that were 'formulaic' or 'schematic'. He did, nonetheless, recognize established patterns of response, as much subject to physical laws as matters of planes, perspective and proportion. The classical literature about artists such as Pheidias and Apelles made it clear that those masters had wrestled with the technical challenges of representing what was beautiful, marvellous and 'moving'. Classical relics were object-lessons accordingly.

The most celebrated example of an artist implementing Alberti's advice must be Raphael's 'Deposition', or 'Entombment' (Fig. 66). The commission of this painting is an *istoria* in itself, involving the violent death of a young man and a grief-stricken mother (who happened to be called Atalanta). Its composition appears to heed Albertian strictures about numbers of figures (about eight or nine), and the ideal mix of age and gender among them; and from a series of drawings – which one would call 'preparatory sketches', if they were not so exquisitely executed – we see how Raphael worked towards a visual choreography that would make sense as an altarpiece, and also as memorial within the chapel of a recently bereaved family. There is little doubt that Raphael, in gathering the 'concepts' he needed for the eventual picture, resorted to an antique sarcophagus showing Meleager or something similar. It is a sign of Raphael's artistic ingenuity, however, that no particular sarcophagus can be identified from any of the drawings (Fig. 67).

Fig. 64 Detail from a sketchbook ('London I') of 'Amico' Aspertini, c.1533: apparently a motif from a Meleager sarcophagus (it may be the piece illustrated in Fig. 63). Aspertini was in Rome around the same time as Raphael, and made

numerous drawings from antiquities then visible. Pen, ink and wash on vellum.
London, British Museum 1898.1123.3 (7).

Fig. 65 Pencil drawing of a detail from a Meleager sarcophagus in the Palazzo Doria Pamphilj, Rome, by G. D. Campiglia, c.1710–30. (This sarcophagus is not to be confused with that in Palazzo Doria.) Eton College Library Bm 8.50.

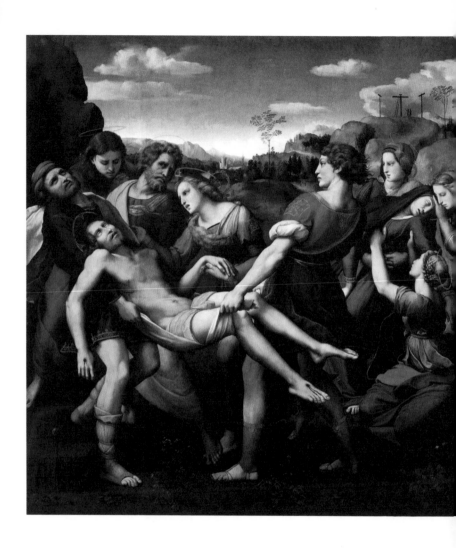

THE SARPEDON KRATER

What Raphael extracted from the sarcophagi was the impression of movement around a motionless object. The two foreground figures lifting the body of Christ – one of them a muscular young man – are braced as if hauling up some solid joist; a senior man, presumably Joseph of Arimathea, assists, casting a worried glance to the viewer – to remind us, perhaps, that this is a covert operation, which has to be done swiftly. The right arm of the corpse dangles down, in the *leitmotiv* we have identified as 'the arm of death'. Bands of cloth discreetly cover those parts of the body which it would be improper (at the time, and in a church) to represent – but the basic contrast of a horizontal stripped body among a vertical draped entourage, which Raphael may have seen on a sarcophagus preserved at Perugia (Fig. 68), is striking enough.

Fig. 66 *Deposition:* oil on wood, by Raphael, 1507. We do not know the title of the picture – it is strictly speaking neither 'Deposition' nor 'Entombment', but a moment in between – only that it was originally painted for the Baglioni family chapel in the church of San Francesco al Prato, Perugia. 1.84 × 1.76 metres (6' 1" × 5' 9"). Rome, Galleria Borghese.

overleaf Fig. 67 Pen and ink study for the '*Deposition*', by Raphael, *c.*1507. Some sixteen drawings survive as studies for the painting. Insofar as their chronological sequence can be determined, the early, more 'static' compositions place the figure of Christ upon the ground, lying left to right, with attendant figures variously lamenting. As the series develops, the body is lifted up, its direction reversed, and diagonal agitation introduced (with Mary the mother of Jesus falling back in a faint). H 21.3 cm (8 in). London, British Museum 1963.1216.3.

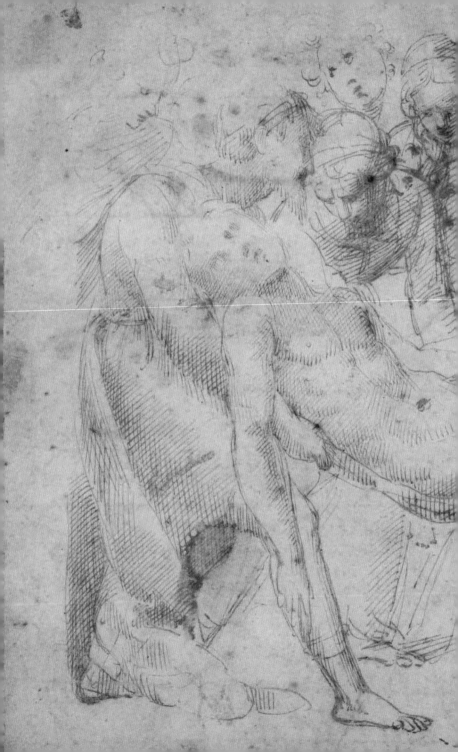

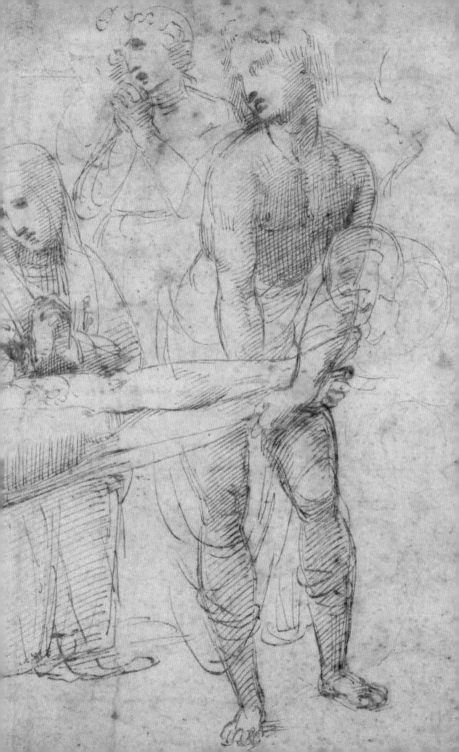

Fig. 68 Detail of a late second-century AD sarcophagus, once kept at the Abbey of Farfa, in the Sabine Hills. H of sarcophagus 92 cm (3 feet). Perugia, Museo Archeologico Nazionale dell'Umbria 1886.

Raphael's senior contemporary Luca Signorelli must also have looked at such sarcophagi, for he gratifyingly depicts one, in grisaille, in the background of an image placed in a niche-annexe of his best-known work, the San Brizio chapel for Orvieto cathedral (Fig. 69). Christ is about to be placed in a tomb: given the absolute chronology of the Crucifixion, why should it not be a Roman-style sarcophagus? Signorelli is content to isolate a few figures on the sarcophagus: he gives the dead figure a beard, but otherwise his 'source' is taken to be a Meleager relief (and is catalogued as such, though no original monument has been located).

While he was working on his fresco-programme for Orvieto, Signorelli also undertook to paint a large altarpiece for a church in his home town of Cortona. This is described as a 'Lamentation at the Foot of the Cross': beyond two basic objects in the foreground – a skull and a hammer – the semi-naked body of Christ is prominent, with elaborately robed figures in the background variously grieving or grave of demeanour (Fig. 70). Thanks to the modern ease of comparing images, it is clear that Signorelli has economized his artistic effort, and effectively reversed a cartoon

Fig. 69 Detail of a fresco by Luca Signorelli in the chapel of Saints Faustino and Pietro Parenzo, within the Capella San Brizio of Orvieto Duomo, 1499–1504. Figures of the eponymous martyrs flank a scene of Christ lamented by his mother (background) and Mary Magdalene.

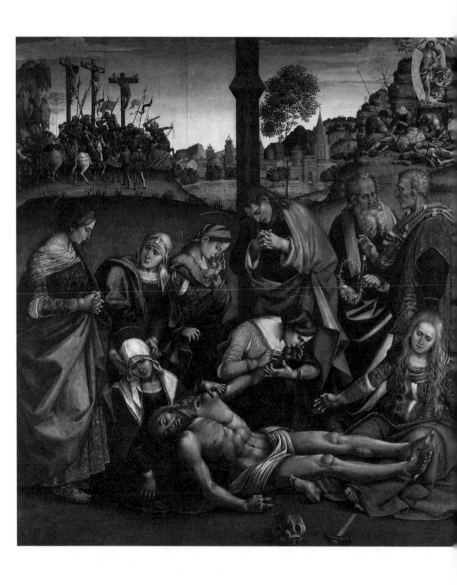

Fig. 70 *Lamentation at the Foot of the Cross* by Signorelli, 1501–2. Oil on wood, 2.70 × 2.40 metres (8' 10" × 7' 10"). Cortona, Museo Diocesano.

to serve at both Cortona and Orvieto: not only the body of Christ, but also the figures of the Virgin and Mary Magdalene. No shame in so doing: but some commentators have wanted to relate the Cortona picture to a story in Vasari (who could remember meeting Signorelli as a boy), telling how Signorelli suffered the loss of a son at Cortona. Vasari relays the anecdote that the artist, pained yet refraining from tears, had the boy's body stripped, and made a full-length portrait 'of what nature had given, and harsh fate taken away'.

Did this portrait of the dead son (named Antonio) furnish a model for the dead Christ? That suggestion, made long ago, has been discounted on the basis of documentary evidence, indicating that Luca Signorelli consigned his Cortona altarpiece in February 1502, and that his son Antonio died (probably of plague) later that year. Disregarding such evidence, however, there is another problem here – perhaps obvious only to those viewers who know about gymnasium culture. The body of Christ in this picture is no 'natural' body. Like Michelangelo's Adam on the ceiling of the Sistine Chapel, it is the configuration of a classical athlete or hero. Antonio Sigorelli may have been a fine young man: but he is historically unlikely to have possessed such muscular bulk and definition – especially if he had suffered the wasting effects of an epidemic disease. In this sense, Vasari's story is unbelievable. The Christ of Signorelli's 'Lamentation' is based upon no 'real-life' model, but rather draws upon the heroic somatotype embodied by Sarpedon as projected by Euphronios.

Many subsequent artists, whether they followed Alberti's advice directly or else simply the trend it created, undertook to represent the body of Christ as medically *dead*: among them Titian (Louvre), Rosso Fiorentino (Sansepolcro), Pontormo (Florence), and Vasari himself (Arezzo). Protagonists of the 'baroque', such as Caravaggio (Vatican), followed in their way. But perhaps, at this point, it is worth reminding ourselves of the

'visual DNA' at work here. A gift to Warburg's project – though not known to him, and kept in the museum of a minor town in the Alban Hills southeast of Rome – is a small but remarkable marble relief generically classified as an *oscillum* (Fig. 71). Such circular plaques would once have been suspended within the peristyle walkways of a Roman villa (see e.g. the House of the Telephus Relief at Herculaneum). But one could be forgiven for not recognizing it as a piece of Graeco-Roman sculpture.

Originally this tondo showed the sort of scheme we have already encountered in various media (see Figs. 54–6). Two warriors bear the naked body of a casualty, with an elderly bearded figure, probably paternal, in attendance. One of the warriors is also unclothed, the other wears a short tunic; both were evidently once shown as helmeted. Then the piece was reworked by a sculptor of the late Renaissance. The elaboration was not extensive, yet it was sufficient to alter effect and significance. Chiselling around the heads of the three vertical figures, the later artist contrived to give each one a halo. Thus was the pagan image Christianized: a 'Deposition' conjured from the iconographic detritus of classical antiquity.

Fast forward to the French Revolution. In July 1793, a popular protagonist of the Revolution, Jean-Paul Marat, was murdered – in his bath. It was a singular case of homicide. The victim was in the bath to soothe a skin complaint, and doing his paperwork there; the assassin was a genteel lady armed with a kitchen knife. One of Marat's friends was the painter Jacques-Louis David, who undertook to depict the event. Though David had Marat's body embalmed and put on public view, there was an obvious problem about the undertaking of a picture. How could such a bizarre death be rendered in a convincing yet aesthetically pleasing way?

David, working swiftly, had the picture finished within several months – and it is judged one of his masterpieces (Fig. 72). The artist is applauded for the innovative boldness with which he has

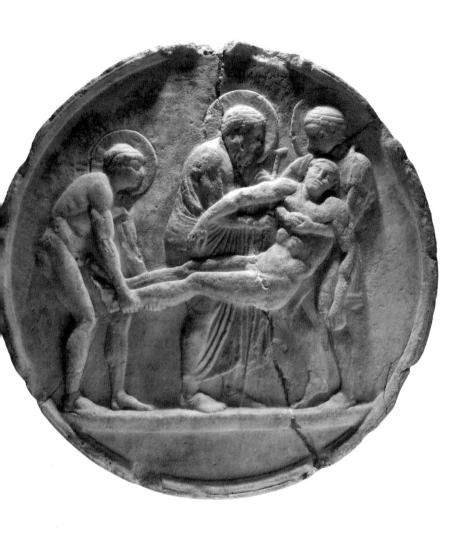

Fig. 71 Marble relief from Velletri (found built into a wall of Palazzo Graziosi). Original perhaps early first century AD; reworked in the early sixteenth century? D. 51.5 cm (1' 8"). Velletri, Museo Civico 405.

broached a contemporary subject. But the apparent immediacy of the representation conceals – as readers, at this stage, will guess – 'hidden depths'. David's mission is to heroicize Marat. To do so, the painter need not have witnessed the actual scene in Marat's bathroom. Better that he consult the sketchbooks from his sojourn in Rome. During his artistic apprenticeship, David tried several times for the *Prix de Rome*, which provided a studio-residency at the Villa Medici. Eventually he was successful, and spent five years immersed among images of the antique. There was (and is) part of a Meleager sarcophagus at the Villa Medici – but David doubtless studied others too (Fig. 73). That experience supplied him with as much as he needed here. The posture of the limp right arm is enough to signal Marat as the classical hero – a person of outstanding virtue; a man whose loss will be widely lamented.

Musicians speak of a leitmotiv – a short recurrent phrase, the 'leading motif' of a piece. Warburg liked to invoke, in visual terms, the *leitfossil* – a 'leading relic', which in the case of David's *Marat* will be the *braccio della morte*. For our purposes (and Warburg's) it is all the same, whether or not David was conscious of the classical element in his 'contemporary' scene. The Sarpedon-fossil has exerted its remote formulaic force.

Is it merely 'academic' to draw attention to this formal debt? For some viewers, a more basic problem is simmering here. A French painter of neo-classical formation has drawn on the classical canon to invest a representation of a squalid and violent event with some sort of atavistic nobility. But does that change the fact that we are regarding as a 'masterpiece' the image of a fellow human murdered in his bath? If we like this picture – must we be sadists?

Not long before David created the painting, that problem of aesthetic gratification had gained some prominence in salons of the learned – thanks largely to an essay published in 1766 by the

Fig. 72 *The Death of Marat* (detail), by Jacques-Louis David, 1793. Oil on canvas. 1.65 × 1.28 metres (5' 5" × 4' 2"). Brussels, Musées Royaux des Beaux-Arts.

NAYANT PU ME CORROMP

ILS M'ONT ASSASSINÉ.

German critic and dramatist Gotthold Lessing. The essay was entitled *Laocoon*, but it was not really focused upon the famous Graeco-Roman statue of that name. Rather, Lessing was attacking the intellectual and aesthetic basis of modern esteem for the statue. He had in his sights J. J. Winckelmann, for whom the Laocoon-group in the Vatican represented a glorious statement of classical grace and control. Lessing's essay is peevish and pedantic, and it was as a poet that he argued for poetry's superiority as a medium of expression. But one of his polemical points still seems sharp. The Laocoon-group shows a man and his sons being crushed and bitten to death by a pair of giant serpents. That ought to be a

Fig. 73 'Death of Meleager': sketch by Jacques-Louis David, *c.* 1775–80. Pen and wash over charcoal. 13.9 × 21.3 cm (5.5 × 8.4 in). Paris, Louvre 26084 Bis.

terrible and revolting sight. So why is it such an uplifting work of art – if it really conveys what it claims to represent?

We noted (see p. 69) Aristotle's elementary observation that humans in general derive pleasure from looking at the representation of something terrible – such as a monster, or a painful death – because it is a successful representation. The pleasure here lies in the act of *mimêsis*, 'imitation', done with such skillful care (*akribeia*) that it is convincing. But Aristotle's analysis is not as useful as it might seem. On the Sarpedon krater, what exactly is being 'accurately' represented? Is it a maimed casualty of violent combat – or rather the body of a superhuman warrior, still amazingly taut when lifted horizontally?

We know that photographs are not necessarily 'accurate' as representations. But one way of approaching the problem of aesthetic gratification from 'distressing' images may be to consider how instances of photojournalism can achieve, within the genre, 'classic' status. A number of pictures taken by Larry Burrows during the Vietnam War have this status, and one of them seems broadly comparable to what is shown on the Sarpedon krater (Fig. 74).

The prime intended viewers of this image were readers of a popular weekly called *Life*: what they saw was someone close to death. Some would say that here is the key: we see danger, trauma, death, at a remove – and feel pleasure, or gratitude, from the fact that it is not happening to us. This is not sadism, but it may be a sort of schadenfreude – the 'damage-joy' that can explain why we laugh at a film-sequence of someone falling off a ladder. '*C'est effrayant, la vie*' – 'life is terrifying': Cézanne's habitual refrain becomes a truth that we all know, but generally hate to admit.

There is another explanation. It derives from research to which neither Aristotle nor Lessing were privy: the advances being made in the sphere of neuroscience, and in particular our understanding of how the human brain operates emotional

Fig. 74 'Four marines recover the body of a fifth as their company comes under fire near Hill 484. Vietnam, October 1966.' Photograph by Larry Burrows for *Life* magazine. Another photographer, Catherine Leroy, is in the background. (Burrows died in a helicopter crash in 1971.)

and aesthetic responses. Aristotle recognized that the dramatic spectacle of tragedy caused engaged reactions among its viewers, for whom the experience ideally induced a sort of emotive 'purge' or catharsis. But why and how do we engage with the virtual reality of dramatic or artistic representation? A number of neurophysiologists currently devote their time to this problem; and while it is premature to state their results as definitive, a reasonable theory has emerged. This proposes that empathy – the sensation of involvement with the feelings of another person – is a natural and involuntary act; a cognitive mechanism. So, we see someone suffering – or an *image* of someone suffering – and this activates 'mirror neurons' within our brain to simulate a response, as if that suffering were ours.

Evidence for this mechanism came to the fore in therapeutic treatments for a particular post-surgical problem. A patient has lost a limb, and gained a prosthetic replacement. How does the complex neurophysiological system of nerve-endings and muscular reflexes reactivate, to make that new limb functional? Part of the rehabilitation consists in viewing the performance of a movement or gesture. The patient watches someone else make the action: the mirror neurons in the patient's brain send the message to act likewise.

This phenomenon of 'embodied simulation' has obvious implications for how we respond to works of art. People rarely shed tears in front of pictures. Yet, as David Freedberg (art historian) and Vittorio Gallese (neuroscientist) jointly claim, 'physical empathy easily transmutes into a feeling of empathy for the emotional consequences of the ways in which the body is damaged or mutilated'. To see a photograph of a dying or seriously wounded soldier being carried by his comrades is therefore not only to 'feel' for the casualty: it is also to read the panic, determination and anxiety in the expressions of those who are rushing for help. It is moreover to wonder about those we

cannot see, who will be close to the casualty – and to imagine the reactions when the body-bag appears at a family home.

So, in scenes of 'Deposition from the Cross', artists may almost prescribe or anticipate a viewer's response. The body of Christ is gathered: his mother falls down in a swoon; other onlookers cannot control their weeping. And so, on the sarcophagi that show the dead or dying Meleager brought home, there are all the outward signs of emotional distress – heads bowed, mouths howling, arms raised, hair and clothes awry. Of course, there are cultural and contextual factors here. But it seems to be basic biology that underpins Warburg's notion of a *Pathosformel* – 'an antique superlative of the language of gestures'.

We have, as they say, come a long way with Sarpedon: only to find, in the end, that he is one of us.

Coda

A Hero's Lingering Death

One final question. It can be briefly addressed – and is arguably irrelevant to all that has gone before. *This hero Sarpedon – did he really exist?*

No one can give absolute dates for his existence. That was as true in antiquity as it is now. For the Greeks, year-by-year chronology began with the inaugural athletic games at Olympia. Subsequently, this 'First Olympiad' was reckoned as 776 BC. What happened before 776 was only vaguely put into sequence. The stuff of history became interwoven with cosmology and myth; and such myths as may have developed out of 'real events' were rarely scrutinized for their historical credibility. As noted (p. 123), there was throughout the classical world widespread credence in an 'age of heroes'. Whether epic poetry about Troy was a cause or a result of hero-cult remains debatable: either way, the poetry about heroes was not categorized as 'fantasy'. There *had* been a great conflict at Troy. Never mind exactly when it took place: individuals claiming to be descendants of its protagonists were around to uphold the family honour.

Homer did not explain why a Lycian prince called Sarpedon joined the Trojan side. Xanthos lies some 430 miles (about 700 km) south of Troy. Some rationalizing explanation could be attempted for a Lycian–Trojan alliance in the Late Bronze Age. But it is not necessary. As Homer reported, the Greek force was drawn from places far beyond the Peloponnese; so Priam, like Agamemnon, could plausibly count upon distant allies. For Homer, this pro-Trojan Sarpedon was fathered by Zeus with Laodameia, a daughter of Bellerophon (whose despatch of the Chimaera was located in Lycia). Evidently, however, there was another tradition, which told how the liaison between Zeus and Europa produced three sons: Minos, Rhadamanthus and Sarpedon. The island of Crete could not contain the trio. Sarpedon headed eastwards. Rhadamanthus, famed for his judgement, did not die, but went to exercise his wisdom in the Underworld. Minos then ruled Crete:

Fig. 75 View of Xanthos, western Turkey. Tombs of heroized ancestors are still prominent amid the remains of the (later) urban structures. The city was abandoned in the tenth century AD, after a succession of Arab raids. Systematic excavations began in the 1950s.

and since his reign was considered to have happened several generations before the Trojan war, post-Homeric commentators came up with various ways of reconciling the disjointed chronology associated with the name 'Sarpedon'. The reasoned explanation was that the Europa-born Sarpedon was grandfather to the Laodameia-born Sarpedon (Diod. Sic. 5.79.3).

Sarpedon senior was credited with the foundation of Miletus in Caria (Strabo 14.1.6). Above all however he was inseparable from the historical definition of Lycia (Hdt. 1.73). Philologists have surmised that a name in ancient Lycian (related to other Anatolian languages, such as Hittite, but eventually written using a version of the Greek alphabet) could be an indigenous form of 'Sarpedon': *Zrppudeine*. One thing, however, became certain (and it may already have been known to Homer and his audience): that Sarpedon was worshipped as a hero at Xanthos, the capital of Lycia.

Xanthos is a pleasant inland diversion from the holiday resorts of Kas and Kalkan (Fig. 75). The view over the Esen (Xanthos) River and its fertile valley calls to mind Sarpedon's fond evocation of his kingdom, as described by Homer (see p. 112). It is not so easy to imagine the catastrophes historically documented for the site. The first came in 540 BC, when the city was besieged

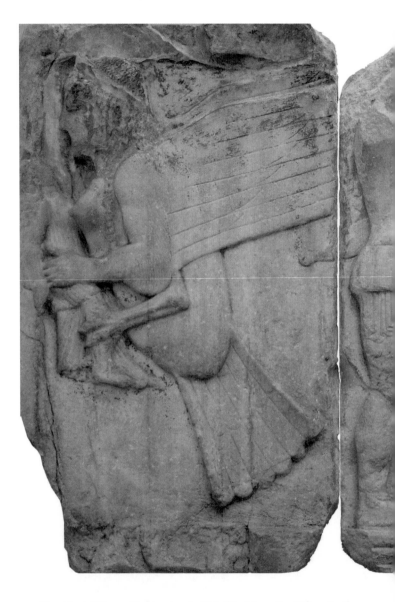

Fig. 76 Part of the marble frieze (north side) of the 'Harpy Tomb' from Xanthos, c.480–470 BC. The tomb takes its name from the hybrid human–bird figures (more like sirens) carrying bodies (to the next life?). This slab appears also to show a

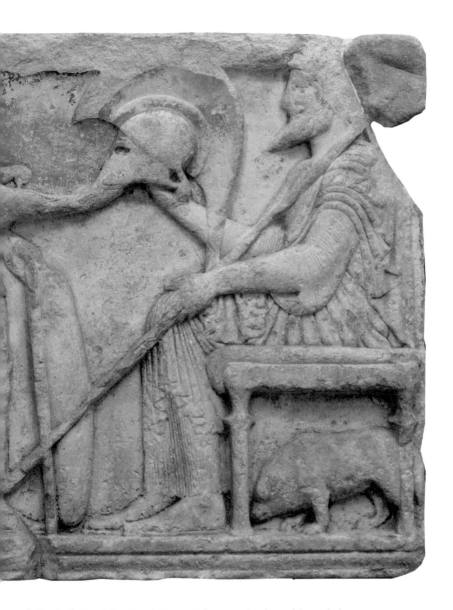

dedicant offering a helmet-trophy to a seated ancestor (Replicas of these reliefs evident in situ on the right-hand tomb in Fig.. 75). H 1.02 metres (3' 4"). London, British Museum 1848.1020.1.

by the Persians. Resistance ended with a holocaust of all those who sought sanctuary on the acropolis. Then there was major fire damage, during Greek campaigns against the Persians *c.*470 BC. Collective memory of these traumas had not yet faded when, in *c.*42 BC, Xanthos was attacked by Roman forces under Brutus, who was raising funds and recruits for his fight against Octavian and Mark Antony. A mass suicide of inhabitants ensued. Relating the course of events, the historian Appian adds a detail important to us: that a detachment of Roman soldiers, finding themselves trapped and outnumbered in the *agora* of Xanthos, sought refuge in the precincts of the place where Sarpedon was venerated – the Sarpedoneion (*BC.* 4.78–9).

Lycia generally presents a landscape of conspicuous funerary commemoration. A striking feature of Xanthos is the presence of spectacular burials within the city (most spectacular of all the 'Nereid Monument', reconstructed in the British Museum). These are interpreted as dynastic memorials – monuments where prayers and offerings were brought to powerful ancestor-heroes. Sculpted reliefs of the 'Harpy Tomb' seem to show scenes of such worship (Fig. 76). This is the cultural context of a *heroôn* or hero-chapel dedicated to Sarpedon – with the implication that his bodily remains were preserved there.

Several ancient sources attest the existence of a Sarpedon cult in Lycia. But where exactly was it? Appian's narrative implies that the Sarpedoneion in Xanthos was not far from the agora/forum, which is situated on the lower slopes of the so-called 'Lycian acropolis' of the city. There are tombs in this area, but presumably the Roman soldiers retreated up the hill, to a point on the acropolis where they were not entirely surrounded, i.e. upon its cliff edge. Henri Metzger, the archaeologist who excavated this area, located a rectangular structure at such a point – and suggested that it had functioned as a *heroôn*, *c.*460 BC. To judge by a number of associated architectural and sculptural fragments

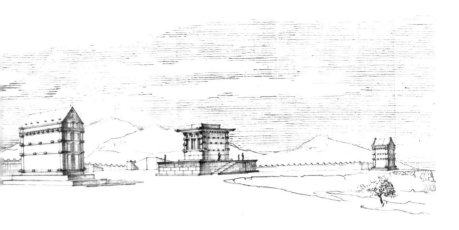

Fig. 77 Reconstruction of the terrace on the top of the Lycian acropolis, Xanthos, as it was in the mid-fifth century BC. The base of 'Edifice G' (centre) measures 15.50 × 10.25 metres (50' 10" × 33' 8").

(some in the British Museum), the structure consisted of a tomb upon a raised dais (Fig. 77). Metzger labelled it simply 'Edifice G'. Subsequent scholars have been less wary – and claimed it as the site of the Sarpedoneion.

There are foundations of Byzantine houses in the vicinity, and the remains of a temple (probably to Artemis). Visitors may notice these; frankly there is not much to see of 'Edifice G' – and nothing has come from it that would firmly establish the connection with Sarpedon. In all likelihood, the fifth-century structure replaced an older monument. For the time being, we can only accept the basic ancient tradition about Sarpedon: that he died at Troy, but was brought home to Xanthos for burial (Ps. Aristotle Fr. 481.58 R3).

The cult of Sarpedon, in some fashion, probably continued at Xanthos until the fourth century AD; and probably ceased not

long after Constantine's Edict of Milan in AD 313, legitimizing Christianity throughout the Roman empire. A bishopric was established at Xanthos. Churches were built – including one upon the 'Lycian acropolis', near to 'Edifice G'; and one of the Lycian dynastic tombs became home to a Stylite monk.

The veneration of Sarpedon as Lycia's hero at Troy will have been curtailed as 'pagan' observance. Yet his image, as we have seen, eventually served as an emblem of supreme self-sacrifice in Christian iconography. Sarpedon the epic hero declared his reason for existence as a quest for 'imperishable glory' (*kleos aphthiton*). He did what he could to achieve this on the battlefield. Homer and the dramatists ensured transmission of those deeds to posterity. The rest was due to Euphronios – who when he painted 'the Sarpedon krater' created an image of traumatic glory that would far exceed its original limits of purpose, time and place.

Fig. 78 Detail of the Sarpedon krater.
Cerveteri, Museo Archeologico.

Appendices

Where abbreviations are used, these follow the conventions of the *Oxford Classical Dictionary* (3rd ed.). The catalogue of a major exhibition of works by Euphronios at the Louvre in 1990 (with variant displays in Arezzo and Berlin) remains a primary point of reference, and is here simply cited as *Euphronios* (i.e. Denoyelle & Pasquier 1990). *FR* = A. Furtwängler & K. Reichhold, *Griechische Vasenmalerei* (Munich 1904–32).

1 PREFACE

Recognition of the iconographic legacy of the krater – as the pagan precursor of Christian *tableaux* – came very soon after its appearance in New York: see P. Devambez, 'Le nouveau cratère d'Euphronios au Metropolitan Museum' in *CR Acad. Inscrip.* 117/3 (1973), 370–2 ('nous évoquerions volontiers la Pietà d'Avignon'). Note also Dietrich von Bothmer's comment when presenting the vase to the Acquisitions Committee of the Metropolitan Museum (Hoving *et al.* 1975, 50): 'The dead Sarpedon is the first in a long iconographical tradition that includes Memnon being carried by his mother Eos, and the dead Meleager carried home from battle. It is at the end of this iconographical tradition that we see finally, in the Renaissance, those poignant pictures of the deposition of Christ and the Pieta.'

2 'THE MILLION-DOLLAR VASE'

The basic modern story of the krater was established within a few years of its arrival in New York: see e.g. K. E. Meyer, *The Plundered Past* (London 1974), 86–100, 302–8. Subsequent journalistic investigations include P. Watson and C. Todeschini, *The Medici Conspiracy* (New York 2006) – well intentioned, but in places confused about details. *Bob Hecht by Bob Hecht*, edited by Geraldine Norman (Vermont 2014)

gathers various testimonia from Robert Hecht, including contradictory accounts of how he came by the vase. V. Silver, *The Lost Chalice: The Real-Life Chase for One of the World's Rarest Masterpieces – a Priceless 2,500-Year-Old Artifact Depicting the Fall of Troy* [*sic*] (New York 2009), attempts to follow the trail of the Sarpedon kylix – and casts some light upon the krater too.

Tarbell's sherds: some from the Akropolis, now reconstituted with the kylix in Athens NM; another, from Cerveteri (ex-Castellani collection), joins with a *pelike* in the Villa Giulia (as Beazley saw) – but belongs to the Smart Museum, University of Chicago (inv. 1967.115.287). Pentheus scene: compare the kylix by Douris in the Kimbell Art Museum, Fort Worth (inv. AP 2000.02) – a piece very likely supplied by Giacomo Medici to Elie Borowski.

Munich krater: the question of provenance studiously evaded in *Münchner Jahrbuch* 22 (1971), 229ff. Etruscan use of the vase: Vermeule 1965, 34. On the kylix from Sant'Antonio: Williams 1991, Rizzo 2009. On the inscription: M. Martelli, 'Dedica ceretana a Hercle', in *Archeologia Classica* 43 (1991), 613–21.

3 EUPHRONIOS AND 'THE PIONEERS'

Lucien Bonaparte's partisan claims for Etruscan culture rested on rather hazy philological skills: he surmised, for instance, from the inscription *Euthymides ho Polio[u]* ('Euthymides [son] of Po[l]lias'), that *hopolio* [*sic*] was Etruscan for 'made' (thus *Museum Etrusque de Lucien Bonaparte Prince de Canino. Fouilles de 1828 à 1829*, Viterbo 1829, 122).

The possibility that the Euphronios who signed *egraphsen* (usually thus, not *egrapsen*) was not the same as the Euphronios who signed *epoiêsen* was entertained by Beazley (*ARV* I, 13); note also Robertson 1992, 43, and Beazley's

further considerations in his 'Potter and Painter in Ancient Athens' (1944), in D. C. Kurtz ed., *Greek Vases: Lectures by J. D. Beazley* (Oxford 1989), 39–59. Furtwängler on 'Euphronios fantasies': *FR* II, 11; on the painter's 'strength in fine detail', *FR* I, 103. The transition from Klein to Beazley is charted in P. Rouet, *Approaches to the Study of Greek Vases: Beazley and Pottier* (Oxford 2001). Beazley never actually acknowledged Morelli as an influence: for his 'Morellian' principle, see *Attic Red-Figured Vases in American Museums* (Oxford 1918), vi.

Euphronios features only marginally in J. C. Hoppin's 1917 monograph, *Euthymides and his Fellows* (Harvard). But the kinship of stylistic detail between the two painters is nicely revealed by Hoppin's insistence (pp. 68–72) that the Berlin krater showing athletes in various poses (Fig. 1) should be attributed to Euthymides. (Beazley's review of Hoppin's book, in *JHS* 37 [1917], 233–7, is instructive.) See also Wegner 1979. The challenges of conducting a 'Morellian' analysis of Euphronios' style are evident from E. Svatik, 'A Euphronios kylix', in *The Art Bulletin* 21.3 (1939), 251–71. There is a more suave account of stylistic hallmarks in Bothmer 1989. For an exemplary quandary of attribution, see M. Tiverios, 'Sosias kai Euphronios', in *Arch. Eph.* 1977, 1–11.

On the Euphronios–Smikros problem, see Hedreen 2016 (with further bibliography) and Williams (forthcoming). The problem is compounded by fragments of an inscribed pillar recovered from the Agora, listing Athenian casualties from campaigns on Thasos and in the Thracian Chersonnese during the year 465 BC (*IG* I² 928). Several of the names recall those associated with ceramic craft *c.*500 BC: thus 'Euphronios', 'Smikythos', 'Sosias' and 'Smikros'. One of the generals leading the campaign is reported to have been Leagros (presumed killed, though he is not on the list). If not coincidence of (common) names, this evidence raises more questions than it answers. According to conventional chronology,

Euphronios would then have been about sixty or seventy years old. Would a man of that age have been involved in such a testing expedition – which was in part to quell a revolt on Thasos, but also to settle a colony at Ennea Hodoi (later Amphipolis) on the River Strymon?

On the painter's presumed presbyopia, Maxmin 1974; Williams 2005 offers an alternative occasion for the Acropolis dedication. For Euphronios experimenting with the medium, see J. Mertens, 'A White-Ground Cup by Euphronios', in *Harv. Stud.* 76 (1972), 271–81; B. Cohen ed., *The Colors of Clay: Special Techniques in Athenian Vases* (Los Angeles 2006), 48–51 (Agora Museum inv. P 32344) and 123–4. The nature of 'naturalism' in Pioneer work is nicely discussed in Neer 2002 (esp. Ch. 2). For Gombrich and the first frontal foot, see E. H. Gombrich, *The Story of Art* (12th ed., London 1972), 51–2.

On the 'curious exhibitionism' of Euphronios with regard to anatomical detail, see Maxmin 1973 (whence the quote) and Villard 1953. For Euphronios' drawing within its wider ambience, see D. Williams, 'The drawing of the human figure on early red-figure vases', in D. Buitron-Oliver ed., *New Perspectives in Early Greek Art* (Washington 1991), 285–301.

4 ATHENS AND THE SYMPOSIUM

On the krater within the symposium, Lissarrague 1990 (also Lissarrague, *The Aesthetics of the Greek Banquet* [Princeton 1990]), 19–460; note also M. Langer, 'Where should we place the krater? An optimistic reconstruction', in A. Avramidou & D. Demetriou eds, *Approaching the Ancient Artifact* (Berlin 2014), 385–98. That the krater might stand for 'mixing' in a wider sense, see R. Schlesier, 'Kratêr. The mixing-vessel as metaphorical space in ancient Greek tradition',

in F. Horn & C. Breytenbach eds, *Spatial Metaphors: Ancient Texts and Transformations* (Berlin 2016), 69–84.

The case for painted pottery being 'subsidiary' to metal vessels is polemically made in M. Vickers & D. Gill, *Artful Crafts: Ancient Greek Silverware and Pottery* (Oxford 1994). Counter-arguments, and estimates of the ancient value of painted vases, are to be found in Williams 1996, and Boardman 2001; see also R. M. Cook, *Greek Painted Pottery* (3rd ed. London 1997), 259–62. Vase-painters, for all their virtuosity in draughtsmanship, were likely to have participated in all stages of production – thus Boardman 2001, 142: 'I feel sure that even a Euphronios sometimes carried the wood and skimmed the clay.'

For discussion of 'at-home' symposia, see L. C. Nevett, *Domestic Space in Classical Antiquity* (Cambridge 2010). It is worth adding here that painted pottery marked as 'state property' was apparently used for the communal meals (*syssitia*) granted to public officials at Athens: see A. Steiner, 'Private and public: links between the symposium and syssition in fifth-century Athens', *Cl. Ant.* 21 (2002), 347–90, and K. M. Lynch, *The Symposium in Context: Pottery from a Late Archaic House near the Athenian Agora* (Princeton 2011). For Euphronios cups from the Agora, see *AJA* 103 (1999), 298.

There are several commentaries on and discussions of Xenophanes' prescription for a decorous symposium: I have drawn principally upon C. M. Bowra, 'Xenophanes, Fragment 1', in *Cl. Phil.* 33 (1938), 353–67 (incidentally, Maurice Bowra was sponsor of Dietrich von Bothmer's Rhodes Scholarship to Oxford); see further F. Hobden, *The Symposion in Ancient Greek Society and Thought* (Cambridge 2013), 25ff. An approachable survey of sympotic poetry is given in D. A. Campbell, *The Golden Lyre* (London 1983): see esp. Ch. 2.

Much discussion of symposium-scenes in late-archaic Attic red-figure vase-painting in Catoni 2013; also K. Topper, *The Imagery of the Athenian Symposium* (Cambridge 2012). Dionysiac revels depicted by Euphronios are discussed by I. Scheibler in Wehgartner 1992, 104–12. On the *kottabos*-game, see E. Csapo and M. C. Miller, 'The "kottabos-toast" and an inscribed red-figured cup', in *Hesperia* 60 (1991), 367–82. The proposal to see Spartan *hetairai* on the St Petersburg psykter comes in G. Ferrari, *Figures of Speech: Men and Maidens in Ancient Greece* (Chicago 2002), 19–20; alternatively see P. Kretschmer, *Die griechischen Vaseninschriften* (Gütersloh 1894), 87, noting that other *kottabos*-casts are similarly inscribed in Doric, and likening this practice to e.g. the use of French for terms in the sport of fencing.

'Who would have suspected a relationship between an aristocratic, a coveted inaccessible beauty, and a craftsman from the Kerameikos…?' (Frel 1983, 147). Who indeed? On the Leagros phenomenon, see Shapiro 2000 and *id.* 2004. The phrase *Leagros kalos* has also been found upon a black-glaze or black-figure fragment from a pit in the agora of Eretria, deemed to date shortly after the Persian sack of Eretria in 490 BC (the vase appears to have been a psykter).

Credit to a doctor for spotting the scar tissue on Sarpedon's body: H. Johnson, 'The wounds of Sarpedon', in *The Lancet* 357 (2001), 1370.

Discussion of the *Patrokleia* here is indebted to A. Barchiesi, *Homeric Effects in Vergil's Narrative* (Princeton 2015), 1–34. Note that Bacchylides fr. 20E (Campbell) also hymns the solicitude of Zeus for Sarpedon.

On viewing the hero's body: C. Segal, *The Theme of the Mutilation of the Corpse in the Iliad* (*Mnemosyne* Suppl. 17, 1971); and Ch. 7 of

H. Lovatt, *The Epic Gaze* (Cambridge 2013). Regarding a battlefield casualty, note the epic resonance of Herodotus 9.25.1. On the size of heroes, and ancient use of megafauna, see A. Mayor, *The First Fossil Hunters* (Princeton 2000), 104–56. For the claim that a 'heroic code' in Homer is 'complete and unambiguous', and beyond rational discourse, see M. I. Finley, *The World of Odysseus* (2nd ed. Harmondsworth 1978), 113. For Euphronios' depictions of Ajax and Achilles, see Padgett 2001 (Ajax cup: Robertson 1981, 25–8).

See Neils 2009 for the argument that Sarpedon's body was viewed as that of a 'soft' barbarian enemy. (She cites passages from Homer, e.g. *Il.* 22.370–5, but Euphronios would be evoking a very different narrative about Sarpedon if this interpretation was right, and so far as we know, it is Homer who constructs Sarpedon as a character in the epic tradition.)

The names of the figures on 'Side B' of the krater are discussed in John Boardman's contribution to Cianferoni *et al.* eds 1992, 45–50; see also Bothmer 1976, 494–5. For further exploration of the meaning of the scene, see N. J. Spivey, 'The Piping Crab', in *Mediterranea* (forthcoming).

6 AN IMAGE FOR THE AFTERLIFE

Up-to-date survey of Cerveteri's archaeology: V. Bellelli *et al.*, *Gli Etruschi e il Mediterraneo: La città di Cerveteri* (Rome 2014). On the Etruscan taste for/use of Greek vases, see Spivey 2007 (with previous bibliography), and Lubtchansky 2014; also J. de la Genière ed., *Les clients de la céramique grecque* (Paris 2006), and Cerchiai 2008. For Euphronios and Cerveteri, see Arias 1980. Over-valued vases? – quote from M. Vickers in *AJA* 94 (1990), 619. Greek vases in non-funerary use at Cerveteri: see M. Cristofani *et al.*, *Caere 3.1: Lo scarico arcaico della Vigna Parrocchiale* (Rome 1992), 61–105.

Tomb of the Lionesses: quote from M. Pallottino, *Etruscan Painting* (New York 1952), 44. Pezzino krater: the case for Patroclus made by P. E. Arias, 'Morte di un eroe', in *Arch.Cl.* 21 (1969), 190–203; cf. D. Deorsola *et al.* eds, *Veder Greco: le necropoli di Agrigento* (Rome 1988), 221.

Hypnos and Thanatos: Lessing 1769 remains a jaunty essay on why Death was rarely symbolized by a skeleton; and Robert 1879 a useful collection of visual data. Beyond K. Heinemann's sensitive dissertation *Thanatos in Poesie und Kunst der Griechen* (Munich 1913) – plus relevant entries in *LIMC* – see C. Mainoldi, 'Sonno e morte in Grecia antica', in R. Raffaelli ed., *Rappresentazioni della morte* (Urbino 1987), 9–46; and H. A. Shapiro, *Personifications in Greek Art: The Representation of Abstract Concepts 600–400 B.C.* (Zürich 1993), 132–47. For the images of Hypnos and Thanatos on Athenian lekythoi, see Oakley 2004, 125–37 (including a catalogue of sixteen examples). Note that the presence of Hermes on a poorly preserved lekythos in the Athens National Museum (inv. 1830) depends upon what a modern draughtsman made of the piece: see E. Buschor, 'Attische Lekythen der Parthenonzeit', in *Münchner Jahrbuch* n.s. 2 (1925), pl. 5.

7 THE AFTERLIFE OF AN IMAGE (I)

For the Alexandria inscription, see *Rev. Arch.* 40 (1880), 166–70.

Euphronios' Memnon fragment is Metropolitan Museum 11.140.6. The claim has been made that a number of vases deemed to show Sarpedon may rather represent Memnon – see M. E. Clark & W. D. E. Coulson, 'Sarpedon and Memnon', in *Museum Helveticum* 35 (1978), 65–73. This connects to the long-running debate about the relationship of the *Iliad* to the *Aethiopis*. Arguing from vases to establish the content of lost epic can be circular (E. Löwy,

'Zur Aithiopis', *Neue Jahrb.* 1914, 81–94, is more cautious); more convincing is Bothmer 1987, and *Euphronios*, 114.

Other *cistae* with corpse-bearers as handles include New York Metropolitan Museum 22.84.1; Berlin 6236; London BM 738-20 263; Villa Giulia 13199 (Amazons). Quote from J. D. Beazley, *The Lewes House Collection of Ancient Gems*, Oxford 2002 [Oxford 1920], 36.

Aeschylus fragments are edited and discussed in Sommerstein 2008; for staging of the *Europa/Carians*, see Keen 2005, esp. 64–7. On the New York vase, Messerschmidt 1932 and Picard 1953: see also A. Kossatz-Deissmann, *Dramen des Aischylos auf westgriechischen Vasen* (Mainz 1978), 66–74, and O. Taplin, *Pots and Plays* (Los Angeles 2007), 72–4; and note also the *hydria* in Policoro (inv. 35294), showing (on the shoulder) Hypnos and Thanatos aloft with a body.

Iliac tablets: quote from M. Squire, *The Iliad in a Nutshell: Visualizing Epic on the Tabulae Iliacae* (Oxford 2011), 175.

For the ivory plaquette from Pompeii: advancing the Adonis identification (and a 'scene startingly reminiscent of the Deposition'), see P. W. Lehmann, *Roman Wall Paintings from Boscoreale in the Metropolitan Museum of Art* (Cambridge, Mass., 1953), 58; see also B. Schneider, 'Zwei römische Elfenbeinplatten mit mythologischen Szenen', in *Kölner Jahrbuch für Vor- und Frühgeschichte* 23 (1990), 255–72 (esp. 265–7).

For the Grottaferrata relief, see L. Musso, 'Il trasporto funebre di Achille sul rilievo Colonna-Grottaferrata: una nota iconografica', in *Bull. Comm.* 93 (1989/90), 9–22; further discussion and full bibliography in A. Ambrogio *et al.*, *Sculture antiche nell'Abbazia di Grottaferrata* (Rome 2008), 90–100. (For original composition, see Winckelmann, *Monumenti Inediti* [Rome 1767], Fig. 136.)

Warburg's concept of the 'pathos formula', and its application, remain problematic: see J. Knape, 'Gibt es Pathosformeln?' in W. Dickhut *et al.* eds, *Muster im Wandel* (Göttingen 2008), 115–37. For divulgation and discussion see E. H. Gombrich, *Aby Warburg: An Intellectual Biography* (2nd ed. Oxford 1986), and R. Woodfield ed., *Art History as Cultural History: Warburg's Projects* (Amsterdam 2001).

For Beazley and the 'tracking' paradigm, see J. Whitley, 'Beazley as theorist', in *Antiquity* 71 (1997), 40–7.

'It was the fate of the Renaissance, that its cot stood in a coffin': the line (literally translated) is André Jolles quoting his younger self, from a lecture given at Groningen in 1897, in a letter to his friend Johan Huizinga: see L. Hanssen *et al.* eds., *J. Huizinga: Briefwisseling I: 1894–1924* (UtrecH 1989), 326. As the letter makes clear, Jolles was thinking of Nicola Pisano's use of the Phaedra sarcophagus in Pisa's Campo Santo (*pace* Settis in Catoni 2013, 85).

The Alberti passage is rendered from his Italian edition: the Latin is a little different – and the basis for C. Grayson's translation, first published in 1972. See also A. Grafton, '*Historia* and *istoria*: Alberti's terminology in context', in *I Tatti Studies in the Italian Renaissance* 8 (1999), 37–68. For sarcophagi potentially available to Alberti, see C. Robert, *Die antiken Sarkophag-reliefs* 3.2 (Berlin 1894), pl. 96; and P. P. Bober and R. Rubinstein, *Renaissance Artists and Antique Sculpture* (London 1986), 145–7. The story of the Barberini sarcophagus, lost and found: B. Kuhn-Forte, 'Der wiederentdeckte Meleagersarkophag Barberini in São Paulo. Provenienz und grafische Dokumentation (ca. 1516–1630)', in *Pegasus* 13 (2011), 41–75.

For other Meleager sarcophagi, beyond the *corpus* provided by Koch 1975, see formal analysis of a group of such sarcophagi by G.

Traversari, 'Sarcofagi con la morte di Meleagro nell'influsso artistico della Colonna Aureliana', *MDAI(R)* 1968, 154–62. See also comments on particular pieces, viz.: R. Calza, *Antichità di Villa Doria Pamphilj* (Rome 1977), no. 189; L. Guerrini, *Palazzo Mattei di Giove: le antichità* (Rome 1982), no. 64; G. Becatti, 'Un sarcofago di Perugia e l'officina del Maestro delle imprese di Marco Aurelio', in L. F. Sandler ed., *Essays in Memory of Karl Lehmann* (New York 1964), 30–7; A. M. McCann, *Roman Sarcophagi in the Metropolitan Museum of Art* (New York 1978), 61–6.

Possible influence upon Giotto: A. Bush-Brown, 'Giotto: two problems in the origin of his style', in *Art Bulletin* 34 (1952), 42–6. Ghiberti quote: from R. Krautheimer, *Lorenzo Ghiberti* (Princeton 1970), 293. Donatello's use of Roman sarcophagi: M. Greenhalgh, *Donatello and His Sources* (London 1982); H. W. Janson, 'Donatello and the antique', in *Donatello e il suo tempo* (Florence 1968), 77–96. Signorelli: on Vasari's anecdote and the Cortona *Deposition*, M. Cruttwell, *Luca Signorelli* (London 1899), 10; T. Henry, *The Life and Art of Luca Signorelli* (London 2012), xiii–xv; 215. On the legacy of the 'dead arm' element, see G. Pellegrini, *Il braccio della morte: migrazioni iconografiche* (Cagliari 1993).

On Raphael's use of sarcophagi, see Spivey 2001, 112–21; C. L. Ragghianti, *La Deposizione di Raffaello* (Milan 1947); K. Hermann-Fiore ed., *Raffaello: La Deposizione in Galleria Borghese* (Milan 2010), 129–31. On Vasari, see L. De Girolami Cheney, 'Giorgio Vasari: Il trasporto di Cristo o Cristo portato al Sepolcro', in *Artibus et Historiae* 32, no. 64 (2011), 41–61.

On David, see S. Howard, *A Classical Frieze by Jacques Louis David* (Sacramento 1975). For assorted David drawings from Meleager sarcophagi, see P. Rosenberg & L.-A. Prat, *Jacques-Louis David 1748–1825: Catalogue raisonné des dessins* (Milan 2002).

Research in the field of 'embodied cognition' is rapidly developing: citation here is limited to D. Freedberg and V. Gallese, 'Motion, emotion and empathy in esthetic experience', in *Trends in Cognitive Science* 11 (2007), 197–203.

9 CODA

On Sarpedon's Lycian pedigree, see P. Kretschmer in *Glotta* 28 (1940), 104; also Janko 1992, 371ff. For 'Edifice G' at Xanthos, see H. Metzger, *Fouilles de Xanthe* II (Paris 1963), 49–61. Keen 1996 presents the optimistic case for regarding it as the Sarpedoneion; see also A. G. Keen, *Dynastic Lycia* (Leiden 1998), 186–92.

Bibliography

Arias, P. E. 1980. 'La provenienza dei vasi di Euphronios', in *The Preservation and Use of Artistic Cultural Heritage: Perspectives and Solutions*, Varese, 59–70.

Barbanera, M. 1994. 'Un'impronta gemmaria Cades e il problema dell'iconografia del trasporto funebre dell'eroe', in *Arch.Cl.* 46, 385–400.

Boardman, J. 2001. *The History of Greek Vases*. London.

Bothmer, D. v. 1976. 'Der Euphronioskrater in New York', in *AA* 1976, 485–512.
———— 1981. 'The death of Sarpedon', in S. L. Hyatt ed., *The Greek Vase*, New York, 63–80.
———— 1987. 'Euphronios and Memnon? Observations on a red-figured fragment', in *Metropolitan Museum Journal* 22, 5–11.
———— 1990. 'Euphronios: an Attic vase-painter's view of the human body', in *Dialexeis 1986–1989* (Goulandris Foundation), 25–42.
———— 1994. *s.v.* 'Sarpedon', in *LIMC* 7, 696–700. Zürich.

Catoni, M. L. 2010. *Bere vino puro: immagini del simposio*. Milan.

Catoni, M. L., Ginzburg, C., Giuliani, L. & Settis, S. 2013. *Tre figure: Achille, Meleagro, Cristo*. Milan.

Cerchiai, L. 2008. 'Euphronios, Kleophrades, Brygos: circolazione e committenza della ceramica attica a figure rosse in Occidente', in *Workshop di archaeologia classica* 5, 9–28.

Cianferoni, G. C., Cygielman, M. & Iozzo, M. (eds). 1992. *Euphronios: Atti del Seminario Internazionale di Studi*. Florence.

Denoyelle, M. (ed.). 1992. *Euphronios peintre: Actes de la journée d'étude organisée par l'Ecole du Louvre et le Département des antiquités grecques, étrusques et romaines du Musée du Louvre, 10 octobre 1990*. Paris.

Denoyelle, M. & Pasquier, A. (eds). 1990. *Euphronios, peintre à Athènes au VIe siècle avant J.-C.* Paris.

Frel, J. 1983. 'Euphronios and his fellows', in W. G. Moon (ed.), *Ancient Art and Iconography*, Wisconsin, 147–58.

Haspels, C. H. E. 1930. 'Deux fragments d'une coupe d'Euphronios', in *BCH* 54, 422–51.

Hedreen, G. 2016. *The Image of the Artist in Archaic and Classical Greece: Art, Poetry, and Subjectivity*. Cambridge.

Hoving, T. 1993. *Making the Mummies Dance: Inside the Metropolitan Museum of Art*. New York.

Hoving, T. *et al.* 1975. *The Chase, the Capture: Collecting at the Metropolitan*. New York.

Janko, R. 1992. *The Iliad: A Commentary, Vol. IV: Books 13–16*. Cambridge.

Keen, A. G. 1996. 'The identification of a hero-cult centre in Lycia', in M. Dillon (ed.), *Religion in the Ancient World: New Themes and Approaches*, Amsterdam, 229–43.
———— 2005. 'Lycians in the *Cares* of Aeschylus', in F. McHardy (ed.), *Lost Drama of Classical Athens*, Exeter, 63–82.

Klein, W. 1886. *Euphronios. Eine Studie zur Geschichte der griechischen Malerei* (2nd ed.), Vienna.

Koch, G. 1975. *Die Mythologischen Sarkophage, 6: Meleager*. Berlin.

Lessing, G. E. 1769. *Wie die Alten den Tod gebildet: eine Untersuchung*. Berlin.

Lissarrague, F. 1990. 'Around the *krater*: an aspect of banquet imagery', in O. Murray (ed.), *Sympotica: A Symposion on the Symposion*, Oxford, 196–209.

Lubtchansky, N. 2014. '"Bespoken vases" tra Atene e Etruria?', in *Annali della Fondazione per il Museo 'Claudio Faina'* 21, 357–81.

Maxmin, J. 1973. 'Euphronian legs reconsidered', in *Athens Annals of Archaeology* 6, 299–301.
———— 1974. '*Euphronios Epoiesen*: Portrait of the Artist as a Presbyopic Potter', in *G&R* 21, 178–80.

Messerschmidt, F. 1932. 'Büchenbild und Vasemalerei', in *RM* 47, 122–51.

Nagy, G. 1983. 'On the death of Sarpedon', in C. A. Rubino and C. W. Shelmerdine (eds), *Approaches to Homer*, Austin, 189–217.

Neer, R. T. 2002. *Style and Politics in Athenian Vase-Painting*. Cambridge.

Neils, J. 2009. 'The "unheroic" corpse: re-reading the Sarpedon krater', in J. H. Oakley and O. Palagia (eds), *Athenian Potters and Painters* Vol. II, Oxford, 212–19.

Nørskov, V. 2002. *Greek Vases in New Contexts*. Aarhus.

Oakley, J. H. 2004. *Picturing Death in Classical Athens: The Evidence of the White Lekythoi*. Cambridge.

Ohly-Dumm, M. 1974. 'Euphroniosschale und Smikrosscherbe', in *Münchener Jahrbuch* 25, 7–26.

Padgett, J. M. 2001. 'Ajax and Achilles on a calyx-krater by Euphronios', in *Record of the Art Museum, Princeton University* 60, 2–17.

Pasquier, A. 1981. 'Nouvelles découvertes à propos du cratère d'Antée peint par Euphronios', in *Revue du Louvre*, 1–9.

Picard, C. 1953. 'La mort du Sarpédon d'apres une tragédie perdue d'Eschyle (Europé) sur un vase du Metropolitan Museum (New York)', in *CRAI* 1953, 103–20.

Rizzo, M. A. 2009. 'Ceramica attica dal santuario in località S. Antonio a Cerveteri', in S. Fortunelli & C. Massenia (eds), *Ceramica attica da santuari della Grecia, della Ionia e dell'Italia*, Perugia, 369–85.

Robert, C. 1879. *Thanatos*. Berlin.

Robertson, M. 1981. 'Euphronios at the Getty', in *The J. Paul Getty Museum Journal* 9, 23–34.
———— 1988. 'Sarpedon brought home', in J. H. Betts, J. T. Hooker & J. R. Green (eds), *Studies in Honour of T. B. L. Webster* Vol. II, Bristol, 109–20.
———— 1992. *The Art of Vase-Painting in Classical Athens*. Cambridge.

Settis, S. 2000. '*Ars Moriendi*: Cristo e Meleagro', in *Annali della Scuola Normale Superiore di Pisa* s. 4, *Quaderni* 1–2, 145–70 (= Catoni *et al.* 2013, 85–108).

Shapiro, H. A. 2000. 'Leagros and Euphronios: painting pederasty in Athens', in T. K. Hubbard (ed.), *Greek Love Reconsidered*, New York, 12–32.

———— 2004. 'Leagros the satyr', in C. Marconi (ed.), *Greek Vases: Images, Contexts and Controversies*, Leiden, 1–11.

Sommerstein, A. H. 2008. *Aeschylus: Fragments.* Harvard.

Spivey, N. J. 1991. 'Greek vases in Etruria', in T. Rasmussen & N. Spivey (eds), *Looking at Greek Vases*, Cambridge, 131–50.
———— 2000. *Enduring Creation*, London and Berkeley.
———— 2007. 'Volcanic landscape with craters', in *Greece & Rome* 54, 229–53 (= D. Yatromanolakis ed., *An Archaeology of Representations*, Athens 2009, 50–75).

Tsingarinda, A. 2009. 'The death of Sarpedon: workshops and pictorial experiments', in S. Schmidt & J. H. Oakley (eds), *Hermeneutik der Bilder. Beiträge zur Ikonographie und Interpretation griechischer Vasenmalerei.* Munich.

Turner, M. 2004. 'Iconology vs iconography: the influence of Dionysos and the imagery of Sarpedon', in *Hephaistos* 21/22, 53–79.

Vermeule, E. 1965. 'Fragments of a symposion by Euphronios', in *Antike Kunst* 8, 34–9.

Vernant, J.-P. 2001. 'A "beautiful death" and the disfigured corpse in Homeric epic', in D. L. Cairns (ed.), *Oxford Readings in Homer's Iliad*, Oxford, 311–41.

Villard, F. 1953. 'Fragments d'une amphore d'Euphronios au Musée du Louvre', in *MonPiot* 47, 35–46.

Webster, T. B. L. 1972. *Potter and Patron in Classical Athens.* London.

Wegner, M. 1979. *Euthymides und Euphronios.* Münster.

Wehgartner, I. (ed.) 1992. *Euphronios und seine Zeit.* Berlin.

Williams, D. 1991. 'Onesimos and the Getty Iliupersis', in *Greek Vases in the J.P. Getty Museum* 5, 41–62.
———— 1996. 'Refiguring Attic red-figure: A review article', in *RA* 2, 227–52.
———— 2005. 'Furtwängler and the Pioneer painters and potters', in V. M. Strocka (ed.), *Meisterwerke: Internationales Symposion anlässlich des 150. Geburtstages von Adolf Furtwängler*, Munich, 271–83.
———— (forthcoming). 'Villard and the Campana Collection; Euphronios and Smikros'.

Index

Illustrations are in *italics*.

Acknowledgements

Citations from Homer's *Iliad* are from E. V. Rieu's translation, with occasional minor alterations.

For assistance and guidance in various ways, may I thank: Vincenzo Bellelli, Giulia Bertoni, James Clackson, Jasper Gaunt, Richard Hunter, Geraldine Norman, Michael Padgett, Michael Squire, Peter Stewart, Christos Tsirogiannis and Dyfri Williams. Surviving errors are *culpa mea*.

Beyond their general support, the Faculty of Classics and Emmanuel College have assisted with the costs of images.

I am grateful to Richard Milbank for his encouragement to write the book, and to Georgina Blackwell for nursing it through publication.